THE
DA VINCI
LEGACY

THE
DA VINCI
LEGACY

HOW AN ELUSIVE 16TH-CENTURY ARTIST
BECAME A GLOBAL POP ICON

JEAN-PIERRE ISBOUTS and
CHRISTOPHER HEATH BROWN

APOLLO
PUBLISHERS

Apollo Publishers books may be purchased for educational, business, or
sales promotional use. Special editions may be made available upon request.
For details, contact Apollo Publishers at info@apollopublishers.com.

Visit our website at www.apollopublishers.com.

Library of Congress Cataloging-in-Publication Data is available on file.

Print ISBN: 978-1948062-34-3
Ebook ISBN: 978-1-948062-35-0

Printed in the United States of America.

Cover and interior design by Rain Saukas.
Cover image © make.

CONTENTS

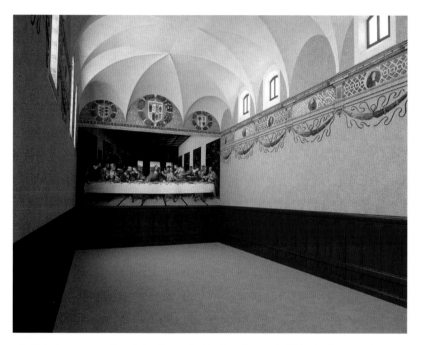

A digital reconstruction of the *Cenacolo* (the Last Supper hall) in the former refectory
of the Santa Maria delle Grazie as it appeared in the early 16th century

INTRODUCTION

A hush fell over the crowd as one of the last lots of the evening was brought into the room. Those in the front rows—the top buyers, curators, and billionaire collectors—moved slightly forward in their seats, craning their necks to better see the portrait on the dais in front of them. Among their ranks were some of the most powerful dealers and collectors in the world, including New York's Larry Gagosian; David Zwirner and Marc Payot of Hauser & Wirth; Eli Broad and Michael Ovitz from Los Angeles; and Martin Margulies from Miami. Those standing in the back of the room pushed and jostled in the hope of catching a glimpse of the painting, a surprisingly small panel at just 26 by 19 inches. Outside, New York was enjoying one of the last balmy nights of the city's famous Indian summer, but inside, the air conditioning systems were working overtime to cool the rising heat of the packed room.

Jussi Pylkkänen, the global president of Christie's, seemed unfazed as he looked at the more than one thousand dealers, advisors, journalists, and critics who had somehow secured tickets to get inside his auction hall at Rockefeller Center. He cleared his

throat, brushed some dust from the lectern in front of him, and said, "And so, ladies and gentlemen, we move on to Leonardo da Vinci, his masterpiece of *Christ the Savior*, previously in the collection of three kings of England." Inwardly, however, Pylkkänen could barely contain his excitement.

The reason is simple: works by da Vinci are rare. So rare, in fact, that any time a bona fide work by this elusive Italian artist makes it to an auction floor, it automatically generates headlines all over the world. Unlike, say, Vincent van Gogh, who could turn out one or more paintings in a day, Leonardo labored over his paintings for months, even years. The reason, his 16th-century biographer Giorgio Vasari claimed, is that "the work of his hands could rarely match the perfection of his imagination." But that judgment tells only half the story. The fact of the matter is, Leonardo saw himself as much more than a mere painter. He was fascinated by science, nature, human biology, and great mysteries such as the flight of birds or the movement of water. He burned with ambition to become a famous architect like his friend Donato Bramante, or an engineer like his fellow Florentine Filippo Brunelleschi, who had secured his fame by creating a vast dome over the central crossing of Florence's cathedral. At the same time, Leonardo was fascinated by optics and the way our eyes perceive the effect of atmosphere and depth; he spent hours investigating the play of light and shadow on the face of a beautiful young woman. Yes, Leonardo believed he was much more than a painter—a character who, in the quattrocento, the 15th century, was still considered little more than an artisan with a dirty smock. If he were alive today, he would be called a true Renaissance man, even though, ironically, that term had yet to be invented when Leonardo was alive.

As a result, there are only some *eighteen* paintings that we can reliably accept as true da Vinci "autograph" works today. That is an amazingly small number, especially when you consider that Leonardo's contemporary, Sandro Botticelli, completed well over a hundred paintings during the same time period. And these are just the Botticellis that we know of, since the artist burned a goodly number of his mythological paintings after he heard the sermons of a fiery monk named Savonarola. Worse, two of Leonardo's most famous frescoes, the *Last Supper* in Milan and the *Battle of Anghiari* in Florence, are no longer visible in their erstwhile glory: the former because the mural is hopelessly damaged, and the latter because it was overpainted in the latter part of the 16th century. Only a handful of copies give us an inkling of the immense visual power that these works brought to the Renaissance.

For Leonardo, this was especially unfortunate because frescoes—which cannot be bought or sold, and always remain in place—were the principal medium in which an artist could secure his reputation for all time. Leonardo's chief rivals, Raphael and Michelangelo, had sealed their celebrity with a series of highly successful frescoes in Rome. Raphael made his name by painting murals for the *stanze* (or the papal "rooms") in the Vatican, while Michelangelo became immortal for his magnificent frescoes in the Sistine Chapel.

Little wonder, then, that when Leonardo finally made his way to the Vatican, long after these rivals had made their mark, he was roundly ignored by Pope Leo X. Despite the best efforts of the pope's brother, Giuliano de' Medici, the pontiff could not be bothered to toss a bone to the painter from Florence. When, at long last, the pope reluctantly agreed to give Leonardo a commission for a painting, Leonardo immediately began to distill a new

mixture of oil and herbs for the final varnish. The pope was heard to mutter, "Bah, this man can't do anything right, for he thinks of the end before he begins his work."[1]

Copy by an unknown artist of Raphael's *Portrait of Giuliano de' Medici*, ca. 1515

After spending several frustrating years on the periphery of the papal orbit in Rome, hoping for a major commission that never materialized, Leonardo realized that his cause was lost. The Medicis never had much love for Leonardo, even when he was a young prodigy at the studio of his master Andrea del Verrocchio.

For this, Leonardo blamed his lack of a formal education; as everyone knew, Lorenzo de' Medici was a notorious snob. Now that the Medicis had captured the throne of St. Peter, Leonardo's chance of matching the fame and glory of his competitors was receding by the day.

When his only patron, Giuliano de' Medici, died in March of 1516, after a long battle with tuberculosis, Leonardo knew that the writing was on the wall. His last patron in Italy was gone. He would have died a pauper, unmourned and unloved, if a king from another country, François I, had not come to his rescue. The French king was kind enough to offer the ailing artist a comfortable place of retirement, not far from his own palace of Amboise on the Loire River. And so Leonardo removed himself from the beating heart of the Renaissance, the papal court in Rome. As it happened, it was the same summer of 1516 when Raphael reached the apex of his fame with *Woman with a Veil* (its pose slyly copied from Leonardo's *Mona Lisa*), and Michelangelo carved the first figures for his monumental *Tomb of Pope Julius II*.

Few courtiers in Rome noticed Leonardo's departure. He was simply an old man whose time had come and gone. Ensconced in a villa in Amboise, bent by age and felled by a stroke, Leonardo waited patiently until death carried him away on the night of May 2, 1519. Many of his notebooks, compiled over the course of his long career, were lost to the four corners of the earth.

That is where the story of Leonardo da Vinci should have ended. Except that it did not.

Today, Leonardo da Vinci is the most celebrated artist in the world. His *Mona Lisa,* the portrait of a pretty Florentine housewife, is routinely cited as the most famous painting around the globe. In addition to museums like the Uffizi and the Louvre, countless "da Vinci museums" have sprung up in recent years,

featuring reconstructions of Leonardo's intricate machines, including designs for a tank, a bicycle, a mortar, and a parachute. Special exhibits of his paintings, such as the blockbuster London exhibit *Leonardo da Vinci: Painter at the Court of Milan* in 2012, are able to attract millions of visitors. The Louvre, for example, reports that the *Mona Lisa* alone typically draws *nine million* visitors per year.

The same is true for popular literature about the artist. Dan Brown's fictional thriller, *The Da Vinci Code*, became one of the all-time best sellers in 2003, with an estimated eighty million copies sold worldwide to date. And in 2017, a book about Leonardo da Vinci by Steve Jobs biographer Walter Isaacson zoomed to the top of the *New York Times* nonfiction best-seller list.

How did this happen? Where does all this da Vinci mania come from? Why, exactly five hundred years after his passing as a recluse in a remote French villa, is Leonardo one of the leading pop icons of our day? And why did more than one thousand buyers, critics, and journalists cram themselves into an auction room at Christie's to see a painting that had been dismissed as a copy only twelve years earlier?

This book is the first to try to unravel this mystery—a mystery that is quite possibly the last remaining enigma about this elusive genius. What strange phenomenon intervened to make sure that Leonardo was not relegated to the dusty pages of history, like so many other talented artists of the Renaissance? How did his mystique as a solitary genius survive five centuries of European history, and why does it continue to fascinate us in modern times?

To answer this question, we will embark on a journey—a long and fascinating journey that begins in a manor in Amboise in France in 1517, and ends in a packed auction room at Christie's, one balmy evening in November 2017.

1.
LEONARDO IN AMBOISE

If there is one thing we know without question, it is that Leonardo always had a strong affection for the French, and they for him. We might think that's no surprise, given the reputation of France as a mecca for art, architecture, music, and good food. Who would not want to spend his retirement in a beautiful home near the river Loire, an area known throughout the world for being home to some of the country's most famous vineyards?

That may be true today, but it was not the case in the early 16th century. Through much of the Middle Ages, it was actually the court of Bourgogne (Burgundy) that had led French culture, in art as well as poetry and music. Here, for example, was the birthplace of a new form of music, a beautiful polyphonic style developed by renowned composers such as Gilles Binchois and Guillaume Dufay. But in the 14th century, France was devastated by the Black Death, which wiped out a third of the nation's population. This was followed by the even more devastating Hundred Years' War, pitting the English House of Plantagenet against the French House of Valois, in which Joan of Arc played such a prominent role.

As a result, by the dawn of the 16th century, France was a mere shadow of its former self. Many of its artists and architects still labored in the Gothic style, rather than embracing the exciting new impulses from Greco-Roman art that had produced the Italian Renaissance. France, in sum, was in danger of losing its place as one of the leading cultural centers of Europe.

The French king Louis XII, who came to power in 1498—just as Leonardo neared completion of the *Last Supper* in Milan—was very much aware of the problem. It was this king who fell under the spell of Leonardo's art after his armies captured the duchy of Milan in 1499. The king used his emissaries to commission a Madonna painting from Leonardo in 1501 (possibly the *Madonna of the Yarnwinder*), and then ordered a full-size copy of the *Last Supper*, painted on canvas.[2] So close was Leonardo's relationship to the French court that the king began to refer to him as "nostre peintre et ingénieur ordinaire," proclaiming Leonardo the court's official artist and engineer.

But before the relationship between Leonardo and his French admirer could blossom, Louis XII died on January 1, 1515, succumbing to an aggravated case of gout, a form of inflammatory arthritis that was a very common cause of death in those days. Worse, the king had no male heir to succeed him. By papal consent he had annulled the marriage to his first wife, Joan, Duchesse de Berry, because of her reported sterility—a case that was later avidly studied by King Henry VIII of England, in his attempt to secure a papal annulment of *his* marriage to Catherine of Aragon. Louis had then eagerly tied the knot with Anne of Brittany, the widow of his cousin Charles VIII, so as to bring Brittany under the sway of the French crown and produce a needed heir. Anne gave birth to two daughters, but was unable to present her husband with the desired crown prince. She then died in 1514, one

year before Louis, who reportedly loved her to distraction.

The death of Louis XII left his son-in-law and cousin, François, as the only plausible successor. Indeed, at the tender age of four, François had already inherited the title of Duke of Valois. He had a strong claim to the throne if Louis XII's marriage to Anne of Brittany remained without male issue, as indeed was the case. François's own marriage to Anne's daughter, Claude, could only solidify his claim.

Fortunately, the young king was the product of a new age in France. By the end of the 15th century, most French artists and architects were ready to admit that French culture had been overtaken by the avant-garde of the Italian Renaissance. This was the reason why Louis XII had decided to order a life-size copy of the *Last Supper*. In his mind, no other painting so captured the astonishing accomplishments of the Renaissance than this monumental work. King François, his successor, proceeded a step further by making the development of an authentic French Renaissance style a matter of state policy. As a young man, he had been indoctrinated in new humanist theories by his tutors, Christophe de Longueil, a humanist from Brabant, and François Desmoulins de Rochefort. As a result, the new king was determined to bring France into the fold of the Renaissance, but on a more systemic basis. He devised a comprehensive strategy to attract Italian artists, sculptors, and architects to France so they could inculcate the new Renaissance style into the fabric of French artistic life. It was during François's reign, for example, that the French court began to amass the huge collection of Italian art that eventually filled the Louvre Museum.

It was therefore most fortuitous that in October 1515, Pope Leo X decided to invite François to a summit in Bologna. The purpose of this high-level meeting had very little to do with art.

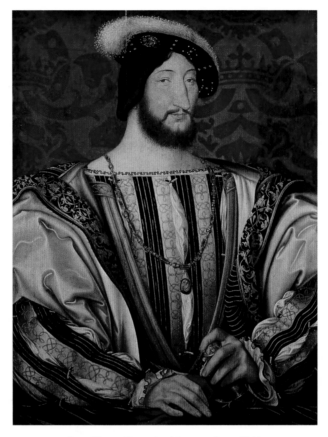

Jean Clouet, *Portrait of François I*, ca. 1530

François had just ousted a short-lived restoration of the Sforza family's rule in Milan and once again installed the French—much to the alarm of the Papal States and other Italian powers. In fact, the pope hoped to convince François to join a pan-European alliance of sorts that would bring peace to Europe, and allow all nations to focus their combined energies on the looming threat of the Turks. While Leo X failed in this endeavor, he did one important thing: he decided to bring Leonardo da Vinci along in his entourage.

Thus, François was able to meet Leonardo face-to-face for the first time. What the king had been told about this éminence grise is unclear, but his lieutenants in Milan would undoubtedly have informed him about the paintings that Leonardo had produced for Georges d'Amboise, the head of the previous French government in the city. As subsequent events would show, the impression that Leonardo made on King François was most favorable. An envious Benvenuto Cellini later wrote that François was "totally besotted" with Leonardo. What exactly transpired between the two is unknown—no document or letter has survived about this episode—but it is possible that François chose this moment to offer Leonardo a pension, with the position of artist-in-residence, should he decide to settle in France.

The summit ended on December 17. The king and the pope returned to their respective domains, but not before François bestowed a French title on Leonardo's patron, Giuliano de' Medici, by naming him Duke of Nemours. Some historians have interpreted this elevation to mean that François and the pope were devising a plot to put Giuliano on the throne of Naples, which was traditionally located in the Spanish Hapsburg sphere of influence. If this had truly come to pass, it is possible that the last phase of Leonardo's life would have unfolded in Naples, rather than France!

But fate had something else in mind for the unfortunate Giuliano. The thirty-seven-year-old duke was suffering from tuberculosis, with his health in steady decline. In October, Leonardo had written his benefactor, saying that he was "so greatly rejoiced, most illustrious Lord, by the desired restoration of your health," but that restoration proved illusory. In March 1516, Giuliano finally succumbed to his illness. From that point he might have faded from history, were it not that he was a Medici.

When Michelangelo began building a Medici chapel at the New Sacristy of the basilica of San Lorenzo in Florence, he designed the now-famous tomb with its sculptures of *Day* and *Night*. Here, Giuliano's remains were laid to rest—thus bestowing immortality on this hapless member of the Medici family.

The duke's untimely death left Leonardo without a patron, at a court that was now fully in the thrall of stars such as Raphael and Michelangelo. And yet Leonardo was not ready to give up, for his hope was now fastened on the new St. Peter's Basilica. This massive project had stalled upon the deaths of its principal architect, Bramante, in 1514, and of his successor, Giuliano da Sangallo, in 1515.

While passing through Florence on his way to the summit in Bologna, Leonardo made a number of sketches and studies for the reconstruction of the Medici quarter in Florence, including a façade for San Lorenzo, the family church of the Medici dynasty. Perhaps he hoped that these designs would convince the pope of his qualities as an architect and engineer, and thus earn him the task of continuing the new basilica.

Unfortunately, Leo X was not persuaded. The pope may have been amused by some of Leonardo's ingenious tricks—Vasari writes of a lizard that Leonardo dressed up as a dragon, complete with wings, and of a mechanical lion that delighted the summiteers in Bologna—but for important commissions, he preferred to rely on his celebrity painters, Raphael and Michelangelo. Both of these artists wound up working on the new St. Peter's; Leonardo was left alone in his Belvedere apartment, quietly working on the Louvre *Mona Lisa* and the *John the Baptist*, while his assistants Francesco Melzi and Salaì tiptoed around him.

As we have seen, in the summer of 1516 the old master finally acknowledged that his time in Rome, and indeed in Italy, had

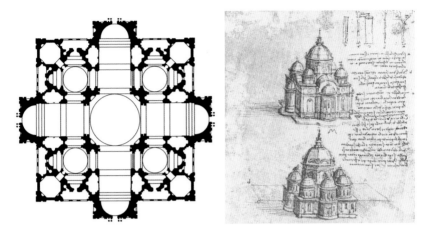

Left: The original plan of St. Peter's Basilica as designed by Bramante in 1506. The central plan of a domed Greek cross was later changed to that of a Latin cross.

Right: Leonardo's drawing of two domed churches, which appear to closely follow Bramante's design of St. Peter's Basilica.

come to an end. He accepted François's offer and moved to the village of Amboise. It was not a trivial decision; travel in Europe at that time, particularly across the Alps, was an arduous and dangerous undertaking, certainly for a man who was sixty-four years of age. Roads and bridges were often in disrepair, and even in the summer it was not unusual to see the principal passes—Mont Cenis, Great St. Bernard, St. Gotthard, or Septimer—covered in snow. Thieves and bandits preyed upon vulnerable travelers, including those who traveled with many possessions in their train, as Leonardo obviously did. He had refused to part with his three great masterpieces, the *Saint Anne,* the *Mona Lisa,* and the *John the Baptist,* regardless of the source of their patronage or ownership. Inns were often full, or in such a state that it would have pained a sophisticate like Leonardo to spend a night in

21

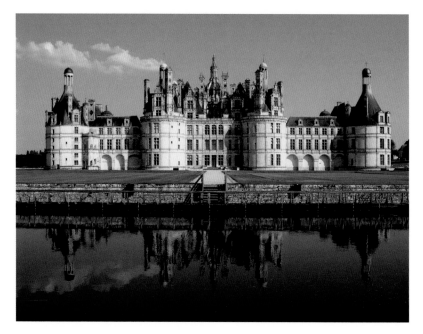

The Château de Chambord, begun in 1519 by King François I

them. But against all odds, he succeeded in crossing from the Aosta Valley into the rolling lowlands of the Rhône.

At that time, the French kings did not reside in Paris, but at various châteaus sprawling along the Loire Valley. The most sumptuous of these was the Château d'Amboise, built on a spur above the Loire, which had served as the official royal residence since the mid-15th century. It was here, in 1498, that King Charles VIII hit his head against a door lintel, incurring such a massive hemorrhage that he died shortly thereafter. François had also begun a comprehensive renovation of the Château de Blois, a vast complex that had originally been built in the 13th century. There, Joan of Arc was blessed by the archbishop of Reims before she launched the attack that drove the English forces out of Orléans. In addition, King François had commissioned the design of an

View of the old medieval center of Amboise

entirely new palace, the Château de Chambord, which eventually became the most magnificent of all his architectural conceits.

The purpose of these and other renovations was to bring France's royal palaces, mostly built in the Gothic style, up to date in the vernacular of Italianate Renaissance architecture. The Loire Valley was therefore a hub of frenzied building that drew hundreds of Italian masons, sculptors, artists, glaziers, and weavers. Seen in this context, the invitation for Leonardo to come to Amboise was therefore less surprising than is sometimes thought. He was simply one in a stream of Italian artists and artisans who were flocking to France, the new hotbed of European patronage. It has even been suggested by hopeful French art historians that Leonardo may have been consulted on the design of Chambord, though there is no documentation to support this thesis. In fact,

the "Italian" features of this castle are mostly limited to the artic-
ulation of the façade with classicizing details. In form and intent,
the castle remains faithful to the paradigm of French medieval
palaces, including mansard roofs with their garrets and dormers,
and a profusion of towers and chimneys. One would be hard-
pressed to see Leonardo's hand in any of this.

A Leonardo drawing in the Windsor Castle collection is
commonly believed to be the sketch from around 1518 for a
royal palace to be built in Romorantin, close to Blois, for the
queen mother. This suggests that Leonardo was indeed consulted
on matters of architecture by his new royal patron, who had a
great zest for new palaces.[3] But this drawing reveals a design that
hews very closely to Italian precedent: flat roofs and symmetrical
facades, articulated as uniform bays.

The Manor of Cloux

The travel party that arrived in Amboise in the late summer of
1516 was significantly smaller than the one that Leonardo had
led from Milan to Rome. This time, only his pupils and close
companions Francesco Melzi and Salaì, as well as a Milanese ser-
vant, Battista de Vilanis, accompanied him. It is likely that Salaì
returned to Milan in late 1517, for in 1518 he was busy with the
upkeep of a small vineyard that had been granted to Leonardo by
Ludovico Sforza, the Duke of Milan, many years before.

King François was extremely generous. He installed Leonardo
and his party in the charming Manoir de Cloux, known today
as Clos Lucé, which was just a ten-minute walk from François's
own residence at the Château d'Amboise. Previously, this manor
house had served as a pleasure pavilion of sorts for the French
court. Its lush gardens had even been used as lists for summer
tournaments. An underground passageway connected the manor

to the royal residence; either François or Leonardo could use it in inclement weather—not an unusual occurrence in northern France. "Here you will be free to dream, to think, and to work," François said as he took Leonardo around his new dwelling. To further assure the comfort of his aging guest, the king endowed Leonardo with an annual pension of 1,000 *écus au soleil*.[4]

It is difficult to relate this sum to an equivalent in a modern currency, given the very different rates for food and upkeep in the 16th century. Still, it is probably fair to say that this pension would be worth between $75,000 and $125,000 today—certainly a princely amount for someone who had yet to produce anything of significance for his young royal patron. But perhaps it was sufficient that Leonardo's fame lent the court of François the type of Italian allure that he so eagerly sought. Indeed, Leonardo was now formally addressed with the title of *peintre du Roy*, "the King's painter." Title aside, everyone must have realized that the old master was no longer able to undertake any new commissions, other than to draw, or to dab on the panels he had brought with him. Leonardo's actual work was limited to the aforementioned sketch for a palace at Romorantin, as well as designs for masques, and perhaps a system of canals for the Loire.

That obviously did not apply to Melzi and Salaì. Some historians suggest they may have used this pleasant respite in France to work on copies of the paintings that Leonardo brought with him, including the *Saint Anne* and the *Mona Lisa*. And there may have been a good reason for this. In return for the king's generous pension, it is likely that Leonardo agreed to bequeath to François, upon his death, the three works he had brought to Amboise. In that case, Melzi and Salaì would be able to return to Italy with copies of these works, to serve as models for other copies in the future.

And so Leonardo spent the last three years of his life in the

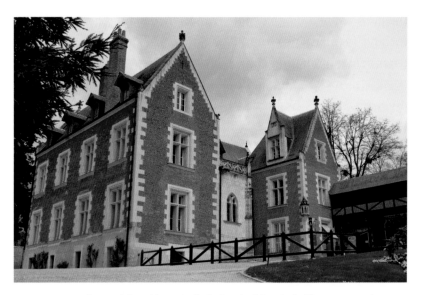

Leonardo's residence in Amboise, the Manoir de Cloux,
known today as Clos Lucé

quiet of his comfortable home, assisted by his loyal pupil and
secretary Melzi, and attended by his servant Battista de Vilanis.
Did he receive many visitors? We don't know. We do know of
one very important visit that took place in 1517, with major
consequences for our understanding of Leonardo's later work.

The visitor in question was an august Italian prelate, Luigi,
Cardinal of Aragon, accompanied by his secretary, Antonio de
Beatis. Why did the cardinal visit Leonardo in a place so far away
from the papal court? The answer is that the prelate had decided
to undertake a grand tour of Europe, of the type that became
popular with the English aristocracy in the 18th century, before
taking up his see at Alessano, in Apulia. It is possible that such a
visit had already been discussed in 1516, when the cardinal left his
mistress, a young woman named Giulia Campana, to accompany

the pope to the Bologna summit. If François did use this occasion to offer Leonardo a retirement in Amboise, it is possible he also extended an invitation to the cardinal.

What makes this visit so important is that the cardinal's diligent secretary has left us a detailed report. "In one of the suburbs [of Amboise], His Eminence and we others went to visit M. Lunardo [*sic*] Vinci," de Beatis writes, "[a] Florentine, over LXX years old, of the most excellent painters of our times."[5]

The secretary adds that Leonardo is not just a painter, because "he has also written on the nature of water, on diverse machines and other subjects, according to what he says, an infinite number of volumes, all in vernacular, which if they are to be published, will be beneficial and very delightful." Here is a powerful and possibly the last attestation of Leonardo's notebooks. These notebooks soon passed into the diligent hands of Francesco Melzi and thus—though only in part—into posterity.

The most important passage in the diary, however, is still to follow. "It is true that we can no longer expect anything further from him," de Beatis continues, "because he has been struck by a paralysis on his right side." This would seem to suggest that Leonardo had suffered a stroke. "M. Lunardo can no longer work with colors as he was accustomed," the secretary writes, referring to Leonardo's apparent inability to paint in oils, but "he continues to do drawings and to teach others." In fact, the cardinal's secretary adds, "He has trained a Milanese disciple who does quite good work"—no doubt referring to Melzi, which would suggest that by this date, Salaì had already returned to Milan.

The greatest praise, however, is reserved for the three paintings that Leonardo had installed in his home:

One of these was of a certain Florentine lady, done naturally
at the request of the late Magnificent Giuliano Medici.
The other of Saint John the Baptist, young, and one of the
Madonna with the child, seated on the lap of Saint Anne, all
absolutely perfect.[6]

In sum, the secretary is referring to *The Virgin and Child
with Saint Anne, John the Baptist*, and the *Mona Lisa*, which are
all currently in the collection of the Louvre. Why did Leonardo
insist on bringing these three paintings to his retirement home in
France? What significance did these paintings have for him?

The answer may be quite simple. For Leonardo, these works
constituted the true testament of his oeuvre. Indeed, these are
the only three surviving works from his mature period, possibly
completed in Rome after a long genesis, even though Leonardo
may have kept dabbing at them until the very end. Is there some-
thing that these three paintings have in common? The answer is
yes. They all share one unique Leonardesque feature, the delicate,
mysterious smile—what Louvre curator Vincent Delieuvin calls
an "expression of grace," a "touching, ambiguous and deeply
hypnotic feature."

But could there be another link between them? Is it possible
that all three conform to some iconographic or allegorical prob-
lem that may have been obvious to the 16th-century beholder, but
not to us in modern times? Is that the idea behind the enigmatic
smiles on the three main protagonists in these paintings?

For us, that idea is difficult to accept. While the *Saint Anne*
and the *John the Baptist* are sacred works, the portrait of the
Mona Lisa is obviously a secular painting. We are creatures of
the 21st century, in which the secular and the religious realms
are rigidly separated; we expect the people of the Renaissance

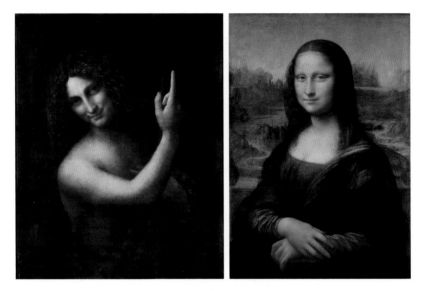

Leonardo da Vinci, *John the Baptist*, ca. 1513–1516; and the *Mona Lisa*
(Louvre version), ca. 1507–1515

to have thought the same. But that is a common failing, and we cannot judge Leonardo by the standards of our own modern era. We must try to understand the workings of his mind in the context of his own age, the Renaissance, which in many ways still carried the theological imprint of the Middle Ages. For medieval men and women, religious and secular concerns were interwoven to a far greater degree—not only because of the greater influence of the Church, but also because daily life was governed by a myriad of religious customs, saint days, and celebrations. Christian thought and beliefs permeated the social fabric of Florentine society on all levels. In this context, the idea of an allegorical program governing Leonardo's three most cherished paintings—a meditation on the coming of Christ as mankind's most defining moment—is less eccentric than it may sound.

If there is one constant in Leonardo's career as a painter, it is the theme of the Madonna. Of the eighteen paintings generally believed to be Leonardo autographs, ten are depictions of the Virgin Mary. Nor are they mere imitations of the standard Madonna genre. From the very beginning, starting with *The Annunciation* of 1475, Leonardo's key focus was on developing a more human, a more *accessible* Mary, free from the stereotypical artistic conventions of the early Renaissance. The halo that still adorns the Mary in *The Annunciation*, so similar to the style of Leonardo's teacher Verrocchio, was abandoned in the *Madonna of the Carnation* painted three years later. From that point on, Leonardo steadily moved away from the stilted motifs of medieval times, which placed Mary with her child Jesus on a throne as Queen regnant. He chose instead to focus on the tender interplay between a young mother and her newborn child. In the *Benois Madonna*, Mary's stern expression relaxes and breaks into a smile as she plays with the child on her lap. By 1490, in the *Madonna Litta*, she lovingly holds the babe in her arms while nursing him at her breast. This growing intimacy between Mary and her son culminates in the *Saint Anne*, which is perhaps Leonardo's most ambitious examination of close maternal bonds, set against the looming future of Jesus's Passion.

So how does the *Mona Lisa* fit into this? Is the sitter of the Louvre *Mona Lisa* somehow a reflection of the Mary motif? In 2006, a group of researchers studied the garment the lady wears, using high-resolution imagery provided by the Louvre. They discovered evidence of a "fine, gauzy veil" that extended around the woman's neck and shoulders, which had been all but obliterated by successive layers of varnish and dirt. In the Prado copy of the *Mona Lisa*, possibly painted by Salaì, this fabric is more clearly visible, the white gauze clearly standing out against the red sleeve

of her left arm. Such a transparent veil, called a *guarnello*, was made of white silk or linen, and worn by Italian women to signal that they were expecting. It was then used to protect a woman's modesty when she found herself compelled to nurse her baby in the company of others. Thus, the *guarnello* also became the attribute of the Virgin Mary, particularly in Madonna portraits that depict her as a young mother with her newborn.

The idea of the Virgin Mary as not only the mother of Christ, but also the eternal mother of humankind, is perhaps best expressed in Leonardo's *Virgin of the Rocks*, painted in Milan in 1483. Some authors have speculated that the grotto behind her is a symbol of the maternal womb, which through the narrow passage offers eternal life in a heavenly sphere.

The *Mona Lisa* may reflect a similar idea: that of the ideal mother, the quintessence of motherhood, informed by the iconographical model of the Virgin Mary. If that is true, then this interpretation would also, at long last, explain the mystery of the smile. Simply put, the lady is smiling for the same reason that Saint Anne and John the Baptist are smiling. Each has been given the secret of the coming Redentore, the Redeemer, which they cherish in their heart.

The idea that Leonardo, the consummate scientist, would want to seal his career with three devotional paintings on the subject of Christian salvation may strike some of us as far-fetched. No artist so embodies the Renaissance ideal of human discovery and observation, unfettered by Church dogma, as Leonardo da Vinci. Though he certainly confessed his belief that nature has a source in the divine, Leonardo never cared much for theological questions or the practices of the Catholic faith. In the first edition to his book, Vasari wrote that Leonardo "could not be content with any kind of religion at all, considering himself in all things

much more a philosopher than a Christian." Though this passage was omitted in the second edition of *Lives of the Artists* in 1568, Vasari was probably referring to the Leonardo of Florence and Milan.

Leonardo's feelings may have changed after 1507, when the opportunity to conduct dissections, using female cadavers, gave him a privileged glimpse of the wonders of life and birth. As his notebooks attest, Leonardo was astonished at the perfection of creation and the marvels of the female body. Inevitably, his interest in spiritual matters deepened as he approached old age. While in Rome, suffering from some unspecified illness, Leonardo chose to register with the Confraternity of St. John of the Florentines. Working on behalf of confraternities was the type of "good works" that Catholics believed would earn them a place in heaven. Leonardo may have joined this group for any number of reasons—a desire to reach out to his fellow Florentines during his exile at the Vatican, or a concern for proper burial rites should he die unmourned in his papal apartments—but a yearning for the comfort of spiritual engagement may have played a part as well.

As the shadows deepened in his manor in Cloux, Leonardo experienced an even deeper desire to be reconciled with the Church. He drafted a detailed will, commending "his soul to our Lord, Almighty God, and to the glorious Virgin Mary," as well as other saints. He also provided detailed specifications for the funeral ceremony and the order of the procession that was to carry his body for burial at the church of St. Florentin in Amboise. In addition, Leonardo requested "three grand masses" to be celebrated by the "deacon and sub-deacon," while no less than "thirty low masses" were to be performed in the church of St. Gregoire and the church of St. Denis. These services were to be illuminated by prodigious quantities of candles, including "sixty

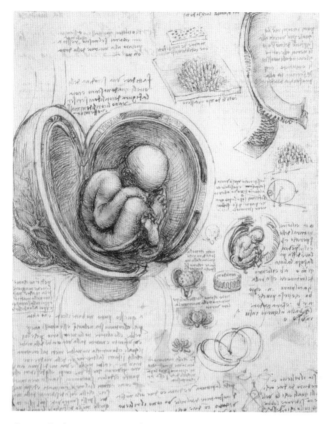

Leonardo da Vinci, *Views of a Foetus in the Womb*, ca. 1510–1513

tapers . . . carried by sixty poor men," with ten pounds of wax in thick tapers to be distributed to the churches involved.[7]

This doesn't sound like the Leonardo from Milan and Florence. These are the words of a man who, in the twilight of his days, is anxious to be reconciled with a faith that he has avoided for much of his life.

As Leonardo approached death, Vasari tells us, "he earnestly wished to learn the teaching of the Catholic faith, and of the good way and holy Christian religion; and then, with many moans, he confessed and was penitent . . . and [took] devoutly the most

holy Sacrament, out of his bed." This may be Vasari's attempt to exonerate Leonardo in case any statements in his notebooks would be considered heretical, as some have claimed. In light of the detailed proceedings he ordered for his funeral, it rings true. No man or woman can truly anticipate their emotions on the threshold of life and death. Here, too, Leonardo revealed himself as a man of his time, a Renaissance scholar who, on the verge of meeting his Maker, sought succor in the Church.

If it is true that the *Mona Lisa* was inspired by Leonardo's lifetime preoccupation with the mystery of the Madonna, then it is fitting that Leonardo kept these three paintings—the *John the Baptist*, the *Mona Lisa*, and the *Saint Anne*—with him through the last chapter of his life. All three are meditations on the mysterious ways in which the divine reveals itself. They are the expressions of a mind that, having studied the secrets of nature, must acknowledge that there are limits to what human reason can accomplish.

2.
THE LEGACY OF LEONARDO'S STUDIO

The Chateau du Clos Lucé, Leonardo's last home before his death, is located some 140 miles from Paris, in what is now the center of Amboise. It can be reached by car in three hours or less, depending on the condition of the local roadways and the much-feared Périphérique ring road around Paris. Many experienced visitors elect to take the train from Saint-Lazare train station, for a journey of just two hours. From the Amboise railway station, a fifteen-minute walk brings them to the grounds of the chateau, and into a different time and place. Painstakingly restored to a condition that resembles the period of Leonardo's stay, the chateau is a wonderful place to visit, even if much of its furniture and decoration is not original. Here, for example, is Leonardo's studio, with life-size reproductions of the *Saint Anne* and the *John the Baptist*, as well as a bronze copy of the huge horse he once modeled in clay for the Sforza equestrian monument. Here too is a kitchen, a lovely dining hall, and the large bedroom in which Leonardo conceivably breathed his last, even though the canopy bed itself dates from a later era.

But the most evocative aspect of the chateau is unquestionably its lavish outdoor gardens. Gently sloping down to the river below, bordered by a copse of trees, they have been lovingly maintained. The visitor cannot fail to imagine Leonardo walking along their many narrow paths, immersed in thought, his faithful assistant Francesco Melzi by his side.

What was going through Leonardo's mind as he strolled through these elegant grounds? Far removed from the heart of the Italian art scene, did he reflect on how his name might be remembered? Did he worry whether his reputation might endure, and whether the many revolutionary changes that he brought to Italian art would be passed on? And if so, would posterity give him credit for these breakthrough innovations? "The fame of the rich man dies," he once wrote, "but the fame of the treasure remains." Would that be true for the small group of paintings that he bequeathed to humankind? Leonardo was aware that during his lifetime, his reputation had been increasingly tainted by the verdict of *non finito*. This was the conviction of many, that the artist, brilliant as he was, in practice was unable to translate his ideas into a tangible collection of paintings and sculptures. That idea was inculcated in the 16th-century mind by Leonardo's first biographer, Giorgio Vasari, who wrote:

> In truth his mind, being so surpassingly great, was often
> brought to a stand because it was too adventuresome, and the
> cause of his leaving so many things imperfect was his search
> for excellence after excellence, and perfection after perfection.[8]

Another factor that threatened Leonardo's legacy was that by the time Leonardo had departed from Italy and settled in Amboise, both Milan and Florence were being eclipsed by the

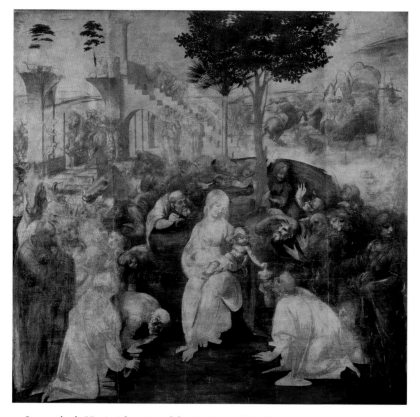

Leonardo da Vinci, *Adoration of the Magi*, ca. 1481. The work was left unfinished.

explosion of artistic activity in Rome. In other words, the two cities in which he had created his greatest triumphs were now considered passé. In contrast to the effervescent artistic scene surrounding Leo X, Florentine and Milanese artists were simply no longer believed to be up to date.

Some authors believe that this was part of the reason why Leonardo scrupulously documented his observations in his notebooks: so that future generations could learn from his knowledge, even if his art was no longer considered au courant. But it is more likely that Leonardo pinned his hopes on the many pupils and

apprentices he cultivated in his studios, each of them adopting his transformative approach to the depiction of three-dimensional reality in paint.

In fact, the scarcity of Leonardo's work, and his reputation as an elusive genius but also an uncompromising perfectionist, had always carried the whiff of a certain mystique. In theory, that mystique could serve as a powerful enabler for his followers to perpetuate his legacy.

The Renaissance Studio

That idea is not so far-fetched when we consider that the concept of a "studio," with assistants, pupils, and collaborators, was a unique product of the early 15th century. It was prompted by a sharp increase in the demand for bespoke paintings as a result of the vast wealth that was pouring into Tuscany in the wake of the Black Death of the 14th century. This plague had all but wiped out the fiercest competitors of the Florentine cloth trade, such as Pisa and Siena. When the markets recovered, the mercantile class of Florence gained a near monopoly in the international trade of dyed wool, and as a result enjoyed tremendous prosperity. As we know, sudden ostentatious wealth always seeks an outlet.

And so the traditional role of the medieval painter, as a producer of religious imagery for the Church, was transformed into that of an all-around impresario of objects for the residences of the well-to-do: devotional paintings, to be sure, but also secular portraits; painted furniture (such as marriage chests, known as "cassone"); coats of arms; tapestries; even staged entertainments. Leonardo's master Verrocchio was often called upon to build all sorts of intricate stage sets and machinery for Medici pageants or masques, as well as costumes, tapestries, and temporary structures such as Roman-style triumphal arches.

This varied output required a staff of skilled assistants, well beyond the normal requirements of a traditional medieval studio. To be accepted as a pupil in a Florentine studio, aspiring artists studied the full range of creative endeavor, including how to draw, to prep wet plaster or wooden panels, to stretch canvas, to sculpt, and to grind and mix pigments in order to create paint (since ready-made paint tubes of the type we use today did not appear until the late 19th century). As the apprentice advanced in skill and experience, he was allowed to transfer a preparatory drawing or cartoon to a plaster or wood surface, or to paint elements of lesser importance, such as details of the background. To acquire such assistants, artists usually accepted promising young pupils at an early age, and trained them through various stages of apprenticeship until they were thoroughly indoctrinated in the style and technique of the master.

This was certainly true of Leonardo, who had been apprenticed to the workshop of Andrea del Verrocchio in 1466, at the age of fourteen. It was a mark of Leonardo's exceptional talent that in 1472 Verrocchio allowed him to paint one of the two angels in Verrocchio's *Baptism of Christ*, commissioned by the monks of the San Salvi monastery. Vasari writes that when Verrocchio saw the angel and realized the superiority of this angel to the one painted by himself, "he never touched colors" again.

That's an interesting comment, because Verrocchio's rather formulaic style was grounded in the use of tempera, a fast-drying, water-based paint that must be applied quickly and allows relatively few subtle gradations. Leonardo, however, never thought in terms of lines (*disegno*), but in three-dimensional tones and shapes (*colore*)—forms that are suggested, rather than defined, through the use of delicate shading and hues. Tempera paint could never achieve such subtle effects. But Leonardo had

A modern reconstruction of Leonardo da Vinci's studio in the
Santa Maria Novella in Florence, ca. 1504

learned a new technique, that of oils, first developed in Northern
Europe. X-ray tests of the *Baptism of Christ* show that while
Verrocchio still painted his figures in contours of white lead,
Leonardo used thin, superimposed layers of colored oils to bring
his angel to life.[9]

It is extremely doubtful that Verrocchio "never touched
colors again," as Vasari writes. Verrocchio continued to accept
commissions for paintings, for the simple reason that it was a
major source of revenue for his bottega. Running a large studio
was a risky venture, even in the heady days of Lorenzo de'
Medici's Florence, and Verrocchio was not a man to take risks.
In 1457, he wrote on his tax statement that he was losing his
shirt trying to keep his shop operating—the Italian expression

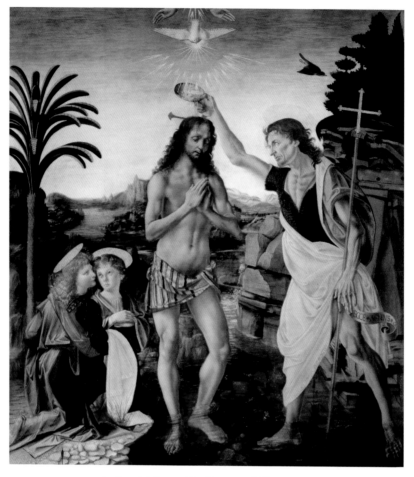

Andrea del Verrocchio, *Baptism of Christ*, 1472

is *non guadagniamo le⁀chalze*, "can't keep our hose on."[10] It is more likely that Verrocchio delegated much of his painting work to Leonardo, so that he could focus on his principal art form, sculpture.

Leonardo's First Milanese Studio

Leonardo was never able to establish a full-fledged studio of his own in Florence, but that changed after he decided to move to Milan in 1482. As he began to receive his first commissions beginning around 1486, Leonardo was finally in a position to assemble his own bottega, which eventually grew to at least six apprentices (or "dependents," as Leonardo described them). These included a painter named Tommaso Masini or Zoroastro; a German artist known simply as Giulio; and a clutch of other pupils, variously identified as Gianmaria, Galeazzo, Bartolomeo, Benedetto, and others.

This group was joined by a rather loutish ten-year-old boy named Giacomo Caprotti, later known as Salaì. Little Salaì became an artist of some talent, as well as Leonardo's close friend and "companion." That the young man was also a rascal and a thief is attested by Leonardo's famous note, in which he wrote:

> On September 7, he stole a silverpoint valued at 22 soldi,
> from Marco [d'Oggiono] who was living with me, and
> he took it from his studio, and when the said Marco
> had searched high and low for it, he found it hidden in
> Giacomo's box."[11]

But Leonardo's workshop did not consist only of young pupils and assistants. Remarkably, it also included Lombard painters who were already accomplished artists in their own right and, in some cases, had completed commissions for the Duke of Milan. This category included Giovanni Ambrogio de Predis, with whom Leonardo had worked on the *Virgin of the Rocks*; the Milanese artists Giovanni Antonio Boltraffio and Andrea Solario; the painter Marco d'Oggiono, who hailed from

the nearby town of Oggiono; and Bernardino de' Conti, who was born in Pavia. This group, particularly Boltraffio, Solario, and d'Oggiono, became the core of Leonardo's following—the Leonardeschi, as we call them—in the decades to come. Over the next few years, other assistants and collaborators moved in and out of the studio, including Bernardino Luini; Cesare da Sesto; an artist named Ferrando Spagnolo or Ferrando the Spaniard, commonly believed to be Fernando Yáñez de la Almedina; and a Spanish compatriot known as Fernando de los Llanos.

The essential difference between apprentices and collaborators was that Leonardo was paid for taking pupils under his wing, because he would also be responsible for their food and clothing, whereas fellow maestri would conceivably share in the proceeds of whatever work they sold together. In this, Leonardo showed his willingness to adopt the Milanese model, rather than the Florentine way of doing business. In Milan, the idea of several painters working together on a large painting or mural, without any single artist necessarily being recognized as the principal author, was accepted operating procedure. Throughout the quattrocento—the 15th century—and beyond, art circles in Milan adhered to that medieval model. In contrast, Florence fostered the idea of the artist as an individual virtuoso, to be known and credited by name. That, in essence, is how Leonardo won his first contract in Milan to begin with—by working collaboratively on a large panel of a Madonna, the *Virgin of the Rocks,* which had been commissioned from the de Predis brothers.

This first period in Milan, under the patronage of the Duke of Sforza, was the high point for Leonardo's studio, even if the artist's relationship with Ludovico Sforza was tempestuous, and the ducal patronage unpredictable. Most of the duke's art budget went to projects at three major religious institutions: the large

monastery of Certosa di Pavia, the Santa Maria delle Grazie, and the Milanese cathedral. Large funds were lavished on Lombard artists who were far less talented but certainly more reliable than Leonardo when it came to delivering on time and on budget. Nevertheless, these years represented what was perhaps the most stable period in Leonardo's career. With his associates and pupils he worked on his great cavallo in clay for the Sforza equestrian monument, wildly praised by his contemporaries; a portrait of Ludovico's official mistress, the fourteen-year-old Cecilia Gallerani, which became the revolutionary *Lady with an Ermine*; an equally astonishing portrait, now called *La Belle Ferronnière*, of another of the duke's paramours, Lucrezia Crivelli; and designs for what became the transformative work of his Milanese career, the fresco of the *Last Supper*.

As Leonardo's notebooks show, between 1490 and 1494 there were at least six assistants working with him, including maestri like d'Oggiono, Boltraffio, and de Predis. This naturally strained the studio's overhead. When the duke fell seriously in arrears with his payments, Leonardo drafted an indignant letter, complaining that "if your lordship thought I had money, your Lordship was deceived, because I had to feed six men for thirty-six months, and I have had only fifty ducats."[12]

The Primacy of Drawing

Like his teacher Verrocchio, Leonardo always emphasized the art of drawing as a principal teaching method in his workshop. A painting requires a long and laborious effort with an uneven outcome. A drawing could be sketched quickly, and then modified or improved upon with just a few strokes.

Virtually everything Leonardo did was informed by drawings: his observations of nature, his engineering designs, his

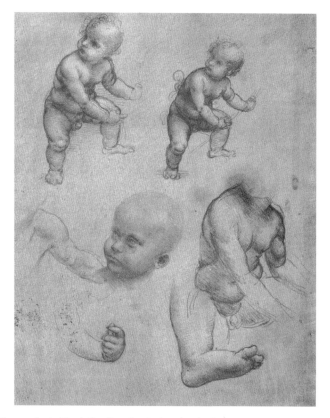

Leonardo da Vinci, *Studies of an Infant for the Saint Anne*, ca. 1503–1507

anatomical studies, his ideas about composition, and lastly, his preparatory studies for paintings, including cartoons for alfresco murals. In short, drawings were the principal medium by which Leonardo communicated his artistic ideas to his followers. As we will see, they made good use of them. According to biographer and Medici physician Paolo Giovio, Leonardo went so far as to forbid his pupils, until twenty years of age, to "use a paintbrush or paints." Instead, he made them "work with lead point to choose and reproduce diligently the excellent models of earlier works, to imitate with simple line drawings the force of nature,

and outlines of bodies that present themselves to our eyes with a great variety of movement." Thus, Giovio believed, Leonardo prevented his students from being "seduced by the brush and colors" before they learned to represent "the exact proportions of things."[13]

In his *Trattato della pittura* or *Treatise on Painting*, which no doubt reflected the lessons taught in his workshop, Leonardo explained why drawing was so important. "First," he instructs the reader, "copy the drawings of accomplished masters made directly from nature, and not practice drawings; follow this through with drawings of relief works alongside drawings taken from the same relief; then move on to drawing from life."[14]

It is not always easy to determine the educational purpose of some of the drawings that Leonardo executed in the years when he ran his first Milanese studio. In many, he appears to be preoccupied with themes that appealed to him personally, rather than those that could be used to teach drawing to a beginning artist. Nevertheless, it is possible to discern some ideas that interested him throughout his career.

One of these is his constant desire to inject life and spontaneity into the motif of the Madonna, which was highly popular in quattrocento Italy.

The clergy, led by the Dominican order, had begun to encourage families to create an area for private prayer in the home. Madonna portraits could serve as a natural focus of such devotional shrines. But the iconography of the Madonna had become rather stale and repetitive. It was dominated by the tradition of the Madonna Enthroned, which showed Mary as an austere heavenly figure, barely aware of the child Jesus on her lap.

From the very beginning of his career as an artist, starting in the workshop of Verrocchio, Leonardo looked for ways in which

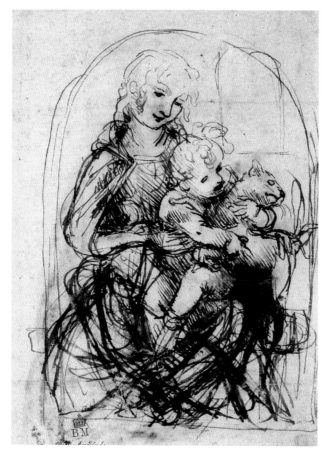

Leonardo da Vinci, *Virgin and Child with a Cat*, ca.1478

Mary and her child could be depicted in a more natural, more affecting way, eliciting empathy and love in the beholder. Starting around 1478, he produced a series of drawings portraying the theme of the infant Jesus and a cat. Having the child play with a cat, for example, could introduce the sense of playfulness and spontaneity that Leonardo was looking for. This, we should remember, was entirely without precedent. Neither in the New Testament nor in the rich literature of Christian Apocrypha—which carried

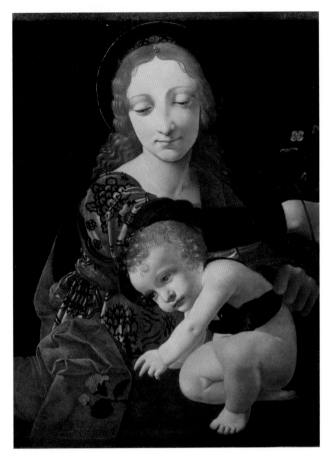

Giovanni Antonio Boltraffio, *Madonna of the Rose*, ca. 1510

the same authority in the Middle Ages as the canonical Gospels—
do we hear of any interaction between Jesus and a cat.

The drawings, including the *Virgin and Child with a Cat*
from 1480, were then avidly studied and copied by Leonardo's
pupils and collaborators. We know this, because Leonardo's
studies later provided inspiration for a number of Madonna
portraits by his former associates, including the *Madonna of the
Violets*, executed between 1498 and 1500, and now attributed

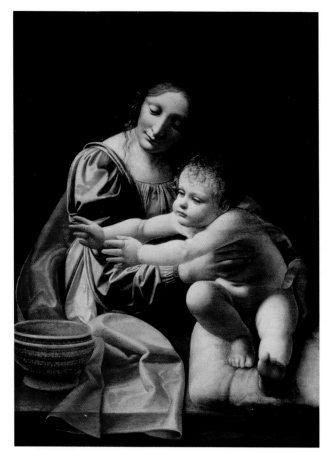

Giovanni Antonio Boltraffio, *Virgin and Child*, 1497

to Marco d'Oggiono. This work was much praised in the late 19th century, and confidently attributed to Leonardo himself, particularly because of its close resemblance to Mary in *Virgin of the Rocks*. That identification is no longer supported, but as late as 1949, David Alan Brown suggested that "the soft shadow and utmost refinement in the modeling of the Virgin's head indicate Leonardo's participation in this exquisite work."

Another example of the pervasive influence of Leonardo's

approach is Boltraffio's *Virgin and Child*, also known as *The Madonna of the Rose*. Painted almost simultaneously with d'Oggiono's work, it depicts Jesus reaching for a rose, symbol of his future Passion, while his mother tries to restrain him. The treatment of Mary appears to be indebted to the *Lady with an Ermine*, while the texture of her finely detailed red hair injects a distinct Northern look.

That d'Oggiono and Boltraffio were at this point the leading lights of Leonardo's Milanese followers is also shown by several other paintings from this period. Each reveals the individual talents of the artists while also emphasizing their indebtedness to Leonardo. Key examples are the *Young Christ*, arguably painted by d'Oggiono around 1490, and Boltraffio's *Virgin and Child*, completed in 1497 and now in Budapest.

Particularly in the latter, Boltraffio appears to have made a leap in compositional technique, compared to *The Madonna of the Rose* five years earlier. While the painting is animated by the same idea—mother and child moving in opposite directions, in order to imbue the scene with a lifelike, dynamic energy—the execution is far more confident and persuasive. In fact, the child now appears to be reaching for something or someone outside of our scope of view, adding a sense of mystery to the painting. The light is more controlled. The delicate, porcelain-like sfumato, or shading, is noticeably softer, made more dramatic by the dark background.

Another example of Leonardo's influence is Marco d'Oggiono's *Girl with Cherries* of 1494, now in the Metropolitan Museum in New York. The painting reflects Leonardo's fondness for depicting androgynous youth, while the cool patina of the skin resembles Leonardo's *Lady with an Ermine*.

What this suggests is that Leonardo's most prominent

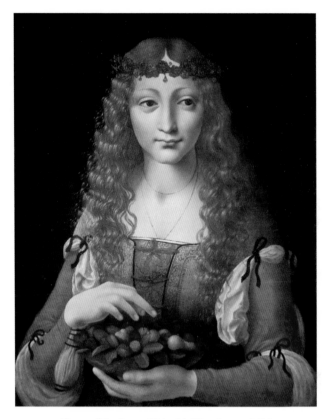

Marco d'Oggiono, *Girl with Cherries*, ca. 1494

Leonardeschi at this stage, de Predis, d'Oggiono, and Boltraffio, increasingly relied on Leonardo's drawings and paintings in the execution of their panels, even though they were now recognized as masters in their own right.

The Interlude of 1499–1506

In 1499, when the pigments of the *Last Supper* were not yet dry, Leonardo's tenure at the ducal court in Milan came to an end. The year before, the French king Louis XII had suddenly turned on Ludovico Sforza, his erstwhile ally, and marched south to

enforce his own claim on the Duchy of Milan. Ludovico had no choice but to flee.

The collapse of the Sforza regime prompted the inevitable breakup of Leonardo's studio and the dispersal of his followers. Leonardo himself fled to Venice, before returning to Florence. Marco d'Oggiono left for his native town of Lecco, and later for Savona. Boltraffio found refuge in Bologna, where he absorbed the art styles of the Emilia region. Only a few of Leonardo's assistants, including Fernando Yáñez de la Almedina and Hernando de los Llanos, joined him in Florence to work on his 1504 fresco of the *Battle of Anghiari* (abandoned in 1506) in the Palazzo della Signoria.

While staying in Florence, bereft of the ducal retainer he had enjoyed in Milan, Leonardo found himself in considerable financial difficulty. In March of 1503, he was forced to withdraw fifty gold florins from his savings account at the Ospedale di Santa Maria Nuova—and continued to do so, every three months, until the summer.[15] So dire were his financial straits that he reluctantly accepted a commission to paint a portrait of a Florentine housewife, a woman named Lisa Gherardini, who was married to a silk merchant named Francesco del Giocondo. Just a few years earlier, he had refused to complete a portrait for a far more influential lady, Isabella d'Este, the Marchesa of Mantua.

Was it just the immediate need for cash that prompted Leonardo to paint the lovely Lisa? Leonardo may have had another inducement for painting the portrait, which became known as the *Mona Lisa*. In 1504, he signed a contract with the Signoria, the republican government of Florence, to paint the fresco of the *Battle of Anghiari* in the Palazzo della Signoria, the government building now known as the Palazzo Vecchio. That was quite astonishing. Everyone knew that the president of the Signoria,

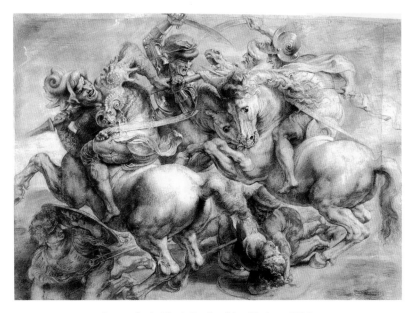

Leonardo da Vinci, *Battle of Anghiari*, ca. 1504.
Copy by Peter Paul Rubens, ca. 1603.

the gonfaloniere Piero Soderini, strongly favored Michelangelo for the project. Leonardo's agreement to paint a portrait of Lisa may have been a quid pro quo arrangement, for the Giocondo family was known to wield a lot of influence at various levels of the Florentine government.[16] Giocondo may have agreed to use his connections and secure the lucrative *Anghiari* commission for Leonardo—if the artist would agree to indulge him with a small portrait of his wife.

The *Anghiari* project could have been Leonardo's greatest triumph. Unfortunately, Leonardo couldn't help but indulge his fascination with experimental pigments. As in the case of the *Last Supper*, the quick-drying tempera technique didn't suit him; he wanted to move slowly, deliberately, applying layer upon delicate layer, so as to achieve the rich three-dimensional effects of his

oil-on-panel technique. To do so, he needed an undercoat that could absorb multiple layers of oil paints. According to the anonymous author known as Anonimo Gaddiano, Leonardo created a unique concoction based on Pliny the Elder's book *Natural History,* which recommended the use of Greek pitch to seal the plaster wall. But the experiment failed; the wall refused to absorb the pigments, causing the paint to drip and run. Paolo Giovio later wrote that the undercoat turned out to be "resistant to paints mixed with walnut oil." As with the *Last Supper*, the fresco began to deteriorate almost as soon as Leonardo's brush left it.[17]

What remained was still magnificent enough to attract a steady stream of artists and visitors for the next half century. As Paolo Giovio wrote, "our sorrow for the unforeseen damage seems only to have wondrously increased the fascination of the unfinished work." Several copies were made, including an oil painting known as the *Tavola Doria*, which reveal that the core of the painting, the battle for the standard, or banner of the Milanese army, was already far advanced, even though the standard itself is missing; only the pole is visible.[18]

Leonardo's Second Milanese Studio

Deeply disappointed by the result of his labors, Leonardo once again set his sights on Milan, the city of his erstwhile glory. A perfect pretext presented itself: he and his Milanese collaborator, Ambrogio de Predis, were still owed payments for their work on the second version of the *Virgin of the Rocks*, which de Predis had delivered to the Confraternity of the Immaculate Conception in 1502. Frustrated in his attempt to recover the final payment, de Predis had lodged a complaint with the new ruler of Milan—who, as it happened, was the king of France, Louis XII. Louis then ordered a judicial hearing, which surprisingly went

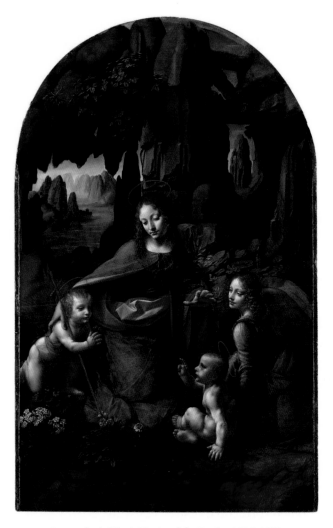

Leonardo da Vinci, *Virgin of the Rocks*, 1506–1508
(London version)

against the artists: the Confraternity claimed that the painting
was still "unfinished." Translated properly, this meant that the
Confraternity believed the painting was more Ambrogio than
Leonardo; the magic touch of the *real* master, they seemed to

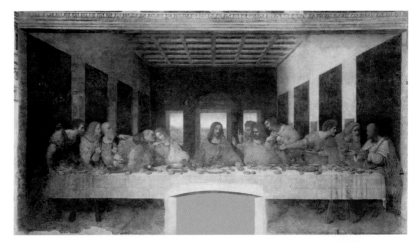

Leonardo da Vinci, *Last Supper*, 1494–1499

believe, was clearly missing. Perhaps the judgment was motivated by other factors. As it happened, Louis XII had become deeply fascinated by Leonardo. When he saw the fresco of the *Last Supper* in the Santa Maria delle Grazie, he ordered his engineers to "carry it into his kingdom . . . safely, and without any regards for expense," as Vasari reports.

When his engineers told him that it was impossible to transport a large wall across the Alps, the king opted for the next best thing: a full-size copy of the *Last Supper*, to be executed by Leonardo and his workshop.[19]

The upshot of these developments was that Leonardo was able to reconstitute his studio in Milan, this time under the generous patronage of a royal commission.[20] But by this time, the character of the studio had changed. During the six previous years, Leonardo's associates had been busy absorbing the influence of other painters—blending the Leonardesque with the most recent movements in Italian art. As a result, the reconstituted studio of 1506 brought together a far more

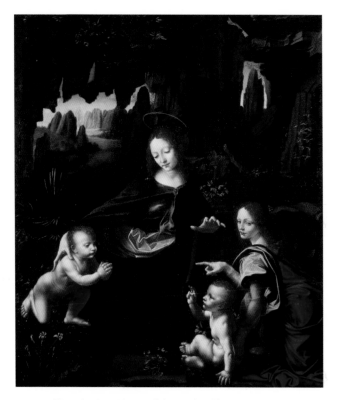

Giampietrino, *Virgin of the Rocks* (Cheramy version)
after Leonardo, ca. 1500–1505

experienced and diverse group of artists. In addition to the original core, the bottega was now joined by a Florentine artist named Giovanni Francesco Rustici, who like Leonardo had been trained in Verrocchio's workshop; a Sienese painter named Giovanni Antonio Bazzi, who also went by the less-than-flattering name of "Il Sodoma," and whose loose morals became the subject of withering critique in Vasari's *Lives of the Artists*; and an artist called Giovanni Pietro Rizzoli, commonly referred to as "Giampietrino" (a contraction of "Giovanni" and "Pietro"), pronounced "Giampèder" in the Lombard dialect.

In addition, the studio was joined by Francesco Melzi, an artist of not inconsiderable talent who eventually became Leonardo's loyal secretary and assistant until his death.

The most important work of this period was, of course, the life-size copy of the *Last Supper* on canvas. Given the speed with which this work was completed—it was delivered by Leonardo's pupil Andrea Solario to the Château de Gaillon in France in 1509—the painting must have been a collaborative effort that involved not only Solario but also Boltraffio and Giampietrino, for reasons that we will see shortly. Leonardo himself supervised the work and, we believe, personally executed the faces of Jesus and John. X-ray examinations of this canvas, which has been quietly on display in the Tongerlo Abbey in Belgium for the last 450 years, indicate that in contrast to all the other figures, there are no underdrawings under the features of these two figures. Leonardo must have painted them directly onto the canvas. Furthermore, the face of John bears a remarkable similarity to the model Leonardo used for his drawing of *Leda and the Swan*, a project that was also coming to fruition at this time.

Leda and the Swan

The crucial role of Leonardo's drawings in the continued development of his Leonardeschi, both during and after his lifetime, is vividly illustrated by a mysterious project from this period, known as *Leda and the Swan*. The original story is taken from Ovid's *Metamorphoses*. This Roman author tells us how the Greek god Zeus fell in love with the beautiful Leda, wife of King Tyndareus of Sparta. Zeus, in the guise of a swan, proceeded to seduce her. As a result of this encounter as well as marital congress with her spouse, Leda conceived and bore two sets of

twins, each delivered in an eggshell. Helen and Polydeuces were the children of Zeus, while Castor and Clytemnestra were the children of her husband Tyndareus.

It was obviously a risqué subject. It's therefore not surprising that during the quattrocento, several artists played with the theme, but hesitated to develop it into a full-blown painting. All such scruples disappeared in the 16th century. The story of Leda and the swan became a highly popular motif, possibly because it enabled artists such as Antonio Allegri da Correggio and Michelangelo to depict the passion of human intercourse, with the swan as a proxy.

Leonardo's first exploratory drawings for this theme date from around 1503 and 1504, during the contemplative hiatus in Florence. An early attempt, now in Windsor, is sketched on the same paper as a rearing horse that appears to be related to the composition of the *Battle of Anghiari*. Leda kneels in classic *contrapposto* position, her torso turned away from the infants crawling next to her.

This "kneeling Leda" concept was further developed in several drawings. One, now in the Devonshire Collection in Chatsworth House, includes Leda's suitor Zeus in his swan disguise. In this more articulated composition, the nude Leda kneels next to her newborn children on her right, while the swan kisses her tenderly on her neck at her left.

A later version, possibly executed in Milan and now in the Museum Boijmans van Beuningen in Rotterdam, shows a variation on this theme. Leda is still kneeling toward her children, but her head is now turned toward the swan while her left hand caresses its neck—thus restoring some of the charged passion of the story. This composition formed the basis for a painting by one of Leonardo's foremost Leonardeschi, Giampietrino. It

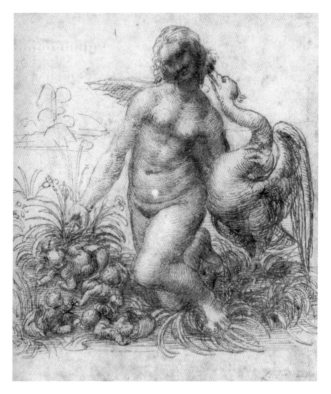

Leonardo da Vinci, *Study for Leda and the Swan*, ca. 1503–1504

was possibly begun around 1506 or 1507, and now is held in Kassel, Germany.

Of all of the Leonardeschi, Giampietrino's is perhaps the most consistent and recognizable style, deeply beholden to Leonardo, particularly in the execution of atmosphere and emotional expression. This is also true of his full-length painting of the *Nymph Egeria*, now in the Brivio-Sforza collection in Milan, which appears to portray the same model who sat for the Kassel *Leda and the Swan*. On this basis, some historians have argued that the Kassel painting should be dated around 1510.

In the meantime, however, Leonardo had developed a second

Giampietrino, *Leda and the Swan*, ca. 1506–1510

approach to the Leda motif. In this final and most satisfactory solution, Leda stands in a classic contrapposto pose. While her torso is turned toward the libidinous swan, her voluptuous thighs face the beholder, and her gaze is turned the other way, toward the four infants scrambling out of their broken eggshells. This "standing Leda" version probably dates from 1504, when Raphael briefly joined Leonardo's studio, for we have a drawing by the younger artist that closely follows this composition.

For many years now, scholars have energetically debated whether Leonardo actually executed a painting based on this composition, or whether it was left to his studio associates to

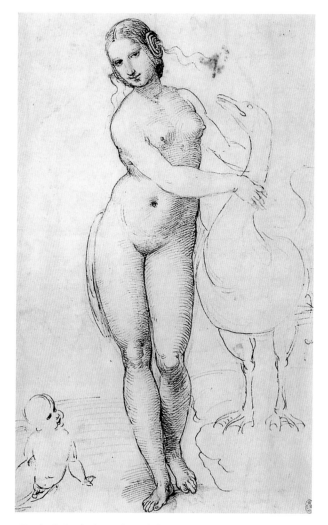

Raphael, *Study for Leda and the Swan after Leonardo*, ca. 1504

translate the drawing or perhaps a more finished cartoon into a panel. The consensus today appears to favor the idea that Leonardo did execute a finished painting—his only portrait of a full-length female nude. This is also suggested by the famous study of Leda's hair, dated around 1505 and 1506, which indicates that

Leonardo da Vinci, *Study for Leda and the Swan*, ca. 1505–1506

Leonardo's ideas for the painting were far advanced at that time. Additional evidence may be found in a 1590 report by the Italian artist and author Gian Paolo Lomazzo, who saw a *Leda and the Swan* in the royal collection at Fontainebleau. Another observer, the 17th-century scholar Cassiano dal Pozzo, saw this work some thirty years later, describing it as:

A standing figure of Leda almost entirely naked, with the swan at her and two eggs, from whose broken shells come forth four babies. This work, although somewhat dry in style,

is exquisitely finished, especially in the woman's breast; and for the rest of the landscape and the plant life are rendered with the greatest diligence. Unfortunately, the picture is in a bad state because it is done on three long panels which have split apart and broken off a certain amount of paint.[21]

This work then reappears in inventories of Fontainebleau, dated 1692 and 1694, only to vanish after that date. One theory suggests that it was burned on orders of the Marquise de Maintenon, the second wife of Louis XIV, a deeply pious

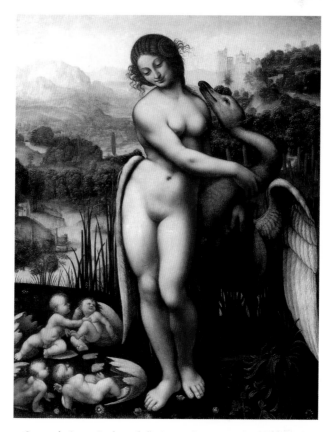

Cesare da Sesto, *Leda and the Swan* after Leonardo, 1508–1510

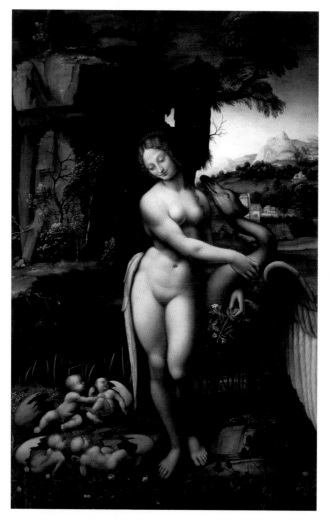

Francesco Melzi, *Leda and the Swan* after Leonardo
(the *Spiridon Leda*), ca. 1508–1515

woman who despised all forms of overt eroticism. The Venetian
playwright Carlo Goldoni, who visited Versailles in 1775, con-
firmed that the *Leda* was no longer on display, but also noted
that the work was not included on a list of paintings that the

Marquise had reportedly ordered destroyed.

That the painting was once highly popular is unquestionably true. At least five Leonardeschi painted copies of the *Leda*, all after 1510, which suggests that the original must have been completed at that time.

What is so remarkable about these copies is that none of the background vistas are alike. Leda is alternatively positioned in front of a rock-like formation near a lake, or against a Flemish panorama of deep, rolling fields, or framed by a landscape dotted with homes and castles perched on a hill. This would argue in favor of the idea that Leonardo never finished a painted version with a background in place—quite in contrast to the attention he lavished on the backgrounds of his paintings from around 1506 onward.

Of all these copies, the version by Melzi, the so-called *Spiridon Leda*, appears to be the most accomplished, and perhaps closest to Leonardo's original, if indeed there was one. For example, the treatment of Leda's hair closely resembles Leonardo's drawing in Windsor. The vegetation in the foreground is executed with meticulous precision, as is the sfumato texture of Leda's skin, in marked contrast to the copy by Cesare da Sesto, where the plants and trees are a mere afterthought, obviously depicted with little interest. In the copy painted by Il Sodoma, the variations from the original theme are even more striking. Instead of four infants in their eggshells, we now see two children of toddler age, with a village and several figures in the distance. Taken together, these versions display a remarkable homogeneity when it comes to the nude figure of Leda herself, while almost everything else appears to be subject to the invention of the artist.

The Trinity of Saint Anne

Notwithstanding the popularity of the *Leda* motif, the work that exerted the greatest influence on the associates of Leonardo's studio is *The Virgin and Child with Saint Anne*. In this painting, Leonardo's lifelong meditation on the mystery of motherhood and the theme of the Madonna finds its culmination. Though hardly known today, Saint Anne was a prominent figure in the Middle Ages. She does not appear in the canonical Gospels, but she is described in various apocryphal writings, beginning with the 2nd-century Protoevangelium of James, where she is introduced as the mother of Mary and grandmother of Jesus. During the Middle Ages, which made little or no distinction between canonical and noncanonical writings, she was as revered as a cardinal figure of the Holy Family.

This was particularly true in Florence, since it was on the feast day of St. Anne—July 26, 1343—that the city had risen in revolt against Gautier VI, Count of Brienne, restoring itself as a republic in the process. That moment in history gained further significance in 1494, when the city ousted another dynasty, that of the Medicis, and again returned to its republican roots. As Vincent Delieuvin has noted, the veneration of St. Anne then increased in the years that followed.[22]

The question that has bedeviled scholars is: why did Leonardo undertake such a monumental work, and for whom?[23] One theory holds that the *Saint Anne* began as a commission from Louis XII, who as we saw had married his predecessor's widow, Anne of Brittany, in order to retain France's claim on the duchy of Brittany. Naturally, St. Anne was the queen's patron saint. Given the close contacts between Leonardo and the French court at the time—Leonardo was working on a *Madonna of the Yarnwinder* for Florimon Robertet, one of the king's counselors—it seems

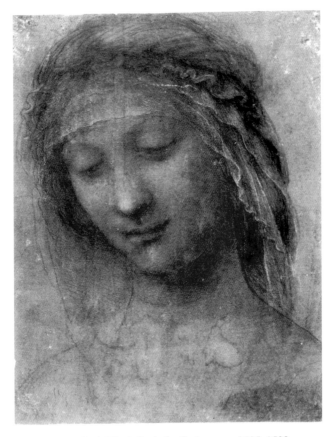

Leonardo da Vinci, *Study for St. Anne*, ca. 1505–1508

feasible that Louis would turn to the most famous artist in his orbit to commission a painting for his queen. Another theory suggests that the *Saint Anne* stemmed directly from Leonardo's 1501 stay at the Servite monastery in Florence where, as Vasari writes, "he made a cartoon showing a Madonna and a St. Anne, with a Christ."[24]

Whatever the case may be, the idea of a group portrait of Anne, her daughter Mary, and the infant Jesus would have appealed to Leonardo because of its psychological complexity. It overlays one

maternal bond over another, creating an unprecedented level of emotional depth, in both an aesthetic and a theological sense. Authors on Leonardo don't often refer to Leonardo's interest in theological concepts, since most are content to perpetuate the stereotype of the artist as a scientific maverick, a dyed-in-the-wool empirical secularist rejecting all Church dogma. That is, perhaps, an unconscious projection of our own ideas about the separation of church and state, and of faith and science. But that would be a mistake. While the Renaissance certainly empowered individuals to explore the world beyond the restrictions of Christian doctrine, that does not mean that they felt less attached to Christian ideas.

More important, an artist in the Renaissance was *expected* to be intimately familiar with the Catholic repertoire if he was to receive any commissions from either the Church or private patrons; both were likely to want sacred scenes. In 1492, just three years before Leonardo's Milan studio began gearing up for the *Last Supper* fresco, the Dominican friar Michele da Carcano summarized the essential purpose of sacred art, which artists were expected to serve, as follows:

> *First*, on account of the ignorance of simple people, so that those who are not able to read the scriptures can yet learn by seeing the sacraments of our salvation and faith in pictures

> *Second*, on account of our emotional complacency; so that men who are not aroused to devotion when they hear about this histories of the Saints may at least be moved when they see them, as if actually present, in pictures. For our feelings are aroused by things seen, more than by things heard.

Third, on account of our unreliable memories Many
people cannot remember in their memories what they hear,
but they do remember if they see images.[25]

In other words, a painter was expected to be fully informed
about the devotional quality of a given motif, as well as the
traditional iconography by which each of the figures was to be
depicted, so that the largely illiterate faithful could recognize the
character and understand the role he or she played in the story.
Thus, an artist such as Leonardo couldn't simply be guided by
his imagination—or *invention*, as the Renaissance called it—as a
modern artist would today. He needed to respect established con-
ventions about the way these sacred scenes were to be portrayed:
to both instruct the faithful and instill piety in the beholder.

For Leonardo, however, the theme of the St. Anne Trinity rep-
resented another, even greater challenge. Placing three figures in
a dynamic cycle of movement and emotion was always difficult,
as illustrated by the complexity of the *Virgin of the Rocks*. In
that case, Leonardo's solution was to place the figures in a loose,
pyramidal composition, in which gestures and poses inferred a
relationship among them. The problem was that this robbed the
figures of any close emotional attachment to one another.

The *Saint Anne* was perhaps an opportunity to rectify this.
Unlike the characters in the *Virgin of the Rocks*, here were three
figures who shared a unique and powerful connection—that of
mother and child, the strongest human bond imaginable, across
two generations. The challenge was how to exploit the intense
emotional power of this relationship. This is vividly illustrated
in a series of studies showing how Leonardo grappled with var-
ious solutions, placing his figures this way or that way, moving
ever closer to the optimal configuration.

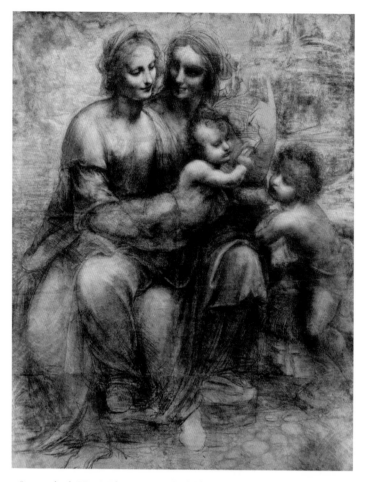

Leonardo da Vinci, *The Virgin and Child with Saint Anne and Saint John the Baptist* (the *Burlington House Cartoon*), ca. 1499–1500

Among these designs was a life-size cartoon that Leonardo executed for the Servite friars in Florence, lovingly drawn with wash and silverpoint to give the drawing a highly realistic finish. The monks were deeply taken with this work. They were so pleased that they organized a public exhibit of the finished

drawing, which had people lining up around the block—perhaps the first public exhibition of a work by Leonardo da Vinci:

> When it was finished, men and women, young and old, continued for two days to flock for a sight of it to the room where it was, as if to a solemn festival, in order to gaze at the marvels of Leonardo, which caused all those people to be amazed.[26]

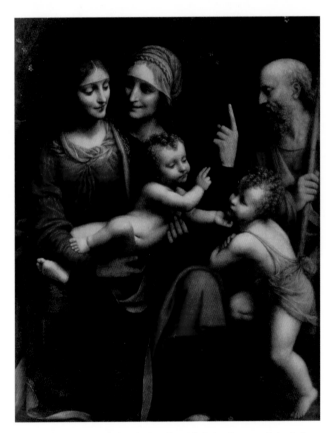

Bernardino Luini, *The Holy Family with Saint Anne and the Infant John the Baptist*, ca. 1509–1515

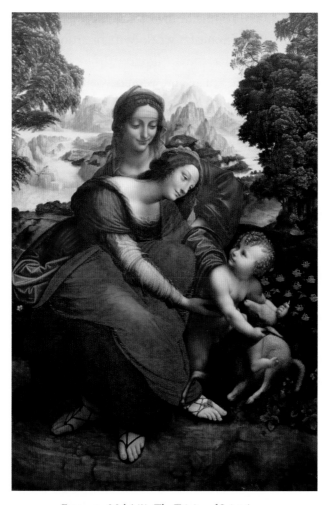

Francesco Melzi (?), *The Trinity of Saint Anne*
(the *Hammer Saint Anne*), ca. 1508–1513

It is hard to imagine such a public display if the Servite friars had not been happy with Leonardo's final design, or felt that the terms of their contract had not been met.

Unfortunately, this particular cartoon has not survived. What has survived is what most historians believe is an *earlier*

cartoon—the famous full-size drawing which today has pride of place at the National Gallery in London.

Known to scholars as the *Burlington House Cartoon*, it shows the three figures in a horizontal composition, with the addition of a fourth—John the Baptist as a young child. As part of this configuration, Mary is seated on St. Anne's right leg, while holding the child Jesus in her arms. Jesus bends forward to bless the young John the Baptist, who crouches next to St. Anne. This suggests a counterclockwise flow of allegorical narrative: Jesus identifies his cousin John as the one who will announce him as the Messiah. Mary's response is ambiguous; is she holding or restraining Jesus? Clearly, she wants to protect her young child from the Passion that John is destined to prophesy. Her mother Anne, however, turns to her and points to heaven, reminding her that this is God's will; though she too anticipates the terrible suffering that is to come, she urges her daughter to submit to God's plan.

The cartoon is a magnificent, highly finished work; a perfect painting in monochrome, executed in chalk and wash with highlights in white chalk. The face of Mary is as lovely as any of Leonardo's portraits of women. Its painterly quality must have appealed to Leonardo's pupils, for at least one of his followers, Bernardino Luini, then executed a painting based on the cartoon. Luini, one of Leonardo's most accomplished Leonardeschi, followed the principal composition closely, particularly in the fine rendering of Mary's head. But he also added the figure of Joseph, perhaps in an attempt to balance the composition with a figure on the right.

And yet, Leonardo himself was not satisfied with the solution. Soon he went back and revisited the idea from scratch, ultimately arriving at a very different and more vertical solution, as documented by Fra Pietro da Novellara, a prominent Carmelite cleric from Mantua who visited Leonardo's studio in Florence in 1501.

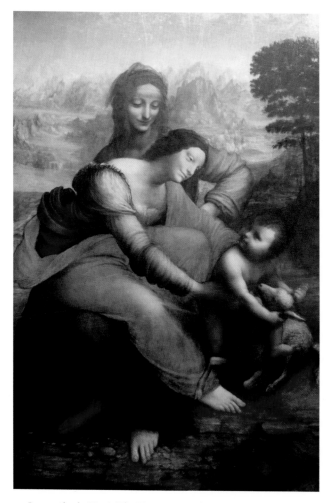

Leonardo da Vinci, *The The Virgin and Child with Saint Anne*
(Louvre version), ca. 1507–1515

In this new version, Mary is still seated on St. Anne's lap, but as studies from around 1506 indicate, Jesus has now slipped off *her* lap and is crouching next to Anne, holding a lamb. This forces Mary to bend forward, just as Jesus turns his head to meet her gaze. Mary appears to try to restrain her child from

embracing the lamb, since it is the symbol of the great sacrifice that awaits him. Anne, meanwhile, neither restrains nor corrects her daughter; she simply contemplates the scene, torn between her love for her daughter and her knowledge of God's plan. But her mysterious, *Mona Lisa*–like smile reveals her knowledge of the ultimate outcome: the salvation of humankind. The same bittersweet smile has begun to form on Mary's lips: she too knows that her son's sacrifice as the Paschal Lamb is necessary for humanity to be redeemed.

Where once the composition was static, the new arrangement is filled with a circular flow of movement, each gesture a response, a reaction to another. This dynamic was instantly grasped by our perceptive eyewitness, Fra Pietro, who wrote:

> It shows an infant Christ of about one-year old *almost escaping* from the arms of his mother. He has got hold of a lamb and *seems to be squeezing* it. The mother, *almost rising herself* from the lap of St. Anne, holds on to the child in order to *draw him away* from the lamb, which signifies the Passion. Saint Anne is *rising somewhat* from her seat; it seems she wants *to restrain her daughter* from trying to *separate the child* from the lamb, which perhaps symbolizes the Church's desire that the Passion should not be prevented from running its course.[27] (Italics ours.)

Since the first copy of this new composition dates from 1508, it is plausible to suggest that Leonardo did not make considerable progress on the *Saint Anne* until his second Milanese period. At least three copies by Leonardeschi were then made between 1508 and 1513 alone.

The first of the three, previously attributed to Salaì but

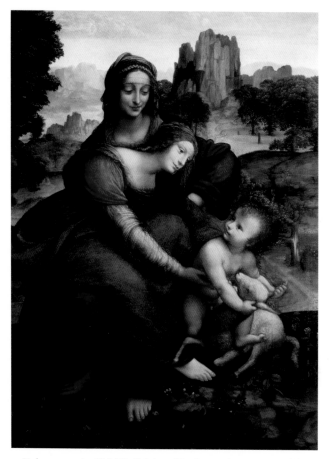

Unknown artist (Salaì?), *Trinity of St. Anne*, after an original by
Leonardo da Vinci (Uffizi version), 1520–1525

probably by Melzi, is now in the Hammer Museum at UCLA
in Los Angeles, though currently exhibited in the J. Paul Getty
Museum. Infrared reflectogram photography has revealed
numerous modifications, known as "pentimenti," which strongly
suggest that the copy was made under Leonardo's supervision.[28]
The second *Saint Anne* copy, by an unknown artist, is now in the
Prado Museum in Madrid, while the third is currently in a private

collection in Paris. A fourth copy, now in the Uffizi in Florence, was made during Leonardo's subsequent stay in Rome, arguably between 1514 and 1516.

Of these, the Hammer copy, which is in excellent condition, best captures the evolution of Leonardo's *Saint Anne* at that time. The painting abounds with the type of delicate detail that by now had become one of the hallmarks of Leonardo's style, including the lovely cluster of "columbines, anemones and wild strawberries" in the foreground.[29]

And yet, Leonardo was not yet finished with his own *Saint Anne*. He continued to work on it, first in Milan and subsequently in Rome, in search of the perfect solution.[30] That solution is what we see in the Louvre painting of the *Saint Anne* today. Whereas the Hammer copy was still framed by lush foliage and trees on either side, Leonardo's final version retains only one solitary tree at right, perhaps as an allegorical reference to the Tree of Jesse, which in the Gospels of Matthew and Luke connects Jesus to the House of King David. The anemones and wild strawberries are gone, as are the sandals on Mary's and Anne's feet; in the final composition, all are barefoot, perhaps to stress their saintly character.

These modifications liberate the scene from the fussy detail of its surroundings, and serve to enhance its monumental presence. It is as if these three figures are suspended on the boundary between earth and heaven—an idea reinforced by the contrast between the earth tones of the foreground, and the ephemeral, shimmering treatment of the background.

This did not prevent Leonardo's "intermediate" version, painted by Melzi, from spawning several other copies by Leonardeschi. One version, now in a private collection in Paris, hews very closely to the Hammer painting. Another copy is believed to have belonged to the Marquis Giovan Francesco Serra,

duke of Milan in the mid-17th century, before it was purchased by King Philip IV of Spain. Today, it forms part of the collection of the Prado in Madrid.

Indeed, the source for most copies of the *Saint Anne* that we have today is not Leonardo's Louvre original, but Melzi's Hammer copy! A 2012 exhibit at the Louvre identified no fewer than thirteen derivative versions of this painting.[31] One reason, perhaps, is that after Leonardo took the original *Saint Anne* with him to France, the Hammer copy was the closest thing to Leonardo's vision that Italy possessed. The work was exhibited in the Church of Santa Maria presso San Celso in Milan, and soon gained a reputation as an autograph work by the hand of Leonardo himself, rather than a copy. This explains why it served as the model for so many copies, painted by Leonardeschi as well as other artists throughout the 16th and 17th centuries.

One key example is the fine painting now in the Uffizi in Florence, dated around 1510–1525, and most often attributed to Salaì. Though largely faithful to the Hammer copy, it shows Mary and Anne barefoot, as in the Louvre version, which may suggest that Salaì updated the motif after Leonardo finished his final version.

The *Saint Anne* was perhaps the last major work that Leonardo developed while he was still operating a flourishing studio. After his departure to Rome in 1513, and subsequently to France in 1516, his followers went their separate ways, many settling in towns throughout Lombardy. In doing so, would they remain faithful to Leonardo's style? Would they continue to be Leonardeschi?

3.
THE LEONARDESCHI AFTER LEONARDO

What happened after the dispersal of Leonardo's last studio in Milan? Were his pupils and associates able to perpetuate his unique style, and thus his reputation as a leading artist of the Italian Renaissance? In other words, did Leonardo's followers actively sustain the mystique of Leonardo da Vinci?

It may be surprising to know that this question has seldom been addressed with any depth. So in this chapter we will try to retrace the steps of these painters, and see to what extent they remained beholden to the Leonardesque, the signature style of Leonardo da Vinci.

But what does this mean, the "Leonardesque?" What made Leonardo's art so unique? Scholars generally identify five principal features that were the direct result of Leonardo's ability to observe nature as both a scientist and an artist. They are:

1. The use of the pyramid as the principal geometric basis of a composition, as in *The Virgin of the Rocks*;

2. The importance of expressing a shared emotional intensity between painted figures, as in the *Saint Anne*;

3. The idea of modeling a human face with subtle shading, known as Leonardo's sfumato (literally "smoky") technique, as in the *John the Baptist*;

4. The dramatic use of chiaroscuro, the contrast of light and dark passages, as in the *Lady with an Ermine*; and

5. The use of so-called "optical perspective," atmospheric effects to suggest depth, rather than linear perspective, as in the background of the *Mona Lisa*.

Let's now turn to seven of Leonardo's most important followers, to see how they applied these Leonardo inventions to the development of their own art.

Giampietrino

The first of these is Leonardo's loyal follower known as Giampietrino. Research by Pietro Marani and others has found that Giampietrino was probably born in Ospedaletto Lodigiano, a town some 32 miles southeast of Milan, and that he probably attained full status as a master in 1509. In that year, he purchased a comfortable house in the parish of San Pietro in Gessate in Milan, which suggests that he was doing rather well at the time. Several years later, he was enrolled as a member of the painter's guild of the Scuola di San Luca.

Of all the Leonardeschi, Giampietrino remained one of the most faithful imitators of Leonardo's style, as evidenced by the deep chiaroscuro of his portraits and the soft sfumato of the

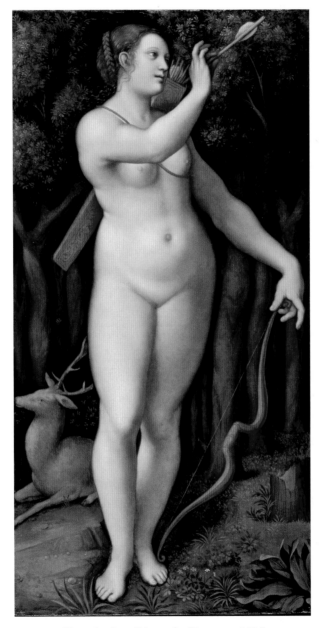

Giampietrino, *Diana the Huntress*, 1526

sitter's skin. Giampietrino (or one of his patrons) was especially attracted to nude female heroines from Greco-Roman mythology and history, such as Dido, Cleopatra, Venus, and Diana. In addition, he painted several female figures from the New Testament, including Salome (invariably shown with the head of John the Baptist), Mary Magdalen, and the Virgin Mary. A key example is the *Diana the Huntress*, dated 1526 and now in the Metropolitan Museum of Art, which may once have formed one part of four panels, each of identical size, depicting famous female deities in mythology.

The painting shows Diana drawing an arrow from the quiver on her back. The treatment is Leonardesque and the pose of the goddess betrays the influence of *Leda and the Swan*, of which Giampietrino made a copy. However, the composition is also indebted to engravings by the Florentine artist Rosso Fiorentino.

As we saw, Giampietrino was one of the lead artists who worked on a life-size canvas copy of Leonardo's *Last Supper* for King Louis XII between 1507 and 1509. The fame of this copy then ensured that he was commissioned to paint a second, near-life-size copy of the *Last Supper* around 1520. Who ordered this painting is not clear, though it eventually became known as the Certosa di Pavia copy.[32]

In 1784, when Lombardy was ruled by the Hapsburg dynasty in Vienna, Emperor Joseph II took the unprecedented step of ordering scores of religious houses throughout his domain suppressed, since in his opinion they were "unproductive." Some seven hundred monasteries were closed, their wealth and property were forfeited, and the population of monks and nuns was reduced from around sixty-five thousand to less than twenty-seven thousand. Most of their ancient treasures were auctioned off. Thus, Giampietrino's large canvas came under the hammer.

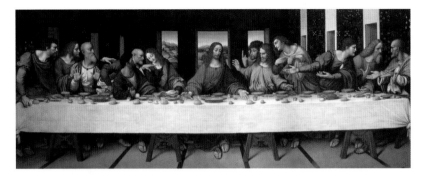

Giampietrino, *Last Supper* (after Leonardo), known as the
Certosa di Pavia copy, ca. 1520

Fortunately, it was purchased by a wealthy Milanese art patron who recognized its value, and decided to donate it to the newly formed Pinacoteca di Brera gallery on permanent loan. In 1818, the painting was shipped to England, where it was put on sale once more. In 1821, it was purchased by the Royal Academy of Arts, now at Burlington House in London. Following the current restoration of the building, this wonderful copy is now on display once more.[33]

Close inspection shows that the Certosa di Pavia *Last Supper* is indeed a faithful copy, and particularly of interest for the detail it shows us of the pavement and the tapestry, neither of which are still visible in the original fresco in Milan. Unfortunately, the top third of this canvas was cut off.

In the 1520s, however, things were changing in Lombardy. After 1523, in the wake of a major outbreak of the plague in Milan, it appears that a certain reaction set in against the novelties of the Leonardesque style. Several Lombard artists, including Giampietrino, decided to return to the expressive sentimentalism of the Late Gothic style in Lombardy. One favorite theme of this Gothic tradition was the suffering Christ.

Giampietrino, *Christ on the Road to Calvary*, ca. 1530

Nevertheless, Giampietrino remained true to Leonardo's penchant for monumental treatment. Instead of showing Christ as a full-length figure, as Gothic artists had done, Giampietrino shows Jesus in close-up, as it were, while his naked skin is treated with a delicate sfumato, in sharp contrast to the brutish face of the soldier behind him. One of Giampietrino's last works was the *Nativity and Annunciation* in the predella of the altarpiece in Besnate, dated to the early 1550s, before the artist died in 1553. The monochrome treatment of the figures, with its sharp contrast of light and dark, creates an almost sculptural look that harks back to the reliefs of the early quattrocento.

In sum, Giampietrino remained faithful to Leonardo's legacy in the decade after the closure of the Milan studio. But his fame as an artist was largely limited to the duchy of Milan, and faded soon after his death. It is only in recent decades that art historians have come to appreciate his work, both as a Leonardesco and a Lombard artist in his own right.

Giovanni Antonio Boltraffio

Some historians have claimed that Boltraffio and Bernardino Luini were Leonardo's most talented artists, and we are inclined to agree. Whereas Luini's work excels in its sensitive emulation of Leonardo's late style, Boltraffio's art is remarkable for its originality and superb technique.

In addition, there was a personal reason why Leonardo may have felt close to Boltraffio: like him, Boltraffio was born out of wedlock, with a father who hailed from a prominent family. Though the status of a bastard did not carry a strong social stigma in the latter part of the 15th century, it did mean that Boltraffio could not enjoy the same educational and financial opportunities that a legitimate son would have. This must have struck a chord with Leonardo, who was the illegitimate son of Ser Piero, a young notary who became one of the leading attorneys of quattrocento Florence. And although Ser Piero took pains to enroll young Leonardo in the workshop of Verrocchio—which, as we saw, required Ser Piero to pay a stipend—Leonardo was forever aware of his lower social status in the highly educated artistic circles of Florence. Rubbing shoulders with the likes of Lorenzo Ghiberti, Domenico Ghirlandaio, and young Michelangelo—who knew Latin and could hold their own in sophisticated company—wasn't always easy.[34] Maria Teresa Fiorio has suggested that Boltraffio's status as a "natural son"

Boltraffio, *Portrait of a Lady with a Cup*, ca. 1495–1505

may even explain why he chose a trade as a painter, a career
that under normal circumstances would have been eschewed by
members of the nobility.[35]

Boltraffio's talent is already on full display in a breathtak-
ingly beautiful painting, entitled *Portrait of a Lady with a Cup*,
also known as *Portrait of a Young Woman as Artemisia*, now in
the Mattioli Collection in Milan. The expressive depth of this
portrait, so full of conflicting emotions, is perhaps the closest
that any of Leonardo's followers came to emulating the master's

Boltraffio, *Portrait of a Youth*, 1495–1498

ability to capture the "motions of the mind" (*moti dell'animo*).[36] The mysterious air of this portrait is further enhanced by the fact that we have no idea who the sitter is.

Some have argued that the work must be a portrait of Costanza d'Avalos, Duchess of Francavilla. A poem by the 16th-century Italian poet Enea Hirpino refers to a portrait of the lady *sotto il bel negro velo* ("under a beautiful black veil"). In 1968, the Museo Poldi Pezzoli declared it was "a portrait of Mary Magdalene." More recently, however, the Italian art historian

Andrea de Marchi has suggested that the lady may be the mythic figure Artemisia.

In a collection known as the *Noctes Atticae* ("Attic Nights"), the 2nd-century Roman author Aulus Gellius tells the story of a woman named Artemisia, who was deeply in love with her husband Mausolus, the king of Caria. When the king died and was cremated in a magnificent funeral pyre, Gellius writes, "Artemisia, inflamed with grief and with longing for her spouse, mingled his bones and ashes with spices, ground them into the form of a powder, put them in water, and drank them."[37] This may explain the presence of the cup, which is the only significant attribute in the painting other than the black mourning veil.

As the world knows, Artemisia was not content with this public display of grief. She went on to build the Tomb of Mausolus, ranked as one of the Seven Wonders of the Ancient World and from which our word "mausoleum" is derived. Another, more prosaic identification of the sitter points to Isabella of Aragon, daughter of the king of Naples, who was widowed upon the passing of her husband, the legitimate duke of Milan, Gian Galeazzo Sforza. As Antonio Mazzotta has argued, the dress worn by the widow in this portrait appears to blend black and blue, the traditional dress of mourning in 15th-century Naples.[38]

Another example of Boltraffio's striking realism, and uncanny ability to penetrate his sitter's soul, is the equally enigmatic *Portrait of a Youth* of 1495–1498, now in the National Gallery in Washington, DC. Its exceptional quality, with its echo of Leonardo's *La Belle Ferronnière,* has prompted suggestions that Leonardo himself may have been involved in the portrait. If that is true, then this would indicate that the sitter was a highly prominent personage, one who would have insisted on the intervention of the master himself.

Boltraffio, *Madonna and Child with St. John the Baptist,
St. Sebastian and Two Donors*, also known as the
Casio Altarpiece, 1500–1502

It has been suggested, for example, that the boy is none other than Francesco Sforza, son of Duke Gian Galeazzo Sforza by his wife Isabella of Aragon. Since we just saw that Isabella may be the sitter of *Portrait of a Lady*, it is possible that the portrait of this youth once formed part of a group of ducal family portraits.[39]

Boltraffio's most important work, however, is the *Madonna and Child with St. John the Baptist, St. Sebastian and Two Donors*, also known as the *Casio Altarpiece*, now in the Louvre in Paris. The patron who commissioned the work, Giacomo Marchione de' Pandolfi da Casio, had a son who later gained renown as the Bolognese poet Girolamo Casio.[40] Following the

Renaissance convention of placing the donors of the painting as quasi-witnesses in the sacred scene itself, the panel depicts the elder Casio on the left, and his son Girolamo as a poet laureate on the right.

What is so striking about this painting, however, is that it represents a complete break with Leonardo's penchant for chiaroscuro, for deep contrasts of light and dark. This scene is bathed in the tones of the "golden hour" of sunset, perhaps under the influence of the art of Bologna and the Emilia region, where Boltraffio settled in the early 1500s. The slightly awkward contrapposto position of the infant Jesus is clearly linked to Boltraffi's drawing, *Study of a Child, Turning Right,* in the collection of the Louvre. In this respect, at least, Boltraffio continued one of Leonardo's principal themes: trying to capture the dynamic movement of a restless infant on his mother's lap.

In fact, it is in his portraits that Boltraffio continued to hew closely to Leonardo's precedent. A key example is his *Portrait of a Boy as Saint Sebastian,* which quite possibly represents a member of the Casio family. The three-quarter pose, the soft sfumato of the boy's face, and the careful detail of the hair cascading down to his shoulders clearly identify this work as painted by a pupil of Leonardo.

Bernardino Luini

The third most important member of Leonardo's entourage was Bernardino Luini. Unfortunately, we know very little about this artist. Surprisingly, his name doesn't even appear on the rolls of the Milanese artists' guild of the Scuola di San Luca.

We think that Luini was born between 1480 and 1482 in the town of Runo, near Lake Maggiore, under the name of Bernardino Scapi. In 1500 he moved to Milan with his father, Giovanni

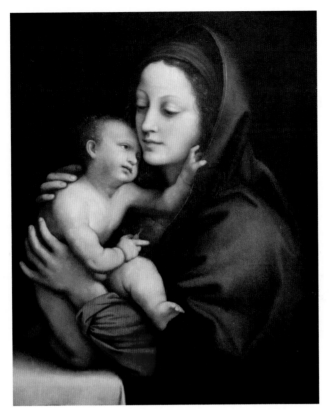

Bernardino Luini, *Madonna with Child,* ca. 1510

Scapi, and enrolled in the studio of a local Lombard artist, who may have been Ambrogio Bergognone. Soon thereafter, he was introduced to Leonardo's Milanese workshop, possibly by his friend Andrea Solario.

The influence of Leonardo is immediately apparent in an early work, the *Madonna with Child,* now in the Kunsthistorisches Museum in Vienna. The painting reveals Luini's strong interest in the tenderness between the young Mary and the infant in her arms. Interestingly, an X-ray of the panel suggests that originally there were two figures flanking the Madonna on either side,

Bernardino Luini, *Christ among the Doctors,* ca. 1510–1520

who may have been either saints or donor portraits. Only later did Luini decide to eliminate these figures and place the central figures of Mary and her infant against a deep-dark chiaroscuro background, similar to Leonardo's Milanese portraits.

Another Madonna from this period, the *Madonna of the Carnation,* now in the National Gallery in Washington, DC, is likewise strongly influenced by a Leonardo motif: a mother's quiet pleasure at seeing her infant son playing with a flower, which serves as a symbolic allusion to his coming Passion.

That Luini must have had access to Leonardo's drawings and cartoons is also shown by his panel of *The Holy Family with Saint Anne and the Infant John the Baptist* of 1515–1520, which as we saw earlier was a faithful derivate of the *Burlington*

Bernardino Luini, *Portrait of a Lady*, ca. 1525

House Cartoon. As Giulio Bora has written, it is even possible that Luini owned this cartoon, either because Leonardo gave it to him, or because he purchased it from Leonardo's estate, administered by Salaì. Many years later it appears in the inventory of Luini's son Aurelio.[41]

Another work that appears to be based on a drawing by Leonardo is Luini's *Christ among the Doctors,* also from this period, and now in the National Gallery in London.[42] The detail of Christ's robe is exquisite, as is the treatment of the hands,

while the face of Jesus is clearly influenced by Leonardo's Christ in the *Last Supper*.

Unlike other Leonardeschi, however, Luini did not slavishly follow Leonardo models. A talented High Renaissance artist in his own right, he adopted the Leonardesque freely and selectively when the work called for it, and if there was a Leonardo drawing or study he could draw from. A wonderful example is his magnificent *Portrait of a Lady*, now in the National Gallery in Washington, DC. With this portrait, Luini truly pays homage to Leonardo as only a painter who has achieved success in his own right could. The identity of the sitter is unknown, but the composition and the somber chiaroscuro were certainly inspired by Leonardo. The lady's smile and the delicate treatment of her hands are evocative of the *Mona Lisa*.

In sum, Luini was one the few artists who could have carried Leonardo's torch well into the High Renaissance. The problem is that he never quite achieved any major renown beyond the small orbit of patrons and churches in Lombardy, and therefore never connected with the mainstream of the High Renaissance in central Italy. Indeed, it was only near the end of the 18th and in the early 19th centuries that Luini was "rediscovered" by collectors. He remains largely a mysterious and elusive figure even today.

Andrea Solario

Even though he never quite matched Boltraffio's imagination or Luini's superb control of the brush, Andrea Solario had always distinguished himself in Leonardo's studio as a dependable interpreter of Leonardo's style. In addition, he had an uncanny talent for absorbing other influences—from Venice, from Rome, and from Northern Europe—and merging these in a style that was uniquely his own. It is perhaps telling that, unlike most other

Leonardeschi, Solario never established his own studio, but was content to work in close association with others, including his brothers, who were active as sculptors and painters.

As was common in 15th-century Lombardy, Solario hailed from a family of artists. In this case, the Solario clan, led by Andrea's brother, Cristoforo, traced its origins to Carona, near Lake Lugano, and subsequently moved to the promising creative milieu of Milan. Andrea's birth date is unknown, though it is likely he was born in the mid-1460s, since his earliest works date from the mid-1490s. It is around this time that he must have joined Leonardo's studio. He was present when Leonardo worked on the *Last Supper* fresco in the Santa Maria delle Grazie—a painting that played a fundamental role in Andrea's career.

His earliest signed and dated work, a *Madonna and Child with Saints Joseph and Simeon* from 1495, was painted for the church of San Pietro Martire, located on the island of Murano near Venice. It betrays the overwhelming influence of Giovanni Bellini, though the attention to texture and detail, such as the embroidered hem of Mary's veil, is undoubtedly a Lombard motif inspired by Northern European art.

Then followed Solario's immersion in the magical world of Leonardo, and the impact was immediate. His *John the Baptist*, now in the Museo Poldi Pezzoli, corresponds closely to Leonardo's paradigm: the pointed finger, the heavy folds of clothing, and the not-altogether-successful sfumato.

Shortly after he finished this painting, Milan was invaded by the French, but Solario seemed to have weathered the storm very well. As we saw, he was soon in touch with the new rulers of the city, including the French governor of Milan, Charles d'Amboise. Here he found a willing audience, no doubt because of his close association with Leonardo, who in the meantime had

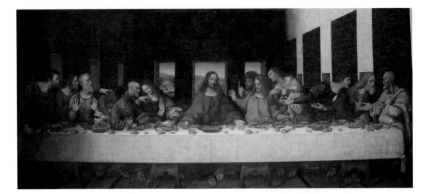

Andrea Solario et al., *Last Supper* (after Leonardo),
known as the Tongerlo copy, 1509

returned to his native Florence. This is the time when we believe
Leonardo worked on his *Madonna of the Yarnwinder*, now in the
Buccleuch Collection, for the king of France. Leonardo may have
been assisted by one of the few pupils who had accompanied him
to Florence, Fernando Yáñez de la Almedina.

If indeed Solario played a key role as an emissary between
Leonardo and his French royal patron, it would explain why in
1507 he was chosen as the lead artist, under Leonardo's supervi-
sion, to paint the very first copy of the *Last Supper*, on canvas, for
that very same king, Louis XII. This highly prestigious commis-
sion would have absorbed much of Leonardo's second Milanese
workshop, including Boltraffio, Luini, and d'Oggiono.

Significantly, Solario himself was then retained by Georges,
Cardinal d'Amboise, the chief minister of King Louis XII, to travel
to France and paint a series of frescoes in the cardinal's family
seat at the Château de Gaillon, in Normandy. This commission
was probably facilitated by the fact that Solario was charged with
taking the huge canvas of the *Last Supper* across the Alps and into
France. A Gaillon accounting statement dated January 20, 1509,

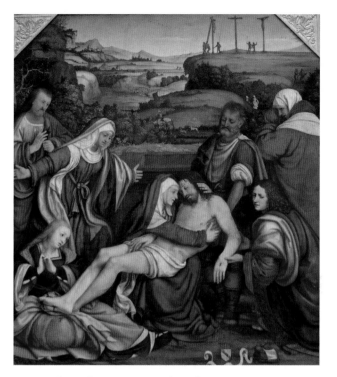

Andrea Solario, *Deposition from the Cross*, 1507–1509

lists the remittance of "129 livres et 10 soldi (around $1,500) à Milan au peintre maistre [master painter] André de Solario."

After the untimely death of Louis XII in 1515, the painting remained in the Château de Gaillon until the death of Georges d'Amboise. An inventory of the chateau, dated 1540, refers to a large painting, "La Cène faicte en toile en grands personnaiges que feu Monseigneur fist apporter de Milan" ("the *Last Supper* made on canvas with monumental figures, which Monsignor had brought over from Milan").[43] Soon thereafter, it was put up for sale. Church records show that the canvas was acquired in 1545 by a cleric named Abbot Streyters for the choir of a new abbey church, then under construction near the Belgian village of Tongerlo.[44]

However, its journey had only begun. Just before 1721, the work was moved from the choir of the abbey church to the central nave, near the northern transept, as part of the refurbishing of the church in the rococo style. Fifty years later, the French Revolution sent shockwaves through Europe. Napoleon's subsequent conquest of the Netherlands had bishops scrambling to safeguard their treasures. The huge canvas was rolled up and hidden in the attic of a local notary named te Herselt.

In 1825 the painting resurfaced once more, this time in the inventory of a painter in the Belgian city of Mechelen, and from there it wound up in the private collection of the Belgian king Leopold I. Only in 1902 was the work returned to the Tongerlo convent in Belgium, where it was once again framed and placed in the right transept of the abbey church.[45]

The Tongerlo copy is unquestionably our best impression of Leonardo's original vision of the *Last Supper*. Though not in good condition—it was heavily damaged in a fire in 1929—the painting provides a fascinating time capsule of what the Milan fresco once looked like. Moreover, the superb execution of the face of John suggests that this passage was painted by Leonardo himself, given his interest in androgynous figures. It is even possible that he used the young woman who sat for his study for *Leda and the Swan* as the model for John's delicate features.

As far as Solario's work in decorating the chapel at Gaillon is concerned, nothing has survived. Much of the chateau, save for some remains of the courtyard and its gatehouse, was destroyed during the French Revolution. The exception is a lovely *Deposition from the Cross*, a depiction of Mary mourning her dead son in a *Pietà*-like scene that became very popular in the centuries ahead. Solario's signature on this panel once included the coat of arms of Georges d'Amboise, later overpainted, which

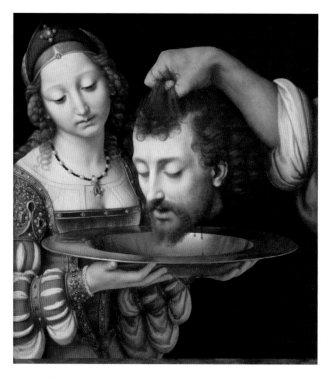

Andrea Solario, *Salome with the Head of John the Baptist,*
ca. 1510–1515

indicates that this work was executed for the decoration of the
chapel of Gaillon around 1509. The position of the angel to the
right, holding the lifeless arm of Christ, is clearly inspired by the
angel in Leonardo's *Virgin of the Rocks.*

The painting underscores what David Alan Brown wrote
about Solario's art: that his style, "while distinctive, is not easy to
define, as it combines elements assimilated from diverse sources
of inspiration."[46] The work appears to blend impulses from Bellini
with those of other Venetian painters such as Vittore Carpaccio
and Antonello da Messina, as well as the German artist Albrecht
Dürer. Dürer, who visited Venice in 1494, created a sensation

101

with his command of fine, almost miniature-like detail, while he himself was overwhelmed by the use of light and indirect reflected color in Venetian art.

The North European influence remained with Solario after he returned to Italy. A typical example is *Salome with the Head of John the Baptist*, now in the National Gallery in Washington, DC. The influence of Northern artists is evident in the attention the painter lavishes on the detail of Salome's dress, at the expense of the drama between the girl and the gruesome head.

And yet Solario was capable of capturing the depth of the human psyche when he set his mind to it—or when his sitter gave him reason to do so—as shown in his *Portrait of Charles d'Amboise*, now in the Louvre. Charles, as we will recall, was the governor of Milan, and nephew of Cardinal Georges d'Amboise, at a time when that family ruled France and its possessions in all but name. It is not clear if this portrait is a Solario autograph or simply a skilled copy, since Charles was so taken with the work that several versions of this portrait exist. Of course, the influence of the *Mona Lisa* is manifest.

Both the d'Amboise family and their master, Louis XII, were profoundly intrigued by the Leonardo mystique. For them, Solario proved to be a convenient surrogate, even though his art tended to stray far from Leonardesque orthodoxy at times.

One important commission remained. In 1513 or 1514, the fifty-four-year-old Solario was commissioned to paint *another* copy of Leonardo's *Last Supper*, no doubt because of his work on the Tongerlo version, which may have been exhibited in Milan before it was shipped to France. This time, the painting was meant to be executed alfresco, on the wall of the refectory at a Hieronymite monastery in Castellazzo outside Milan. An inscription reportedly marked its completion in 1514.

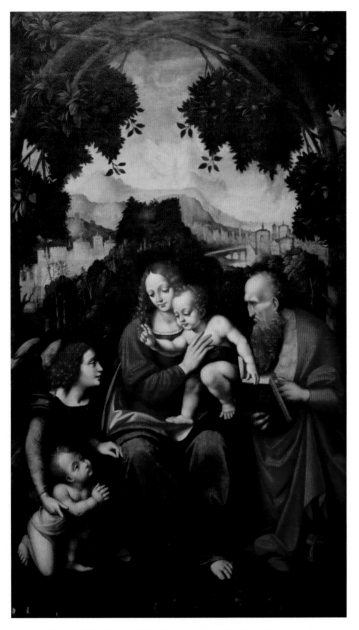

Marco d'Oggiono, *Holy Family with Saint John the Baptist and Angel*, ca. 1500–1510.

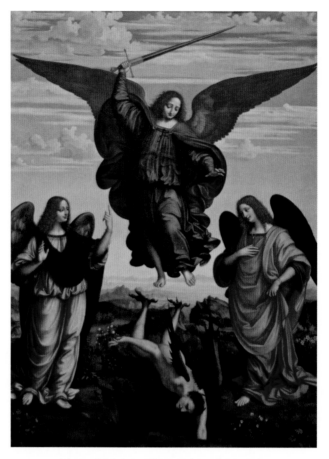

Marco d'Oggiono, *Three Archangels,* ca. 1516

Of all the copies then in existence in Italy, this was widely praised as the most faithful version of Leonardo's original—a judgment that was echoed by visitors as late as the 19th century. When the Castellazzo monastery was suppressed, the fresco was taken down in 1832—a process that caused it to break into pieces—and placed in the Pinacoteca di Brera museum in Milan. The Castellazzo copy was then moved to the refectory of the Santa Maria delle Grazie, where it was exhibited together with other

Last Supper copies—fatefully, as it turned out. Today, the work is known only through prewar black-and-white photographs, though the quality of the work is unmistakable.

Unfortunately, Andrea Solario never gained any international fame outside the royal circle of the French king. Poised on the cusp between the old and the new, between quattrocento naturalism and the drama of the High Renaissance, Solario remained disconnected from both. As a result, he quickly fell into obscurity after the 16th century. It is only in recent decades that art historians have begun to reappraise his work.

Marco d'Oggiono

As in the case of Andrea Solario, history has not been kind to another Leonardo follower, Marco d'Oggiono. The reason is not only because his talent was inferior to that of Luini and Boltraffio, but also because the renowned British art historian Kenneth Clark once branded Marco's art as "peculiarly revolting."[47] But what the artist lacked in imagination, he certainly made up for in his devotion to the models that Leonardo provided.

In fact, Marco was so devoted to his master that it wasn't until the end of Leonardo's first Milanese period that the artist began to look for commissions on his own. He soon found work painting a canvas for the Frari church in Venice, and a panel for a chapel in the Duomo of Savona, neither of which now exists. But the works that did survive vividly illustrate what Janice Shell had to say about him: "without the guidance of an influential old master like Leonardo, or a gifted collaborator like Boltraffio, Marco . . . found himself at something of a loss."[48]

A good example is the *Holy Family with Saint John the Baptist and Angel,* now in the Dr. Bhau Daji Lad Museum (formerly the Victoria and Albert Museum) in Mumbai, India. While the

treatment of folds and shadows is reminiscent of Leonardo, the figures themselves seem lifeless and unconvincing. By contrast, when Marco was able to copy directly from a Leonardo original, the results were considerably better. The face of Joseph, for example, strongly resembles the portrait of Simon in the Tongerlo copy of the *Last Supper*. This would suggest that d'Oggiono worked on this copy, which was probably executed by several members of Leonardo's Milanese workshop.

Marco was probably born in Milan between 1465 and 1470 as the son of a goldsmith. After Leonardo's first Milan studio closed, he briefly worked in Venice and Liguria before returning to Milan in 1504. He then rejoined Leonardo's second Milan studio in 1506 or 1507, and continued to work in the city after Leonardo left for Rome. His most significant independent work from this period is the *Three Archangels* from 1516, now in the Pinacoteca di Brera. It brings together many different Leonardesque motifs: the gesture of the angel at left, pointing upward; the facial expression of Michael, the archangel with the sword, with its echo of the *Virgin of the Rocks*; and the atmospheric vista in the background. Although it is this painting that prompted Clark's rather rude comment, Marco himself must have been proud of his achievement, as he signed his name—"Marcus"—on this panel.

Surprisingly, Marco then did very well for himself. In 1508 he married a lady named Ippolita Buzzi, who owned rental property in the parish of San Satiro, which augmented the couple's income. Their financial condition was further enhanced after the death of Marco's father, Cristoforo, in 1512, who bequeathed all of his property to his son. By the standards of the time, therefore, Marco enjoyed the life of a respected and affluent citizen, who could afford to give his wife the use of her own carriage, finished in velvet—a rare luxury for an artist of the early cinquecento.

By the late 1510s, the fame of Leonardo's *Last Supper* had spread across Italy—so much so that many prominent convents felt the need to commission a copy for *their* refectories. This desire was not only limited to convents. Prominent noblemen may also have felt that their private chapels should be adorned with such a prestigious depiction of Christ and his Apostles. This may explain why another large canvas copy of the *Last Supper* from this period, at roughly two-thirds scale, made its way to the Château d'Écouen, located north of Paris. Unfortunately, the dating of this work is uncertain, though the hand of d'Oggiono—with its tendency to "rubbery" figures, in Kenneth Clark's words—is certainly evident, particularly in the depiction of Christ and other portraits.[49] The painting, which is in fairly good shape, has recently been restored, resulting in shockingly bright candy colors that have been roundly denounced in the press.

Although the circumstances of his death are uncertain, d'Oggiono is believed to have passed away in 1524 during an outbreak of the plague. Writing in 1952, Emil Möller believed that this *Last Supper* was completed in 1530, arguably by Marco's assistants. As such, Marco d'Oggiono's *Last Supper* is today his most tangible contribution to the legacy of his master Leonardo.

Gian Giacomo Caprotti, or Salaì

The young boy who became one of Leonardo's most loyal companions, and played a key role in sustaining Leonardo's legacy, entered the studio in 1490 at the tender age of ten. "Giacomo, aged 10 years, came to live with me on St. Mary Magdalen's day [July 22, 1490]," Leonardo wrote in his notebook.[50] "The second day I had two shirts cut out for him, a pair of hose, and a jerkin, and when I put aside some money to pay for these things, he stole 4 Lire, out of the purse." Leonardo confronted the boy, but as

he wrote, "I could never make him confess, though I was quite certain of the fact." Little Giacomo was simply a *ladro, bugiardo, ostinato, ghiotto'*—a "thief, liar, obstinate, glutton"—a judgment that resolved itself in the nickname "Salaì" or "Salaino," which means "little devil" or, in a more literal sense, "little dirty one."[51]

Nevertheless, Leonardo was unable to part with the boy. The reason, Vasari claims, was that the lad "was most attractive in grace and beauty, with fine curly hair, which pleased Leonardo very much." In fact, it would not stretch the truth to claim that Salaì was perhaps the only person whom Leonardo loved wholeheartedly for much of his life. This is rather exceptional, for Leonardo rarely revealed his inner emotions; nowhere in his notebooks do we find even the slightest expression of his feelings. But that Salaì stirred something in his heart is without question.

Throughout his career, Leonardo produced many sketches and drawings of this handsome young man with seductive curly locks. In one drawing, Leonardo shows his profile facing that of an old man, in a stark contrast of age and youth, of beauty and decay. In another, Salaì appears in recto and verso, fully nude, as a well-muscled man who might have come straight from the local gym, had there been such a thing in Milan at the time.

That Leonardo was gay, and that his relationship with Salaì eventually moved into a romantic sphere, is now almost universally accepted by modern scholarship. Our age has changed the way we look at human relationships outside the heterosexual norm. Freud, writing at the beginning of the 20th century, in a different moral era altogether, suggested that Leonardo sublimated his erotic desire and channeled it into his creative endeavor; for him, Leonardo "represented the cool repudiation of sexuality."[52] Today, however, historians and psychologists no longer need to search for a reason why or how a person develops a certain sexual

Leonardo da Vinci, *Drawing of a Man Seen from Behind*, ca. 1495.
The model is probably Salaì.

Gian Giacomo Caprotti, or Salaì, *Mona Lisa* (the Prado *Mona Lisa*, after an original by Leonardo), ca. 1510–1515

orientation, since we have come to accept that this is a natural part of human development. What's more, there is no evidence that Leonardo deliberately suppressed his sexuality and chose celibacy for fear of censure, social or otherwise. That he was not attracted to the opposite sex is almost certain, for as he wrote in one of his notebooks, "The act of procreation and anything that has any relation to it is so disgusting that human beings would soon die out if there were no pretty faces and sensuous dispositions."[53]

Gian Giacomo Caprotti, or Salaì, *Monna Vanna*, ca. 1515

Unfortunately, Leonardo's heart was not the only thing Salaì plumbed; he also had a voracious appetite for fine clothes, and delved deep into Leonardo's purse to satisfy it. Among other extravagances, Leonardo found himself paying for such things as a silver coat with a green velvet trim, or rose-colored hose.

The idea of a foppish, indolent young man, more interested in fashion than in mastering Leonardo's demanding technique, has prompted most authors, including Walter Isaacson, to dismiss Salaì as a "mediocre talent," on whom Leonardo's training efforts were largely wasted. But this judgment is now being

challenged by several art historians, notably Pietro Marani and Janice Shell. Among others, they point to Vasari's judgment that Salaì was Leonardo's most faithful follower, with a talent that so closely mimicked his master's that "some of their works were sometimes confused."[54]

Part of the problem, as these authors acknowledge, is that Salaì almost never signed his work, and that no specific documents have survived that could point us toward his autograph work. In fact, as Shell has noted, we know more about his business interests than we do about his art. Leonardo gave him part of the lease of a vineyard near the Porta Vercellina (today known as the Porta Magenta), which he had received from Ludovico Sforza in Milan. Salaì subsequently rented the property to tenants, thus securing a modest income for himself, even as he traveled with Leonardo from Milan to Rome, and subsequently to Amboise in France.

For the purposes of our story, Salaì's greatest influence came as a faithful copyist of Leonardo originals. As Shell and Sironi wrote, "Salaì represents another kind of Leonardesco; the faithful replicator of Leonardo's models and, by his own lights, executor of Leonardo's intentions."[55]

We previously saw how a copy of the intermediate version of Leonardo's *Saint Anne*, now attributed to Melzi, spawned a considerable following by itself. One of these is a copy that several authorities ascribe to Salaì, and which today is in the Uffizi in Florence. If this attribution is true, then it is undoubtedly one of the better variations on this theme. In fact, the Uffizi *Saint Anne* treats the face of Anne, and particularly her mysterious smile—Leonardo's trademark—with considerable delicacy. In this, Salaì presents himself as an artist who was in no way inferior to Leonardo's other leading followers.

Very recently, Salaì has also been identified as the artist of what is perhaps the earliest and finest copy of the Louvre *Mona Lisa*, the version currently in the Prado in Madrid. That was not always the case; for a long time, this portrait was believed to have been an obscure copy of North European and possibly Flemish origin. But in 2012, following extensive reflectographic and stereomicroscopic analysis, Ana González Mozo, head of the Prado's technical analysis department, announced that the Prado portrait was actually painted at the same time that Leonardo worked on the Louvre original. She cited the fact that the figures in both versions are identical in size, and may have been produced from the same drawing or cartoon. The tests also show that the artist tried to change or correct multiple details as he worked, arguably prompted by Leonardo himself. These so-called "pentimenti" involved changes to the contours of the back, the shoulders, the hands, and the waist, working with chalk or brush. "It had to be painted at the same time," González Mozo said in an interview published on April 13, 2012; "someone who copies doesn't make corrections because they haven't ever seen the changes. They can see only the surface of the painting."[56]

In 2000, the American art historian David Brown, curator of Italian Renaissance painting at the National Gallery of Art in Washington, argued that a nude portrait of a woman, loosely inspired by Leonardo's *Mona Lisa*, is in fact an autograph work by Salaì. Brown surmised that the portrait must have been painted around 1515, when Leonardo was still marooned in Rome with little or no commissions to his name. This could have inspired Salaì—or even Leonardo himself—to create this rather unusual variation on the *Mona Lisa* theme. One year later in 2001, when the painting went on exhibit in Milan, Italian author and curator Flavio Caroli added, "I am convinced that the portrait was

Salaì (?), *Study for Monna Vanna*, ca. 1515–1520

painted by Salaì from an idea by Leonardo, who was having fun with the famous image he had created ten years earlier."[57]

The theme of the nude *Mona Lisa* is known as *Monna Vanna*, after a character in Dante Alighieri's love poem *La Vita Nuova*. It is probably a mischievous interpretation of the *Mona Lisa*, with Salaì poking fun at his own copy, or the original that his master Leonardo was still laboring on at the time. That the *Monna Vanna* has very little to do with the model who sat for Leonardo's original

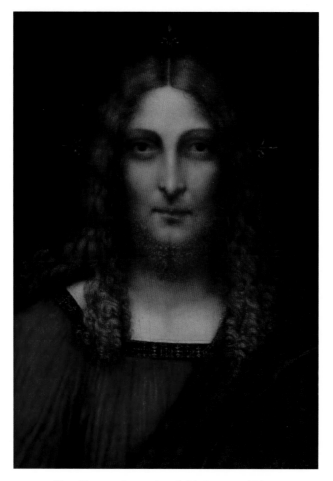

Gian Giacomo Caprotti, or Salaì, *Portrait of Christ*
(after an original by Leonardo), ca. 1510–1515

portrait—Lisa del Giocondo, a prim and proper Florentine house-
wife—is obvious to anyone who has only a passing understanding
of Leonardo's art. The three-quarter position of the *Mona Lisa*
has been replaced with a nearly profile view.

It is also likely that the model for this portrait was a man,
rather than a woman, to judge by the muscular biceps and neck,

and the hint of an Adam's apple. Michelangelo, too, used mostly male models for his female figures in the Sistine Chapel, before adding breasts. What's more, the androgynous features of the lady, so typical of many of Leonardo's portraits, evoke several drawings that may depict Salaì himself. Another clear Leonardesque motif is the delicate sfumato of the sitter's flesh and the superb detail of the Alpine landscape behind her.

Did Leonardo create a *Monna Vanna* treatment himself? In 2017, the Arts page of the *New York Times* breathlessly reported that a drawing of the *Monna Vanna* had emerged, which could have been drawn by Leonardo himself.[58]

The truth of the matter is that the drawing has formed part of the collection of the Musée Condé in Chantilly since 1862, so this was hardly a "discovery." What's more, the heavy-lidded eyes and murky sfumato of the face, as well as the poor execution of the left hand, make it very difficult to believe that this could have been drawn by Leonardo. What it does show, however, is that subtle erotica of this sort was becoming increasingly popular among the wealthy art-buying clientele of the early 16th century, as demonstrated by the depictions of nude goddesses we saw earlier in this chapter.

Outside the oeuvre of direct or indirect copies, the modern historian is at a loss to identify original works by Salaì. And yet, Salaì played a key role in perpetuating Leonardo's legacy by replicating the master's very limited output into copies that, in many cases, posterity accepted as faithful approximations of Leonardo's work. One example is the only painting that, as far as we know, Salaì ever signed and dated; namely, a copy of Leonardo's *Salvator Mundi,* "Christ the Savior."

It is very likely that this is the portrait of Christ that appears on an inventory of Salaì's property, drawn up on April 2, 1525,

after his death. The fact that it was only assessed at 25 scudi suggests that Salaì, rather than Leonardo, was the artist, and that the work was therefore most likely a copy. Nevertheless, this is definitely a portrait by a talented artist who has meticulously captured the original sfumato of Christ's features, as well as the minute detail of curls and circles of Christ's hair and beard. The only major difference from Leonardo's *Salvator Mundi* is the absence of the right hand, raised in a blessing, and the left hand holding a glass orb. Salaì's work may have omitted these details in order to concentrate more closely on the beauty of the face itself, thus enhancing its devotional quality. The work appeared at auction in 2007 at Sotheby's in New York, and was sold to an anonymous buyer for $656,000—nearly double the asking price. Its present location is unknown.

In a very real sense, then, Salaì became the most important custodian of Leonardo's art, and ironically, it is this role that may have led to a rupture between the two, ending a close and deep friendship of almost thirty years.

When Leonardo left for Amboise he was accompanied by both Melzi and Salaì, though Salaì is believed to have returned to Milan in due course. The reason was that Leonardo had left a number of unsold paintings from his Milan and Rome periods—copies of his original paintings, mostly—in his house on the vineyard property in Milan. Perhaps they were too unwieldy to carry along. Or, more likely, Leonardo was still hoping to sell these works on the Italian market, where his name was much better known than it was among buyers in France.

Salaì was obviously the best man to facilitate such sales, particularly since Melzi, Leonardo's other companion in Amboise, was now wholly absorbed in his role as Leonardo's secretary and personal assistant. There was another incentive for Salaì to return

to Milan. At the French court, Melzi, who after all was a young nobleman, was warmly welcomed as "an Italian gentleman living with master Leonardo" and given a grant of 400 écus. Salaì, on the other hand, now forty years old, was merely identified as Leonardo's "servant" and therefore merited a salary of only 100 écus. This would have obviously affected the relationship between the two men.

But then something happened that upset Leonardo greatly. In his will, which was recorded by a local notary, Guillaume Boreau, on April 23, 1519, just a few days after his sixty-seventh birthday, Leonardo stipulated that:

> The aforesaid Testator gives and bequeaths to Messer
> Francesco da Melzo, nobleman, of Milan, in remuneration for
> services and favors done to him in the past, each and all of
> the books the Testator is at present in possession of, and the
> instruments and portraits appertaining to his art and calling
> as a painter [*altri Instrumenti et Portracti circa l'arte sua et
> industria de Pictori*].[59]

In other words, Salaì was explicitly excluded from this bequest of Leonardo's surviving paintings. As a further addition of insult to injury, Leonardo also decreed that the small plot of land outside the walls of Milan, the vineyard that he had entrusted to Salaì's care before moving to Amboise, was now to be divided between Salaì and Leonardo's faithful servant, Battista de Vilanis. Furthermore, only de Vilanis (and *not* Salaì) henceforth received Leonardo's share of taxes on the use of the San Cristoforo canal, which Louis XII had granted him during his second sojourn in Milan. Meanwhile, the balance of Leonardo's account at the Santa Maria Nuova in Florence (in

the amount of four hundred écus) as well as the property he had inherited from his uncle Francesco were to be divided, in one last magnanimous gesture, among Leonardo's half-brothers.

This slap in the face of Leonardo's most beloved friend and companion is shocking, to say the least, and difficult to reconcile with Leonardo's otherwise generous nature. One obvious conclusion is that Salaì must have done something to wound Leonardo greatly.

Though the evidence is circumstantial, the most plausible explanation is this: Salaì was always in need of money. His addiction to a sybaritic lifestyle, including the accumulation of an extravagant wardrobe, never abated. An inventory drawn up at his death listed, among other items, a black damask doublet in the Spanish fashion, lined with velvet, priced at a staggering 40 lire, and another black outfit estimated at 60 lire. To meet his debts, he only had one form of collateral—the hoard of Leonardo's paintings, mostly copies, but the property of Leonardo nevertheless. Backed into a corner, it seems that in early 1519, Salaì opened negotiations with the Sforza family to sell a number of these paintings without Leonardo's knowledge or approval.

On the surface, there may not be anything sinister about this. Selling works from his collection in Milan was arguably what Leonardo expected his erstwhile pupil to do. It would become a problem, however, if Salaì contracted this sale *without* informing his master in Amboise, which it appears he did on March 5, 1519—just six weeks before Leonardo drew up his will. This could suggest that he planned to keep the proceeds for himself. Truth be told, the terms of the contract were extremely generous—some 500 scudi, to be paid in four installments over four years by the duke-in-exile, Massimiliano Sforza.

What could Salaì have done to merit such generous payments?

This question has led to all sorts of strange explanations—Janice Shell suggests that Salaì may have been "Massimiliano's spy"—when in fact, the reason for this secrecy should be obvious. The contract was executed in Paris, which was uncomfortably close to Amboise. Word travels fast, particularly in the intrigue-ridden courts of the early 16th century. And since Salaì desperately needed the money, he may not, or at least *not yet*, have been inclined to let Leonardo know what he was up to.[60] Leonardo, after all, was in failing health. Salaì may have felt that the matter would simply resolve itself in due course.

Boltraffio (?), *Portrait of a Young Man*, believed by some to represent Francesco Melzi; ca. 1507–1510

But this was not all.

A bill of receipt, discovered by Bertrand Jestaz in 1999 in the National Archives in France, specifies a payment of 2,604 lire—an immense sum—to "Salaì, son of Pietro d'Oreno," in exchange "for the delivery to the king of several paintings." This indicates that Salaì was negotiating another major sale as well. Vincent Delieuvin has argued that this bill of sale indicates that Leonardo "had ceded title to his paintings [to Salaì], doubtless as a partial early transfer of his inheritance." But that clearly contradicts the terms of Leonardo's will, which bequeathed this inheritance to Melzi, and *not* to Salaì.[61]

Thus we find that in 1519, Salaì was suddenly flush with money. He was even in a position to make loans to members of the Sforza court and to others, including the painter Giovanni Francesco Stampa.[62] A few years later, he raised himself to such a respectable position that he was able to marry a lady from a highly esteemed family, named Bianca Coldiroli di Anonno.

In our opinion, it is likely that Leonardo found out about Salaì's unauthorized sales, and in retaliation eliminated his erstwhile companion from his last testament, with the exception of part of the vineyard property in Milan where Salaì was living. After all, if Leonardo wanted to sell his workshop's copies to the Sforzas in Paris, or to the French king, he could have done that himself, without the interference of Salaì back in Milan.

If our assumption is correct, then it is perhaps fitting that Salaì, the "little thief," never got to enjoy his ill-gotten gains. Seven months after he married Bianca, Salaì was challenged to a duel, and killed with a crossbow. He was just forty-four. An inventory of his estate was taken, which was discovered in 1990 in the State Archives of Milan. It lists numerous paintings, clear evidence that there was still a valuable cache of art from the

collection that Leonardo had left in his care in 1516.[63]

It is perhaps a sad epitaph to the life of a man who was once indispensable to Leonardo's creativity and happiness, and who became one of Leonardo's most influential Leonardeschi—but on the strength of his work as a copyist, not as an artist in his own right.

Francesco Melzi

During his second sojourn in Milan, Leonardo had the good fortune of being introduced to a bright young man named Francesco Melzi, who despite his noble birth had ambitions to become a painter—a rather shocking choice for an aristocrat, certainly in Milan, where painters were still considered little more than artisans with dirty hands. Francesco's father was Gerolamo Melzi, who had served as a commander of Milan's forces under the French regime in the city. After the Sforza restoration in 1521, Gerolamo found a way to remain in favor with Francesco II Sforza, and worked as a military engineer repairing Milan's walls. This may suggest that Gerolamo had some talent as an architect himself, and could explain why his son's ambitions were not dismissed out of hand.

According to Vasari, Francesco was "a handsome boy when Leonardo was alive and who was greatly loved by him." Melzi probably joined Leonardo's studio around 1507. His name first appears on a drawing of an old man he made in 1510, which is now in the Biblioteca Ambrosiana. Here he is identified as *Francescho de Melzo di anni 17,* which would suggest that he was fourteen when he entered Leonardo's bottega.

Leonardo spent several months on the bucolic estate of Francesco Melzi's father near the small village of Vaprio d'Adda, some 21 miles northeast of Milan, after war broke out in 1512.

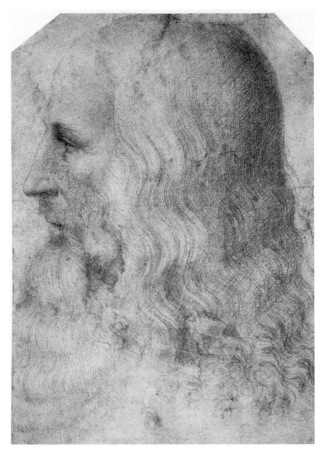

Francesco Melzi, *Portrait of Leonardo da Vinci*, ca. 1515–1518

One year later, Melzi appears in Leonardo's notebook as one of the companions who traveled with him to Rome.

Melzi was still alive when Giorgio Vasari began work on a new edition of his biographical book *Lives of the Artists,* and visited the aging artist in Milan in 1566. Vasari wrote that:

Many of Leonardo's manuscripts on human anatomy are in the possession of Messer Francesco Melzi, gentleman of

123

Milan, who in the time of Leonardo was a very beautiful boy [*bellissiomo fanciullo*] and much loved by him, just as today he is a handsome and courteous old man. He cherishes and preserves the writings as if they were relics, as well as the portrait which is a happy memory of Leonardo.[64]

That Leonardo liked to surround himself with beautiful young men is well known; however, in Melzi's case, that affection appears to have been strictly paternal. After Leonardo's death, Melzi married a young noblewoman, Angiola Landriani, and had no less than eight children by her. Leonardo was certainly close to Melzi, as evidenced by a mock-indignant letter he wrote to him in 1508, while he was stranded in Florence, wondering why Melzi hadn't responded to his letters of late. "You just wait till I get there!" Leonardo wrote, tongue-in-cheek, "and by God I'll make you write so much you'll be sorry." Later, Melzi called Leonardo *mio quanto ottimo padre*, "the best of my fathers."[65]

Like Salaì, and unlike other Leonardeschi, Melzi never pursued an independent career as an artist until after Leonardo's passing. Instead, his activity as an artist was—like Salaì's—entirely focused on copying Leonardo's drawings, and eventually his paintings, to the exclusion of anything else. One of these copies is a sheet of five grotesque heads, probably drawn around 1515 with pen and sepia ink on white paper. We've seen how Melzi is most likely the one who painted the *Hammer Saint Anne*, which reveals the hand of a talented but not altogether imaginative artist. Another work that is attributed to Melzi is the profile portrait of Leonardo himself, possibly executed between 1515 and 1518, either in Rome or in Amboise, and now in the Royal Collection at Windsor. It is the only reliable portrait of Leonardo, executed near the end of his life, and probably the drawing that Vasari refers to in his

Francesco Melzi, *Vertumnus and Pomona*, ca. 1520

Lives of the Artists. It shows that at age sixty, Leonardo was still a handsome man with a flowing beard and long hair, which gave him the air of a savant and the whiff of a *bohémien*.

By then, Melzi had not only become one of Leonardo's most loyal pupils but also his secretary. It was an inspired choice, for without Melzi's diligent organizational skills, it is unlikely that the treasure trove of Leonardo's manuscripts would still be with us today. He enjoyed a warm entrée at the court of King François in Amboise, and was soon recognized as Leonardo's right-hand

man. As such, he is mentioned in the eyewitness account of Antonio de Beatis, the secretary of Luigi, Cardinal of Aragon, who visited Leonardo at his home in Cloux in 1517. As de Beatis wrote, Leonardo "continues to do drawings and to teach others," including "a Milanese disciple who does quite good work"—no doubt referring to Melzi.

Leonardo's loyal assistant was presumably by his side when Leonardo passed away in 1519. Melzi became Leonardo's executor and the principal custodian of his legacy. It is thanks to Melzi's care of Leonardo's chaotic collection of notebooks, as Vasari notes, that a part of his writings is still with us today, even though as many as two-thirds of Leonardo's notebooks are feared lost. This is attested by the Codex Vaticanus Urbinas Latinus 1270, now in the Vatican Library, which is signed twice with "Meltius," and which includes transcriptions of Leonardo's notes from numerous manuscripts and notebooks. In addition, Melzi tried to organize Leonardo's thoughts and observations on the art and technique of painting, in which Leonardo advances his theories about the "motion of the mind" and the need to endow portraits with the inner psyche of the sitter. These were first published in 1651 under the title *Trattato della pittura di Lionardo da Vinci*. The work has since been published many times, most recently under the title *Leonardo on Painting*.[66]

Largely because of his inestimable contribution to our knowledge of Leonardo's writings, the 18th-century historian Pierre-Jean Mariette was the first to try to reconstruct Melzi's oeuvre as an artist. It is he who first identified the *Vertumnus and Pomona*, now in the Gemäldegalerie Berlin, as an original Melzi. The subject is taken from Ovid's *Metamorphoses*: Pomona was the goddess of fruit, while Vertumnus was the god of transformation, who disguised himself as an old woman in order to seduce her.

Only in 1995, after the painting was cleaned, did Melzi's signature miraculously appear under many layers of yellow varnish, confirming Mariette's attribution. The composition of Pomona is deeply beholden to Leonardo models, particularly the *Saint Anne*.

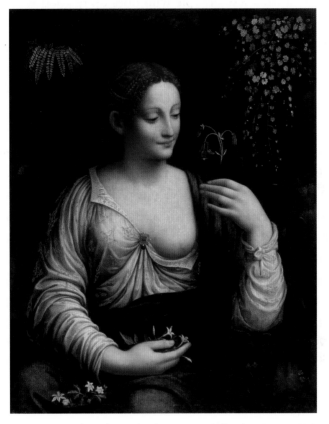

Francesco Melzi, *Flora* (also known as *Columbina*), ca. 1520

The painting is stylistically related to Melzi's portrait of another mythological figure: *Flora*, the goddess of plants, flowers, and fertility, now in the Hermitage in St. Petersburg. As in the case of *Vertumnus and Pomona*, the plants and flowers, as well as the patterns on Flora's blouse, are depicted in meticulous,

Leonardesque detail, thus illuminating their allegorical meaning. The jasmine in Flora's right hand symbolizes purity, and according to Gian Paolo Lomazzo, her lost chastity; the columbine in her left hand and her bare breast represent fertility; and the anemones in her lap suggest death and resurrection, possibly injecting a Christian theme into this pagan allegory.

Of particular note is the sensitive treatment of the exposed breast in both paintings, using a sfumato technique that few of Leonardo's other pupils could have matched. This is one reason why some recent authors have suggested that the *Flora* (also known as the *Columbina*) may be an autograph work by Leonardo himself, though this suggestion has not garnered much support.

While the subject of Flora was a popular one in the Renaissance—witness her depiction in Botticelli's *Primavera* of 1482—this portrait was an opportunity for Melzi to display his literary erudition and knowledge of classical texts. It may also have prompted him to sign his name in Greek, to further highlight his superior education and social status as compared to other artists, particularly Lombard ones.

The third painting that is generally attributed to Melzi is the rather unusual *Portrait of a Young Man with a Parrot*, today in a private collection in Milan. The painting is unconventional because, at first glance, it doesn't appear to be a work from the early 16th century at all. With its bold, almost primary colors, and the angular abstraction of the face, one could almost accept it as an avant-garde work of the early 20th century. What makes the portrait an unmistakable autograph, however, is the presence of the artist's signature. Some believe it could even be a self-portrait.[67]

The Leonardeschi: An Assessment

By the time Melzi died, around 1570, all of Leonardo's other followers had long since passed away. While some, including Boltraffio, Bernardino Luini, and Andrea Solario, had carved out respectable careers for themselves, none had succeeded in matching their master in the quality of their output or their reputation. Part of the reason, perhaps, is that many of these artists lacked the talent to successfully assimilate the Leonardesque with the new and exciting currents coming from Venice and Rome, as Andrea del Sarto, Giorgione, and Correggio later did. Possibly they were simply too beholden to the artistic traditions of their native region, Lombardy, to fully embrace the art of the High Renaissance. Significantly, none of the Leonardeschi settled in what were then the centers of Italian creative endeavor, the papal court in Rome or the newly formed ducal court in Florence after the restoration of the Medici.

Another factor that limited the impact of Leonardo's followers was the devastating plague that struck Milan in 1524 and carried off some of Leonardo's most prominent pupils, including Marco d'Oggiono, Andrea Solario, and Bernardino de' Conti. Cesare da Sesto had died a year earlier.

All of this leads to the inevitable conclusion that Leonardo, as Paolo Giovio already noted in 1527, "left no student of any fame."[68] Instead, those who survived the plague or were working outside of Milan after 1530 slowly surrendered the Leonardesque technique to the new aesthetic winds blowing from Rome and Venice. But although the aura of Leonardo's magic gradually dwindled, it was never fully extinguished.

This begs the question: why? Who, or what, kept the flame alive?

4.

LEONARDO AND THE ARTISTS OF THE HIGH RENAISSANCE

At the dawn of the 16th century Leonardo had formulated five cardinal new ideas: the use of pyramidal configurations as the most stable form of composition; the need for figures to express a shared emotional intensity; the superiority of soft modeling over line and *disegno*; the idea of using dark backgrounds to enhance the soul of the sitter; and above all, the use of optical, atmospheric effects, rather than linear perspective, to suggest depth and form. As Paolo Giovio wrote, "the science of optics was of paramount importance for him, for on it he founded the principles of the distribution of light and shade, down to its most minute details."

Not many artists understood the importance of these five ideas, or how they were fused together to create an entirely new form of art that today we recognize as the High Renaissance. But some did. In fact, it is this small group of artists who took Leonardo's revolutionary concepts and used them to propel their own careers to heights never achieved by any of the master's own followers.

The question is, however, *how* did they apply Leonardo's inventions? And were they prepared to give the master credit? Did they maintain the Leonardo mystique, or did they claim these new ideas as their own?

Raphael

The first and foremost of these artists is, of course, Raffaello Sanzio, better known as Raphael. He was born in Urbino, a region of some cultural renown. Raphael's father, Giovanni Santi, was the court painter to the Duke of Urbino, Federico da Montefeltro. Upon his death in 1482, shortly before Raphael was born, the Duke was succeeded by his son Guidobaldo, whose wife Elisabetta began to import a wealth of Mantuan artists, poets, and musicians to brighten her life. By the 1490s, the previously rather dour Urbino court had become a center of artistic endeavor in its own right.

This is when Raphael's father apprenticed his son to the workshop of Pietro Perugino, who like Leonardo had begun his career under the tutelage of Verrocchio. By the time Raphael arrived, probably around 1496, Perugino had completed a fresco cycle in the Sistine Chapel in Rome and developed enough of a reputation to establish two workshops, one in Florence and one in Perugia.

Truth be told, Perugino was a competent painter but had a somewhat limited imagination. His angels and Madonnas look so similar that it is sometimes difficult to tell them apart. As Vasari put it, "he had reduced the theory of his art to a manner so fixed, that he made all his figures with the same expression." Michelangelo felt so too, and with his characteristic lack of tact once told Perugino that he was a *goffo nell'arte*—which, roughly translated, means "an artistic klutz." Deeply offended, Perugino sued for defamation of character, but the lawsuit went nowhere. This may explain why in 1504, the twenty-one-year-old

Raphael realized that he had reached the limits of what Perugino could teach him, and set his sights on Florence. Vasari claims that Raphael first learned of Leonardo's fame from a group of workmen talking about the large cartoon for the *Battle of Anghiari*, then taking shape in the refectory of the Santa Maria Novella. And so, Raphael journeyed to Florence in 1504 and spent several weeks—perhaps a few months—in Leonardo's studio.

He was present in the bottega when the portrait of the *Mona Lisa* was beginning to take form on a panel in a corner of the studio. In April of that year, del Giocondo had acquired a house next to his own home on the Via della Stufa, to be used as rental property. It is attractive to think that Leonardo could have been living in this adjoining home while working on the *Mona Lisa* commission, since the sitter was just one door away. Significantly, when the young Raphael arrived he took rooms in the Palazzo Taddei, which faced the Giocondo residences on the Via della Stufa.[69]

Leonardo's *Mona Lisa* made a devastating impact on the young Raphael. He was stunned by the pyramidal composition and the three-quarter position of the sitter, in what was obviously a major break with the tradition of painting portraits in profile. He grabbed a pencil and sketched a drawing of the work, then slowly emerging on Leonardo's easel. He noted how the hands were folded below the lady's chest, and how the lady's gaze was pointed straight at him, as if to challenge him. He was also struck by the way the sitter was not depicted against a dark background, but on a balcony of some sort, flanked by pillars that screened her presence from the deep vista of a Tuscan landscape beyond. The purpose of this landscape was to suggest *depth*, while the beauty of an infinite panorama served to emphasize the monumentality of the sitter. Lisa doesn't merely inhabit the space; she *commands* it.

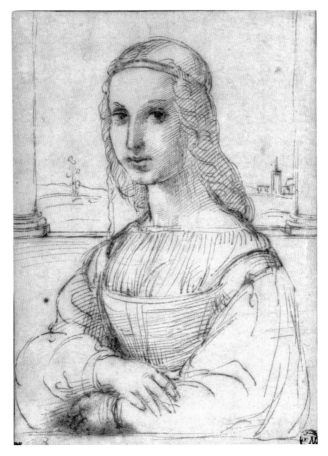

Raphael, *Drawing of the Mona Lisa*, ca. 1504

The drawing of the *Mona Lisa* is only one of several other sketches that Raphael made of Leonardo's panels. As we saw, he also made a drawing of Leonardo's *Leda and the Swan*, now at Windsor.

As a result, for the next five years Raphael's output was strongly dominated by what he had seen in Leonardo's studio. Some of these influences are obvious, such as the series of portraits that all emulate the position of the *Mona Lisa*. Key

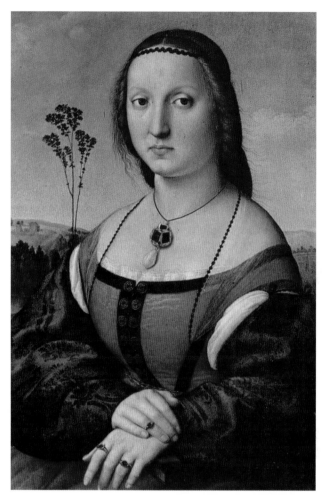

Raphael, *Portrait of Maddalena Strozzi Doni*, ca. 1506

examples are the *Portrait of Maddalena Strozzi Doni* of 1506, now in the Pitti Palace in Florence, and the *Lady with a Unicorn,* today displayed at the Galleria Borghese in Rome. The important difference between these portraits and the *Mona Lisa* is the lack of psychological depth in Raphael's women, and his failure—or lack of interest—to capture his sitters' motions of the mind. These

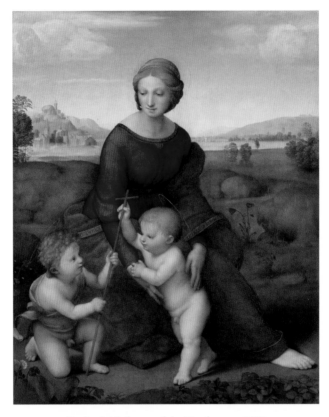

Raphael, *Madonna of the Meadow*, ca. 1506

ladies stare at us, the beholder, with cool indifference, without any of the tantalizing mystery of Lisa's enigmatic smile.[70]

Another, more subtle influence of Leonardo is evident in Raphael's devotional paintings from this period, notably his Madonna portraits. The *Madonna of the Meadow* of 1506, now in the Kunsthistorisches Museum, follows the pyramidal scheme of the *Saint Anne*, which was also beginning to take form in Leonardo's Florentine studio. In particular, Raphael tried to recreate the sense of an emotional movement between the infant Jesus and the young John the Baptist that he had probably seen in

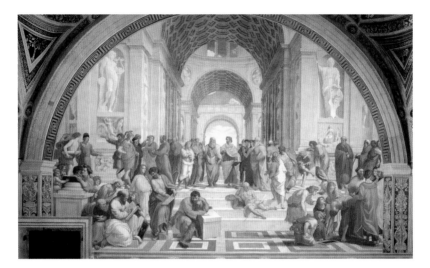

Raphael, *The School of Athens*, ca. 1516. Leonardo was the model for
the bearded man in the center of the fresco, representing Plato.

the *Saint Anne* cartoon, or even the *Burlington House Cartoon*.
Another Leonardesque motif is the rotation of Mary's torso.
While her body is turned to our right; her hands embrace the
infant Christ in the center. Her gaze is turned to the left, toward
St. John.

This idea inspired several other versions on this theme, nota-
bly the *Madonna of the Goldfinch* of 1506, the portrait known
as *La Belle Jardinière* of 1507, and the *Canigiani Holy Family*
of 1508. But even with these compositional influences, and his
own attempts to master Leonardo's seductive sfumato technique,
Raphael never embraced the master's strong chiaroscuro. All of
his paintings remain universally lit with sunlight, so as to better
show the sparkling colors that hark back to Perugino's palette.

The fame of these works, possibly communicated by the
architect Bramante, prompted an invitation from Pope Julius II,
and from that point on Raphael's career was assured. He was

immediately tasked with the decoration of the pope's library in fresco, even though Raphael's experience with this medium was limited. The result was the famous series of *stanze*, the papal "rooms," that sealed his fame. Working rapidly, often with assistants, the artist completed a stunning suite of frescoes that together with Michelangelo's Sistine Chapel ceiling became a hallmark of the High Renaissance. At the same time, he abandoned the soft, ambiguous style of Leonardo, so uniquely suited for oils, in favor of a more robust classicism of bold forms and colors that could be captured quickly and reliably with tempera paint.

This new style derived its inspiration not only from the classical sculptures that littered the Vatican, but also the astonishing forms that Michelangelo was painting on the ceiling of the chapel nearby. The result, in Michael Levey's words, was a "superhuman clarity and grace" that would set the stage for Italian art for the next two hundred years.[71]

Michelangelo

The other titan of this era was, of course, Michelangelo, properly named Michelangelo di Lodovico Buonarroti Simoni. In 1508, Michelangelo had begun work on the magnificent fresco cycle for the ceiling of the Sistine Chapel. He did so with great reluctance, because the reason he had left Florence for Rome was the prospect of designing a massive tomb for the ruling pope, Julius II. Many pontiffs were eager to begin work on their tombs as soon as they were crowned, so as to secure their fame for all posterity.

Michelangelo was a protégé of Lorenzo de' Medici, who had always vastly preferred sculpture over painting. It is therefore difficult to determine if Leonardo's work had any direct influence on the much younger Michelangelo, particularly because

Michelangelo, *The Creation of Adam,* from the Sistine Chapel ceiling, ca. 1508

there was little love lost between the two. What's more, during Michelangelo's formative years from 1488 to 1499, Leonardo was working in Milan.

According to Vasari, the rivalry between the two artists was intense. When in 1504, a prestigious committee of Florentine artists voted to place Michelangelo's towering sculpture of *David* in a place of great honor, next to the entrance of the Palazzo della Signoria (where a copy of the statue still stands today), Leonardo dissented. He suggested that it should be placed deep in the Loggia dei Lanzi opposite the palazzo, "lest it interfere with state ceremonies"—well away from the public view. Vasari suggests that originally, the Signoria had been thinking of giving the *David* commission to Leonardo, though the well-documented antipathy of the gonfaloniere Soderini, president of the Signoria, toward Leonardo makes this difficult to accept.

Soderini then came up with an insidious plan: to commission the young Michelangelo to create a battle fresco in the *same* Grand Council Hall where Leonardo soon began to paint his *Battle of Anghiari*. To add insult to injury, the Signoria awarded

Michelangelo a much higher fee than that promised to Leonardo, which was a mere 150 florins, doled out at a rate of 15 florins a month. This devious plot ultimately came to naught, for neither Michelangelo—tasked to paint the *Battle of Cascina,* another episode from Florence's storied past—nor Leonardo completed their work, and the hall was overpainted—by Vasari, of all people—in the 1540s.[72]

Thus, the great competition between the two giants of Italian art that would have put Florence back on the map as the creative center of the world never came to pass, and both Michelangelo and Leonardo ultimately wound up working in Rome.

Andrea del Sarto

A Florentine artist who was much more eager to adopt Leonardo's radical innovations was Andrea del Sarto. It is always a source of regret for us that so few people are familiar with this artist. When I take friends on a tour of Florence, and particularly the Palazzo Pitti, where many of del Sarto's works are exhibited, the usual response is, Andrea *who*? But to my mind, Andrea del Sarto was one of the most important Florentine painters of the cinquecento, notable for the deep passion and rich coloring with which he endowed his figures.

The word *sarto* means "tailor" in Italian, and indeed Andrea was the son of a tailor, born in 1486. He was trained in the workshop of Piero di Cosimo, and later by Raffaellino del Garbo. As he emerged from his apprenticeship, he was often drawn to the Hall of the Five Hundred in the Palazzo della Signoria to admire the unfinished underdrawing, with some touches of color, of Leonardo's *Battle of Anghiari.* "When Andrea had any time to himself, particularly on feast-days," Vasari writes, "he would spend the whole day in company with other young men,

drawing" from the frescoes in the Hall. In this, Vasari adds, "young as he was, he surpassed all the other draughtsmen, both native and foreign, who were always competing there with one another."

By 1508, Andrea had set up his own workshop together with an old friend, the artist Francesco di Cristofano, also known as Franciabigio. Shortly thereafter, they received their first big commission: a series of frescoes inspired by the life of a Servite saint named Filippo Benizzi, in the forecourt of the church of the Santissima Annunziata in Florence. These were the same Servite friars who had previously commissioned Leonardo to paint an altarpiece in 1501, which only went as far as a cartoon for a *Saint Anne*. Del Sarto completed these paintings so rapidly, in the span of a year, that they commissioned him to execute other frescoes in the church, including an *Adoration of the Magi*.

In 1517, del Sarto created the work that established his reputation: the *Madonna of the Harpies*. This was not its original title, of course; the panel depicts the Virgin Mary and the infant Jesus flanked by St. Francis at left and John the Evangelist at right. The pedestal on which Mary stands, however, shows several figures that were later interpreted as harpies, mythological creatures that appear in Homeric poems as half-human, half-bird harbingers of storms. This gave rise to the title that is still used in English art literature today.

More importantly, the panel vividly shows del Sarto's virtuosity in blending Leonardo's strong chiaroscuro with the bold colors and drapery of Raphael and Michelangelo, using a typical Leonardesque pyramidal composition. The affectionate treatment of the infant Jesus, hugging his mother while shyly smiling toward the beholder, could have leapt from any of Leonardo's drawings of the subject. The result is a naturalism that seems to

Andrea del Sarto, *Madonna of the Harpies,* ca. 1517

stretch across the horizon of the High Renaissance and into the world of the Italian Baroque.

That same year, Andrea painted one of his most famous works, *Portrait of a Young Man,* now in the National Gallery in London. The raking light, the sharp folds of the left sleeve, and the contrapposto position of the sitter, looking over his shoulder toward the beholder, all point to Leonardo's precedents. For a long time it was thought that this was Andrea's self-portrait, but this notion has now been discredited.

That same indebtedness to both Leonardo and Raphael is evident in del Sarto's drawings, which rank him as one of the

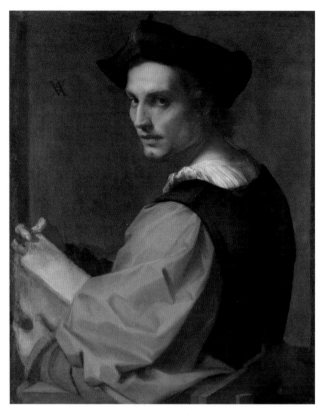

Andrea del Sarto, *Portrait of a Man,* ca. 1517

leading artists in pen and chalk of his time. Some 180 drawings have survived, but only a few appear to have been completed studies. For Andrea, the drawing board was evidently a space to try out new ideas in much the same way that Leonardo did.[73]

Despite his evident success, Andrea often found himself living on the edge of poverty, until two of his works made their way to Europe's most indefatigable collector, King François I. The king promptly extended an invitation to del Sarto to come to France. The artist accepted, and left for Amboise in June of 1518, together with an assistant named Andrea Squarzella. Here they

were showered with "presents of money and rich and honorable garments," according to Vasari, which altogether left little incentive to return to Florence. Indeed, the king commissioned several works, including a portrait of the Dauphin, still in swaddling clothes, for which del Sarto was paid the astonishing sum of 300 gold écus.

But this idyll came to an end when del Sarto's wife Lucrezia started to send him letters, wondering when he planned to return to Florence. Andrea thereupon pleaded with the king to allow him to return to Florence, collect his wife, and bring her back to Amboise, "in order to live more at his ease in France." He also promised to come back "laden with pictures and sculptures of value," if the king consented to give him funds for that purpose.

François agreed and gave him a rich purse of gold. Andrea duly left for Florence, never returned to France, and instead used the money the king had given him to buy himself a house in Florence. This obviously left a very bad taste at the French court. Perhaps the king had seen in Andrea the perfect successor to Leonardo, who by 1518 was no longer painting, and whose health was in steady decline. Instead, Andrea's perfidy doomed his reputation, certainly in France, though it does not seem to have affected his career in Florence. Among others, it was Michelangelo who in 1524 came to del Sarto's studio with a young aspiring artist in tow, full of praise about Andrea's talents. This artist was Giorgio Vasari, who thirty-five years later documented Andrea's life and art in his *Lives of the Artists*.

Vasari's praise for his erstwhile master was not unqualified, however. While Andrea, as he wrote, "demonstrated all that painting can achieve by means of draftsmanship, coloring, and invention," he also lacked "fire and boldness of spirit," which is 16th-century code for a certain indolence and lack of ambition.

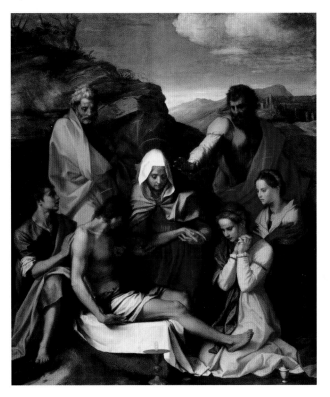

Andrea del Sarto, *Pietà with Saints*, ca. 1523–1524

This insight into del Sarto's psychology is undoubtedly based on Vasari's personal observation of the artist through the final years of his creative activity. Many historians suspect that much of Vasari's account is deeply biased because of the latter's great antipathy toward del Sarto's wife, Lucrezia. A beautiful but highly demanding woman, she may have rubbed him the wrong way. In 1530, during an outbreak of the bubonic plague in Florence, del Sarto contracted the disease and died at age forty-three. Vasari claims that his wife, Lucrezia, refused to tend to him for fear that she, too, would succumb to this disease, and that she outlived her husband by forty years.

Even during his lifetime, del Sarto was universally praised for the quality of his drawings, his brilliant use of color, and his dramatic use of a Leonardesque chiaroscuro to cast his figures in strong, brooding contrasts of light and dark. As such, Andrea's unique style exerted considerable influence on two of his most prominent pupils, the Mannerist painters Rosso Fiorentino and Jacopo Pontormo. But after his death, del Sarto's fame rapidly declined, and only gained a reappraisal in the 1960s, following the publication of monographs by Sydney Freedberg and John Shearman. Today, with recent exhibits at the Frick Collection in New York and the J. Paul Getty Museum, he is recognized as one of the leading interpreters of Leonardo's style, and perhaps the finest draftsman of the High Renaissance.[74]

Giorgione

So far, all of the painters we discussed in this chapter were artists of the cinquecento who received a critical part of their formative training in Florence. Even though it was overshadowed by the papal court in Rome, Florence remained a major fulcrum of creative currents through the first decade of the 16th century, in contrast to Milan, where the ongoing conflict between France and the Holy League forced many artists to flee. That is why Florence produced most of the artists who eventually acquired international fame as the leading lights of the High Renaissance, while many of the Leonardeschi who emanated from Leonardo's workshop in Milan were doomed to mostly regional status, working for local or provincial clients without ever rivaling their counterparts in Florence and Rome.

There is one major exception, however, and that is Giorgio Barbarelli da Castelfranco, commonly known as Giorgione. That he is even known to us today is a near miracle, because only six

works are generally identified as his autographs, and his career was cut short, at age thirty, before it could fully take flight. What's more, Giorgione was the product of another great artistic tradition that owed little to Florence, Milan, or Rome, and that was the art of the Serenissima, the Venetian Republic. Blessed with the reflection of sunlight on its waters, its warehouses filled with rich cloth and silk from the Far East, Venice developed an art movement of strong colors and bold light effects that was both insular and international, yet owed little to anyone but itself. Its primary exponents were the Bellini family, represented by the father, Jacopo Bellini, his two sons Gentile and Giovanni, and his son-in-law, Andrea Mantegna. The Bellinis, and particularly Giovanni, developed a uniquely Venetian style of bright tones, rich vistas, and sharply delineated forms, often cast in the golden light of the sun setting over the Venetian lagoon. Through them, this style was transmitted to Titian, Tintoretto, and Giorgione, eventually entering the mainstream of the High Renaissance.

Although the date of his birth is uncertain—possibly around 1477—the young Giorgione was accepted as an apprentice into the workshop of Giovanni Bellini. In 1500, at the age of twenty-three, he was invited to paint the portraits of two of Venice's leading personalities, the Doge Agostino Barbarigo, and condottiere Consalvo Ferrante, commander of the mighty Venetian forces. That such a young artist was entrusted with such important state portraits proves that, as Vasari writes, "he surpassed by a great measure not only the Bellinis, whom the Venetians held in such esteem, but also every other master who had painted up to that time in that city." A series of highly prestigious commissions followed. Giorgione produced the decoration of the Audience Hall in the Doge's Palace, which today is Venice's leading tourist attraction, and the rebuilt German Merchant Hall, the Fondaco

dei Tedeschi, which today is the slender Renaissance palazzo that tourists see from the top of the stairs of the Rialto Bridge, looking toward the northeast.

In that same year of 1500, an event took place that was a decisive influence on Giorgione's art. He met with Leonardo da Vinci, who was then visiting Venice on his long roundabout journey, after the fall of the House of Sforza, that eventually saw him back in Florence. As Vasari writes,

> Giorgione had seen some things by the hand of Leonardo
> with a beautiful gradation of colors, and with extraordinary
> relief, effected, as has been related, by means of dark
> shadows; and this manner pleased him so much that he was
> forever studying it as long as he lived, and in oil-painting he
> imitated it greatly.[75]

Indeed, it was Leonardo's innovative treatment of modeling faces and bodies with soft contours and blurred shading that remained with Giorgione throughout his short career. The Venetian artist used these influences to formulate a radically new approach to naturalism that broke with the linearity of the Bellini tradition, and introduced a uniquely Venetian spin on the art of the High Renaissance.[76]

A wonderful example of Giorgione's highly individual style is in one of the most mysterious paintings of the Renaissance, *The Tempest*, dated around 1508 and today in the Galleria dell'Accademia in Venice. Its subject matter is an enigma. A nude woman nurses her baby in a landscape lit by the flash of lightning, while a young man at left observes this intimate scene with a studied air of insouciance. The presence of two broken columns in the center may provide a clue that we are looking at a scene from classical

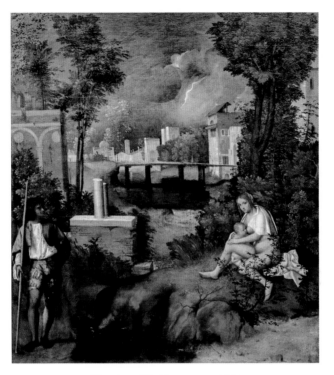

Giorgione, *The Tempest*, ca. 1508

mythology, which would explain the juxtaposition of a nude woman with a dressed man—otherwise only allowed in depictions of Antiquity. Some have tried to interpret the painting as a depiction of the four elements (earth, water, fire, and air), but that still leaves the role of the figures unaccounted for. What is striking in this picture is the role of the landscape: it is not relegated to the background, as was common in the art of the time, but has become the principal motif of the painting. It surrounds the figures and overwhelms them, in much the same way that nature is front and center in Leonardo's *Virgin of the Rocks*. As a result, some authors have called this work the first landscape in European art, an instance of *la nature pour la nature*, as a subject in itself.

149

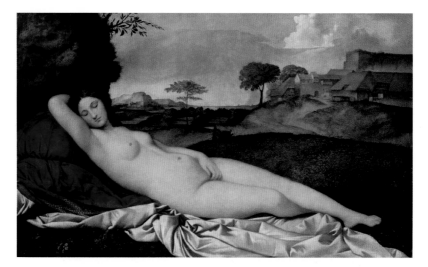

Giorgione (and Titian?), *Venus,* ca. 1510

An equally stunning work is Giorgione's *Venus,* painted in the year of his death, 1510, and now in the Gemäldegalerie Alte Meister in Dresden. Our familiarity with the theme of a reclining female nude, from Titian to Boucher and Manet, can easily obscure the revolutionary character of this work. It could even be considered the first reclining nude in Western art—a motif that became wildly popular in the French Baroque and the art of Boucher and Fragonard. With his expert use of Leonardo's soft sfumato, as well as an exquisite sense of texture and atmospheric perspective, Giorgione created a portrait of the female form that retained its iconic quality well into the 19th century. The painting was unfinished at his death, which leads us to believe that the landscape and sky were probably finished by Titian. Some recent authors have suggested that even the figure of the sleeping Venus is also the work of Titian, though this is a now-familiar debate in modern art criticism. Titian's early style is so similar to that of Giorgione that other works, such as the *Pastoral Concert* in the

Louvre, often spark a tug-of-war of rival attributions. Certainly, Titian's *Venus of Urbino*, painted in 1534 and now in the Uffizi, acknowledges its debt to Giorgione's original.

Correggio

The only other artist of the High Renaissance who remained faithful to Leonardo's style throughout much of his career is the painter known as Antonio Allegri da Correggio, or simply Correggio. As his name suggests, he was born in a small town called Correggio in Reggio Emilia, a province perched between the Duchy of Milan and the Florentine Republic, possibly around

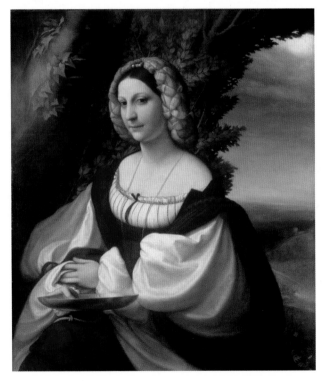

Correggio, *Portrait of a Lady*, ca. 1520–1523

1489. His uncle was a minor painter called Lorenzo Allegri, and it is likely that this artist gave Correggio his initial training. The young artist expanded his artistic horizon with trips to Modena and Mantua, where he absorbed the influence of Lorenzo Costa and Andrea Mantegna. By 1516, he had settled in Parma, in Emilia-Romagna, and remained there for most of his career.

Along the way, Correggio became familiar with the work of Leonardo da Vinci, though largely through the copies by Leonardeschi, which now enjoyed considerable circulation in Northern Italy. This influence is plainly visible in Correggio's *Portrait of a Lady*, dated to the early 1520s and now part of the collection of the Hermitage in St. Petersburg. While the identity of the sitter is unknown, the work is influenced by the *Mona Lisa*, as evidenced by the sitter's three-quarters pose, the luminous quality of her neckline, and the hint of a smile. What is unusual about this portrait is its enormous size, some 103 by 87.5 cm, larger than most portraits of the 15th and early 16th centuries.

Correggio's first major work was the decoration of the inner dome of the Benedictine church of San Giovanni Evangelista in Parma between 1520 and 1521. As befits the church, it is titled *Vision of St. John the Evangelist at Patmos*, and is based on the Book of Revelation:

> Look! He is coming with the clouds;
> every eye will see him,
> even those who pierced him;
> and all peoples on earth will mourn because of him.

(Revelation 1:7)

Correggio, *Assumption of the Virgin*, 1524

With this work, Correggio swept away a century of artistic tradition in order to create something entirely new and original, brimming with vitality. The result is what historians call "trompe l'oeil" ("deceive the eye") painting, in which the illusion of depth is so convincing that the viewer can no longer distinguish between the architectural reality and the painted fantasy. We usually associate this technique with Baroque art of the Counter-Reformation, but Correggio was the first to develop it—almost a century before such paintings became widespread.

In his panel paintings, Correggio continued to freely borrow from Leonardo, not only in terms of composition but also in the

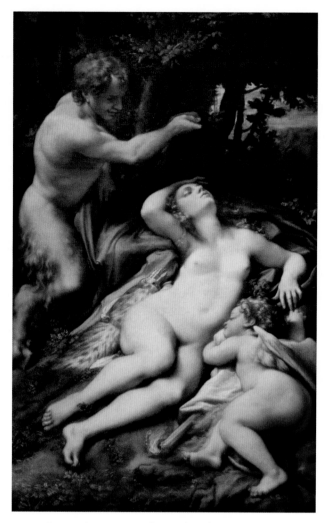

Correggio, *Venus and Cupid with a Satyr*, 1528

chiaroscuro and softness of contour. A key example is his *Nativity*
from 1530, also known as *Holy Night*, now in the Gemäldegalerie
Alte Meister in Dresden. Here, the dramatic use of a single source
of light—the child Jesus—anticipates the theatrical illumination
of Caravaggio, nearly a century later.

Apart from his religious works, Correggio was also familiar with Greek and Roman mythology, which was all the rage in the high-society salons of 16th-century Italy. In 1528, he painted the highly erotic *Venus and Cupid with a Satyr*, most likely for the Duke of Mantua, Federico II Gonzaga. In this work, a satyr uncovers the beautiful Venus, goddess of love, as she lies sleeping in a forest with her son Cupid. Her languid nude body, executed with a typically Leonardesque sfumato, created a sensation.

Some historians have suggested that the painting does not represent Venus, but a story from Ovid's *Metamorphoses* in which Jupiter, disguised as a satyr, is about to rape the nymph Antiope— which would have greatly increased the painting's erotic charge.[77] Be that as it may, the work must have pleased the Duke, for he then decided to commission a series of panels inspired by other stories from Ovid's *Metamorphoses*. These were to depict Jupiter's sexual exploits, under the befitting title of *The Loves of Jove*. In one, the god hides himself inside a cloud so as to better seduce the beautiful Io, daughter of the king of Argos. In another story that we encountered earlier, *Leda and the Swan*, Jupiter changes himself into a swan in order to make love to another unsuspecting belle, the Queen of Sparta. The third painting was to depict Jupiter in the process of impregnating the princess Danaë in the form of soft golden rain, while a fourth was to show the handsome lad Ganymede being carried aloft to Olympus by Jupiter in the form of an eagle. According to a study by Egon Verheyen, the Jupiter cycle was destined to decorate the Duke's private Sala di Ovidio ("Ovid Room") in the Palazzo del Te—for his mistress, Isabella Boschetti— then under construction based on designs by the Mannerist architect and painter Giulio Romano.[78] At least two of these paintings eventually wound up at the Habsburg Emperor's court in Spain, from whence they made their way, via Prague, to Vienna.[79]

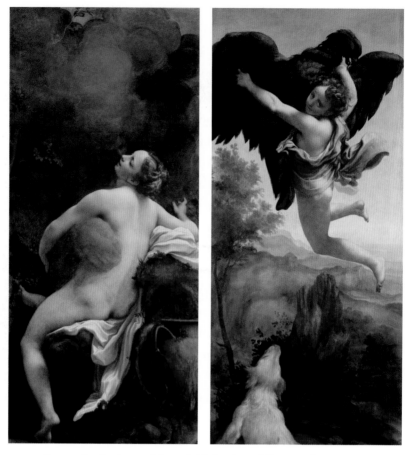

Correggio, *Jupiter and Io* and *Abduction of Ganymede,* ca. 1531

These two, the *Jupiter and Io* and the *Abduction of Ganymede,* became Correggio's most famous works. They are both executed as slim, tall panels, an unusual shape that suggests that they were cut to fit the dimensions of a particular room. Correggio, however, exploits this limitation brilliantly. The lovely nude body of Io is in sharp contrast to the nebulous, almost threatening cloud of Jupiter's manifestation, while her face, lifted high in ecstasy, is a startling expression of feminine

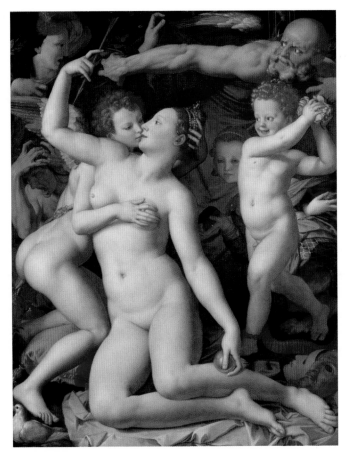

Bronzino, *Venus, Cupid, Folly and Time*, ca. 1540–1545

sensuality that seemingly belongs more to the era of Boucher, rather than the High Renaissance.

Another equally sensuous work—though more by implication than visualization—is the *Abduction of Ganymede*, also in the collection of the Kunsthistorisches Museum in Vienna. It depicts the story of a beautiful shepherd boy in Phrygia being snatched by Zeus in the guise of an eagle, so that he may serve the gods on Olympus as a cupbearer.

Once again exploiting the unique vertical size of the painting, Correggio depicts the youth soaring high on the wings of the eagle, while his nude buttocks and the expectant expression of his face may suggest the homoerotic pleasures that await him in Jupiter's abode. The dramatic foreshortening of Ganymede's body is a variation of a similar figure that Correggio painted in one of his frescoes in the Cathedral of Parma.

With Correggio, the direct influence of Leonardo's style on the art of the cinquecento came to an end. It was replaced by a new movement called Mannerism. While each of these artists we examined—principally Raphael, Giorgione, del Sarto, and Correggio—had some influence on the next generation of artists, the new wave of Mannerist painters drew their principal inspiration from another source: the Sistine Chapel frescoes by Michelangelo.

The result was a new aesthetic that favored sharply etched, elongated forms, painted with painfully bright, even hallucinatory colors, without any regard for the compositional techniques that Leonardo had introduced. Mannerist painters such as Pontormo and Bronzino seemed to delight in chaotic arrangements of their figures, as if to deliberately subvert the compositional harmony and stability introduced by Leonardo.

Consequently, this was the moment when Leonardo's legacy experienced its first major crisis. For all intents and purposes, Italian artists were now turning their backs on the Leonardesque, in order to pursue this strange new aesthetic that seemed to better match the taste of their time. There is very little in Italian Mannerist art that still reminds us of Leonardo's greatest works. So is this the point, roughly in the mid-16th century, when the da Vinci legacy finally came to an end?

By any measure, that is what should have happened—but amazingly, it didn't. The reason is that the legacy of Leonardo was thrown a lifeline from quite a different corner of Italian culture: its literature.

5.
LEONARDO IN THE LITERATURE OF THE 16TH CENTURY

Leonardo's followers failed to attain any broad renown outside their immediate regions, and slowly faded from the artistic scene. Other 16th-century artists who did win fame, such as Giorgione, del Sarto, and Correggio, absorbed Leonardo's revolutionary innovations but fused them with their own highly individual styles. And yet, somehow the Leonardo mystique was kept alive.

Though he wrote voluminously, Leonardo never published any literary works in his lifetime. His notebooks certainly suggest his intention to publish his scientific and anatomical studies, as well as a treatise on painting; but the random arrangement of texts, often interspersed with grocery lists and other reminders, made it difficult to envision a properly organized book. This was further complicated by Leonardo's mirror script—inverted letters, written from right to left—as well as his lack of punctuation, and his use of shorthand. No one knows why he used mirror script. Some have suggested that he may have wanted to safeguard himself against accusations of heresy, since some of his anatomical

observations appeared to contradict official Church teachings.

After Leonardo's death, Melzi tried to organize the various sheets and notebooks in some order, while transcribing many of Leonardo's scribbles into something approximating standard Italian grammar. He was particularly focused on Leonardo's texts for a treatise of painting, as a guide for artists. These and other texts were combined in a compendium known as the Codex Urbinas, which wound up in the Vatican Library. Through copies, this manuscript circulated for more than a century in private collections until it was edited as the *Trattato della pittura* by Raffaelo du Fresne in 1651, both as an Italian edition published in Rome, and a French translation published in Paris. The latter included several illustrations drawn by the renowned Nicolas Poussin, the most important artist of French 17th-century classicism. Most of the other notebooks were not published until the late 19th century, when Jean Paul Richter collated them in a publication entitled *The Literary Works of Leonardo da Vinci*.[80] This was a great loss, for Leonardo's observations of human anatomy could have greatly advanced the practice of medicine in his time.

Fortunately, as the 16th century progressed, a number of authors found themselves compelled to write short biographies about Leonardo. These literary works were immensely valuable in keeping the memory of da Vinci alive, while also, perhaps unwittingly, fostering the growth of what we could call the Leonardo "legend."

Apart from a brief reference to Leonardo in a compendium by Antonio Billi,[81] the first major publication on Leonardo's work was published by Paolo Giovio in 1527, and entitled *Leonardi Vincii Vita (The Life of Leonardo of Vinci)*.[82]

Cover of the 1817 edition of the *Trattato della pittura*, Leonardo's
Treatise on Painting, originally compiled by Francesco Melzi
from Leonardo's notebooks and first published by Raffaelo
du Fresne in 1651

Paolo Giovio

Giovio was a noted Italian physician, historian, and cleric who
studied medicine in Padua before moving to Rome in 1513. He
was appointed by Pope Leo X to the chair of the philosophy
department of the University of Rome, and eventually became
the private physician of Cardinal Giulio di Giuliano de' Medici.

During this period, it is quite possible that he came into contact with Leonardo, who was then attached to the papal court under the patronage of the pope's brother Giuliano.

Soon thereafter, Giovio began to make a name for himself as a historian. He wrote classical treatises such as *De romanis piscibus* (1524) as well as his best-known work, *Historiarum sui temporis libri XLV*, which is a series of biographies of leading men inspired by similar books by Roman authors such as Tacitus and Suetonius. Giovio probably began work on this book in 1549, after a new Pope, Paul III, denied his request to be appointed bishop to his native region of Como. Giovio thereupon moved to Florence, where he remained until his death in 1552.

Giovio's biography of Leonardo, though extremely short (just two pages, including a supplement) is important because of its early date: it was published nearly twenty-five years before the first publication of Vasari's *Lives of the Artists*. At that time, the unfinished fresco of the *Battle of Anghiari* could still be seen in the Hall of the Five Hundred in Florence. Giovio also referred to the Sforza cavallo in Milan, suggesting that fragments of this massive clay horse were still on display. Most importantly, Giovio stressed the scientific underpinning of Leonardo's art, including the "science of optics," with which the artist "founded the principles of the distribution of light and shade down to the most minute details." This is our first published evidence that Leonardo's contemporaries recognized Leonardo's revolutionary approach to modeling by manipulating transitions of light and shade—chiaroscuro—a technique that was rapidly adopted and imitated by leading 16th-century artists, though of course without any attribution.

As a physician, Giovio had great interest in Leonardo's experiments with anatomical dissections, notwithstanding the

artist's lack of medical training. It is because of these autopsies, Giovio argues, that Leonardo developed a superior understanding of the way that "various joints and muscles . . . bend and stretch," though he was apparently under the impression that such cadavers involved only the "corpses of criminals in the medical schools." This, as we know, is not true. In his notebooks, Leonardo describes how he prowled the halls of the Ospedale di Santa Maria Nuova, in search of prospects who might die at any moment. He knew he had to conduct his autopsies while the corpse was still fresh, before decomposition despoiled the organs and made a proper investigation impossible. In a note to himself, dated to late 1507, Leonardo writes how he once came across an old man who was clearly within a hair's breadth of death. Leonardo sat down at his bedside and engaged the patient in conversation. The old man told him he was over a hundred years old and had never had any major illness. Only old age and "feebleness" had got him in the end. "And thus," Leonardo later recalled, "sitting on a bed in the hospital of Santa Maria Nuova in Florence, without any movement or sign of distress, he passed from this life."

A few hours later, he was under Leonardo's knife. "I carried out an autopsy to determine the cause of such a calm death," he continued, and discovered it was a result of the "insufficiency of blood and of the artery supplying the heart and other lower members"—a condition we now know as arteriosclerosis. Leonardo was the first to discover heart disease.

In due course, he moved to another frontier: female cadavers. Few men had as yet ventured to dissect a female, because a woman's chastity was a highly prized virtue in the Middle Ages. A dissection would expose her most intimate parts to the eyes of strangers, compounding the grief of her relatives with

shame. And yet, for Leonardo the anatomy of a woman was the ultimate frontier, the ultimate mystery, for it held the key to the creation of *life*.

Unfortunately, the female body and its attendant secrets of conception and procreation were still jealously guarded by the Church. That is why for much of the 15th century, autopsies could only been be performed by qualified doctors for strictly medical reasons—such as determining the cause of death in times of plague.[83] "By law only unknown and ignoble bodies can be sought for dissection," the physician Alessandro Benedetti wrote in 1497, just ten years before Leonardo's arrival at the Ospedale in Florence. This may have motivated Leonardo to assure Giovio—who was, after all, a physician himself—that he worked only on cadavers of criminals.[84]

In fact, it is conceivable that Leonardo's anatomical experiments are the reason why he caught Giovio's eye to begin with. That said, Giovio recognized that these anatomical and other scientific pursuits may also have served as a powerful distraction. It was precisely because of the time Leonardo spent on the "research of subordinate branches of his art," Giovio writes, "that he only carried very few works to completion." Here was planted the first seed of the *non finito* verdict that haunted the literature about Leonardo for many centuries: the idea that the artist was incapable of completing his works because of the challenges posed by his unbounded imagination. "Owing to his masterly facility," Giovio continues, "and the fastidiousness of his nature, he discarded works he had already begun."[85]

Giovio then proceeds to make brief references to Leonardo's principal works, including the *Last Supper* and the *Saint Anne*. Significantly, he is the first to argue that King Louis XII of France "coveted [the *Last Supper* fresco] so much that he inquired

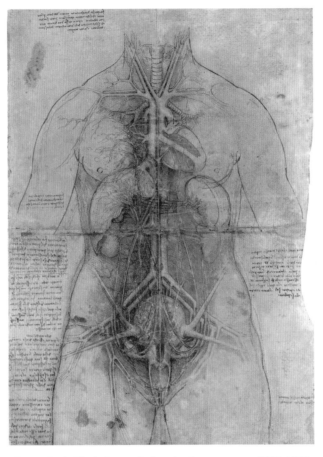

Leonardo da Vinci, *Anatomical study of a woman*, ca. 1508–1510

anxiously . . . whether it could be detached from the wall and transported forthwith to France"—a quest, later repeated by Vasari, that prompted the king to order a life-size copy from Leonardo, which was delivered to the Château de Gaillon in 1509. Giovio also asserts that Louis's successor, François I, "bought [the *Saint Anne*] and placed it in his chapel," an interesting piece of information that was probably relayed to him by either Melzi or officials at the court of François I.[86]

167

Giovio ends his brief biography with another verdict that reverberated through the centuries, that of *nullum celebrem discipulum reliquerit*. Notwithstanding the great crowd of young men who contributed to the success of his studio, he writes, "[Leonardo] left no disciple of outstanding fame"—no one, in other words, who could perpetuate the genius of Leonardo's art in a manner that gave due credit to its master. But as we saw earlier, that judgment is not entirely correct. Though Leonardo's own pupils never "broke through" as celebrity artists of the 16th century, other, more prominent painters were more than ready to learn what they could from Leonardo's art, and incorporate those lessons in the development of their own, highly individual styles.

Anonimo Gaddiano

The next author to write about Leonardo was a mysterious figure who today is known by scholars as Anonimo Gaddiano, the "anonymous Gaddiano." Written between 1536 and 1540, some ten years after Paolo Giovio's work, the book by Anonimo Gaddiano is a broad-brush treatise on art that devotes major sections to the artists of ancient Greece (largely paraphrasing Pliny the Elder), before tackling the work of Florentine artists. Given its focus on Florence and specifically on the benevolent patronage of the Medici, several historians have suggested that the author may have been Bernardo Vecchietti, an influential official at the Medici court of Duke Cosimo I.

That the Gaddiano book is riddled with errors is well known. Its author claims, among other things, that Leonardo painted a portrait of Lisa del Giocondo's son, Piero, even though the child was only eight years old when Leonardo painted the *Mona Lisa*.[87] Gaddiano also misinterprets the chronology of Leonardo's career, placing his work for Sforza *after* his second sojourn in

Florence and subsequent appointment as military engineer in the army of Cesare Borgia. Clearly, Gaddiano was not the scrupulous historian that Paolo Giovio was.

Moreover, it is Gaddiano who first initiates the myth that, given Leonardo's fame during his lifetime, he must obviously have been a beneficiary of Lorenzo de' Medici's exceptional nose for talent. Thus we read, for example, that "in the days of (Leonardo's) youth he was admitted to the company of Il Magnifico, who paid him an allowance and had him work in the garden of Piazza San Marco." At first glance this reference appears to have an aura of truth, since the garden was indeed used by Lorenzo as a workshop of sorts, where young artists helped to repair broken Roman statuary from the Medici collection. But in fact, the garden wasn't acquired until 1480. Leonardo was already twenty-eight years old at that time, a maestro and member of the Florentine guild in his own right. In other words, he would not have been interested in working on bits of statuary with young wannabes in a Medici garden.

It is the same urgent desire to see the hand of the Medici in everything of artistic merit that inspired Gaddiano to spin the tale that "the Magnificent sent him to the Duke of Milan to present, with Atalante Migliorotti, the gift of a lyre, which the latter could play with rare execution."[88] Atalante was indeed an accomplished young musician at the time, who could very well be the sitter of Leonardo's *Portrait of a Musician* from 1490.[89] But this is obviously another piece of Medici propaganda. Leonardo never enjoyed the patronage of Lorenzo de' Medici, for the simple reason that unlike his rivals in Florence, Leonardo was uneducated and unlettered, unable even to write or read Latin. For Lorenzo, who considered himself the leading intellectual of his day, such an artist was not worthy of his attention. Indeed,

what prompted Leonardo to leave Florence for Milan was his inability to penetrate the clannish circles of Medici patronage, exacerbated by the order from the Augustinian monks to stop working on the *Adoration of the Magi*.[90]

Regardless of the motives for Gaddiano's erroneous account, the myth of Leonardo's dispatch to Milan on a "diplomatic mission" was dutifully repeated by Vasari—who, we should remember, was another Medici client. This same story appears in Walter Isaacson's 2017 biography, *Leonardo da Vinci*.

And yet, the work by Anonimo Gaddiano is not without merit. It is this author who, for the first time, confirms that "Messer Francesco de Melzi, a nobleman of Milan" was the executor and beneficiary of Leonardo's will, including "all his money and clothes, books, writings, drawings, instruments, and his treatises on painting, art, and his industriousness." It is Gaddiano who first tells us that Salaì only received half of Leonardo's vineyard, while the other half went to the gardener and servant Battista de Vilanis. Not even Leonardo's remaining funds in his Florentine bank account were to be given to the man who had been his constant companion for most of his youth and adult life. That money, three hundred ducats in all, went to Leonardo's half brothers, despite the fact that these siblings had sued him in order to deprive him of the property that his uncle Francesco had left him.[91]

In addition, Gaddiano cites some Leonardo works that no longer exist, such as an "Adam and Eve in watercolor;" a "head of Medusa with a wonderful and unique collection of serpents," which Vasari also mentions; and "a Leda," not otherwise described, which lends further credence to the idea that Leonardo produced a painting of the subject, rather than merely drawings or cartoons.

Giorgio Vasari

Throughout this book we have often referred to the publication that anchored Leonardo's reputation—and those of many other artists of the Renaissance—known as *Lives of the Most Excellent Italian Painters, Sculptors, and Architects, from Cimabue to Our Times*, written by the 16th-century artist and author Giorgio Vasari. Vasari was born in Arezzo, a town in Tuscany, in 1511, and eventually moved to Florence at age sixteen. Here he joined the studio of Andrea del Sarto, and fell under the spell of Michelangelo, who greatly influenced the development of Vasari's own style as an artist. A visit to Rome in 1529, at age eighteen, sealed his devotion to both Michelangelo and Raphael as the leading artists of the High Renaissance.

Back in Florence, Vasari became a client of the new authoritarian Medici regime led by Duke Cosimo I. He wholeheartedly embraced the intense propaganda cult that Cosimo initiated to seek legitimacy for his rule. The purpose of this propaganda sought to sway a wary Florentine public that had long prided itself on being one of the few "democratic republics" on the Athenian model in Europe. But the political ramifications of Medici rule did not seem to bother Vasari very much. Today considered an artist of only mediocre talent, he was nevertheless highly praised by his contemporaries as a true Renaissance man, adept in painting, sculpture, literature, and architecture.

Indeed, the term "renaissance"—*rinascità* in Italian—was first coined by Vasari. For him, the achievements of Italian artists in the 15th and early 16th centuries amounted to nothing less than a revolutionary "rebirth" of the great artistic traditions developed by the Greeks and particularly the Romans. He is also responsible for proposing the term "Gothic" for the architectural and painterly styles that preceded the Renaissance, since he believed

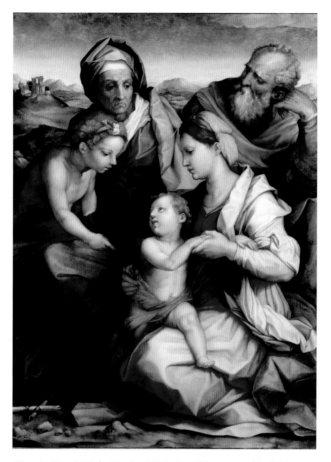

Giorgio Vasari, *Holy Family*, 1530s. Possibly executed in del Sarto's
studio, the painting betrays the strong influence of Michelangelo's Sistine Chapel.

that this creative tradition was nothing short of barbaric, and
deeply associated with native German designs.

His greatest achievement as an artist was the design of several
architectural projects developed for Cosimo I. This included his
design for the Palazzo degli Uffizi, literally the "office complex,"
to house the new Cosimo administration, featuring his masterful
loggia facing the Arno River. This ingenious design created one

of the first genuine Renaissance spaces in Florence. Vasari also renovated the Santa Maria Novella and the Santa Croce, and built an octagonal dome for the basilica of Pistoia.

It is generally believed that Vasari began his research for his book in the late 1530s, when many artists, their relatives, and eyewitnesses of the works he planned to write about were still alive. It is possible, for example, that he sat down with Lisa del Giocondo, the widow of Francesco del Giocondo and the model for the *Mona Lisa*, who was then still living in the family house on the Via della Stufa. This is the moment when Vasari saw what is probably the first version of the *Mona Lisa* that Leonardo painted, which today is known as the *Isleworth Mona Lisa*.[92] As he later wrote:

> The eyes had their natural luster and moistness, and around
> them were the lashes and all those rosy and pearly tints that
> demand the greatest delicacy of execution. The eyebrows were
> completely natural, growing thickly in one place and lightly
> in another and following the pores of the skin. The nose was
> finely painted, with rosy and delicate nostrils as in life. The
> mouth, joined to the flesh-tints of the face by the red of the
> lips, appeared to be living flesh, rather than paint. On looking
> closely at the pit of her throat, one could swear that the pulses
> were beating.[93]

It is improbable that Vasari could have produced such a detailed account of the portrait without seeing it himself, up close. Given that the *second* version—which now hangs in the Louvre—was already in France at the time, in King François's new royal palace at Fontainebleau, he must have seen another version of the *Mona Lisa*. The *Isleworth Mona Lisa* is the most

obvious candidate, since Vasari's description matches this painting closely.

It is simply inconceivable that any other artist—including one of the Leonardeschi from Leonardo's first studio in Milan—could have achieved such marvelous naturalism as early as 1503, when the portrait was begun. That Vasari could have seen this *Earlier Mona Lisa* during his visit to Lisa del Giocondo in the late 1530s or early 1540s has been demonstrated by the Florentine historian Giuseppe Pallanti. He has discovered, using the parish records of the San Lorenzo in Florence, that Lisa didn't die until July 15, 1542, at the convent of Sant'Orsola in Florence, where her youngest daughter, Suor Ludovica, lived as a nun.[94]

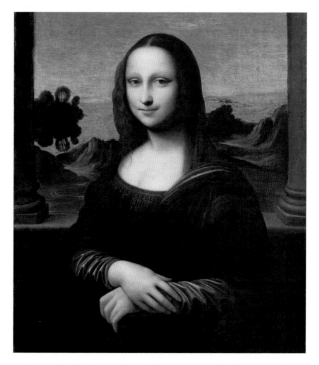

Leonardo da Vinci, *Isleworth Mona Lisa*, also known as the
Earlier Mona Lisa, 1503–1507

In the subsequent years, Vasari continued to travel widely, not only for commissions but also to research his book. He attempted to visit all the locations where prominent works—such as frescoes—were still on display. In his book, hardly a reference is made to a painting or a sculpture without a detailed description of its exact location; indeed, this is what makes the book so valuable for art historians.

Among other sites, Vasari visited Milan, where he saw certain drawings by Bramantino, as well as the tomb of Gaston de Foix in the Church of Santa Marta, designed by Agosto Milanese.[95] While in Milan, he must have been in touch with representatives or royal purveyors of the French king, since the city was still under French rule at the time. During these conversations, Vasari probably learned that three of Leonardo's principal works—the *Saint Anne,* the *St. John the Baptist,* and the *Mona Lisa*—were now in the royal collection in France. This produced the controversial paragraph in his book that has kept art historians guessing about the "real" *Mona Lisa* for decades:

> Leonardo undertook to execute, for Francesco del Giocondo,
> the portrait of *Monna Lisa,* his wife; and after toiling over it
> for four years, he left it unfinished; and the work is now in the
> collection of King Francis of France, at Fontainebleau.[96]

What is so striking about this paragraph is Vasari's comment that the portrait was "unfinished." Of all of Leonardo's works, the *Mona Lisa* is undoubtedly the most polished and finished painting—though the *Isleworth Mona Lisa* is not, as witnessed by the plain background. This also argues for the theory that Leonardo painted two versions of the *Mona Lisa.*

Among the people that Vasari interviewed for his book was

Francesco Melzi, then greatly advanced in age. Melzi showed him Leonardo's notebooks, and Vasari was struck by the way that "Francesci cherishes and preserves these papers as relics of Leonardo." He also describes some other papers that were "in the possession of a Milanese painter . . . which discuss painting and methods of drawing and coloring." This must refer to Leonardo's *Treatise on Painting*, and Vasari adds that "this man came to Florence to see me with the object of having the work printed, and later he went to Rome to put this into effect; but I do not know what happened to him." This suggests that at least one attempt was made to print Leonardo's *Treatise* in the 16th century, though as we saw, the work was not published until 1651.

It is safe to say that Vasari's biography of Leonardo da Vinci—one of the most extensive chapters in this truly encyclopedic book—ranks as one of the most influential publications about the life of the artist. Well researched and well written—though with a typical bent for hyperbole, which could have been a reflection of the narcissistic culture around Cosimo I—Vasari's *Lives* was first published in Florence in 1550. It has served ever since as the primary source for the life and art of Leonardo, and continues to be cited and parsed in modern scholarship today, even though many scholars take issue with Vasari's occasional disregard for facts and his love of gossip. What's more, modern critics deplore his obvious favoritism toward artists from Florence and Rome at the expense of those from other regions, such as Venice.

Be that as it may, *Lives* is a fascinating read. Vasari presents Leonardo as one "marvelously endowed by heaven with beauty, grace, and talent in such abundance that he leaves other men far behind"—a man, in short, of "tremendous breadth of mind." At the same time, he strongly abets and reinforces the *non finito* judgment that originated with Paolo Giovio. As Vasari puts it:

"The truth . . . is surely that Leonardo's profound and discerning mind was so ambitious that this was itself an impediment; and the reason he failed was because he endeavored to add excellence to excellence, and perfection to perfection." This is a more damning judgment by far than the analysis offered by Giovio or Gaddiano. It suggests that Leonardo's inability to realize his visions was rooted in their innate impracticality, as well as his inability to manage the distractions that continuously pulled him away from the work at hand. "As our [Francesco] Petrarch said," Vasari adds, "the desire outran the performance," referring to the 14th-century Italian poet Francesco Petrarca.

Giorgio Vasari, *Lives of the Artists*, 1568 edition

In Vasari's eyes, Leonardo's inability to finish what he started was particularly detrimental for his work as an artist. "Clearly, it was because of his profound knowledge of painting that

Leonardo started so many things without finishing them," he writes, "for he was convinced that his hands, for all their skill, could never perfectly express the subtle and wonderful ideas of his imagination."

Vasari then continues to catalog the works that Leonardo was reputed to have made in roughly chronological order. Most intriguing is his argument of why Leonardo decided to abandon the city of his birth for an uncertain future in Milan. As we saw, Gaddiano claimed that it was all due to the benevolence of Lorenzo de Medici, and that the Magnificent sent him to the Duke of Milan to present, with Atalante Migliorotti, the gift of a lyre, which the latter could play "with rare execution."[97] In Vasari's version, the roles are reversed. It is now Leonardo who is renowned for his performance as a musician and lyre performer. In fact, the lyre in the story has become "a strange and novel design," mostly of silver, which Leonardo is supposed to have fashioned himself. This, then, compels Duke Ludovico Sforza to do Leonardo "the honor of inviting him to visit Milan so he could hear him play the lyre, an instrument of which the new duke was very fond."

There are many other problems with this strange paragraph, not in the least because it is set "in the year 1494," when according to Vasari, "Ludovico Sforza took over the state." As a matter of fact, Leonardo left for Milan in 1482, twelve years before this reputed lyre performance would have taken place. And while it is true that Sforza became the official duke in 1494, upon the death (or murder) of the legitimate pretender, his nephew Gian Galeazzo Sforza, he had actually staged a coup d'etat as early as 1481, and had been ruling as "regent" and de facto duke ever since.

Again, the urgent need to present the Medici in the best possible light, certainly at the court of the notoriously thin-skinned

Cosimo I—given that the Medici had themselves seized power by overthrowing the legitimate government of Florence in 1531—must have inspired this imaginary tale. The truth is quite different: as a young artist Leonardo was consistently cold-shouldered by Lorenzo de Medici and his circle, which prompted him to flee to Milan in the hope of finding a more generous and welcoming patron.[98]

As he comes to the end of Leonardo's biography, Vasari confronts the urgent question of the master's legacy. On the one hand, he admits that Leonardo's "name became so famous that not only was he esteemed during his lifetime, but his reputation endured and became even greater after his death," thus suggesting that the Leonardo mystique was still alive in the middle of the 16th century, despite the paucity of his works then on display. But on the other, Vasari finds himself compelled to qualify Leonardo's fame, particularly as it relates to his limited output and his tenuous relationship with the Church and Christian religion altogether—still a volatile issue in the mid-cinquecento. In the 1550 edition of his book, Vasari writes that Leonardo "could not be content with any kind of religion at all, considering himself in all things much more a philosopher than a Christian." Though the passage was omitted in the second edition of 1568, Vasari was probably telling the truth insofar as the Leonardo of Florence and Milan was concerned. But the author then tries to exonerate his subject. As Leonardo approached death, Vasari writes piously, "he earnestly wished to learn the teaching of the Catholic faith, and of the good way and holy Christian religion; and then, with many moans, he confessed and was penitent . . . and [took] devoutly the most holy Sacrament, out of his bed." This is probably Vasari's attempt to preempt any charge that some of Leonardo's statements in his notebooks could be considered heretical. However, in light of

the elaborate Catholic proceedings that Leonardo specified in his will, it rings true.

The most dramatic impact of Vasari on Leonardo's legacy, however, was still to come. In the 1540s Vasari was commissioned to enlarge the Salone dei Cinquecento (the Hall of the Five Hundred), and to decorate it with frescoes for the purpose of extolling the blessings of Medici rule. This hall, as we will remember, still contained Leonardo's unfinished fresco for the *Battle of Anghiari*, which was attracting artists from all over Europe. After some consideration, Vasari took the unprecedented step of whitewashing this fresco, so that he could paint over it with his own cycle of depressingly repetitive murals. These are the frescoes that tourists to the great hall of the Palazzo della Signoria—now called the Palazzo Vecchio—see today.

A persistent theory claims that out of respect for the old master, Vasari might have found a way of "preserving"

The Hall of the Five Hundred in the Palazzo della Signoria (now known as the Palazzo Vecchio). Leonardo's fresco is believed to have been located at the far right.

Leonardo's masterpiece underneath his own mural. Precisely how Vasari could have accomplished this is not known. Using NASA-developed surface-penetrating radar and samples taken from underneath the Vasari fresco, the Italian scholar Maurizio Seracini announced in March of 2012 that he had discovered a so-called "curtain wall." Behind this wall, Seracini claimed he had found pigment fragments that are consistent with certain ochre-brown base paints in the *Mona Lisa*. This is where the investigation ended; after Seracini's methods came under attack, the Italian government forbade any further invasive techniques that could imperil Vasari's fresco. Perhaps some noninvasive techniques will be developed in the future to determine whether remnants of Leonardo's masterpiece still exist, though most scholars doubt that this would be the case. At least as far as the *Battle of Anghiari* is concerned, that part of Leonardo's legacy is forever lost.

Other References in 16th-Century Literature

Vasari's *Lives* firmly placed Leonardo da Vinci in the consciousness of Italian cinquecento culture. So successful was the book that Vasari prepared a second edition, released in 1568, thirteen years after the initial publication. The encyclopedic breadth of the book became a template for similar efforts in later centuries. In Holland, Karel van Mander wrote *Het Schilder-Boeck* in 1604, which not only contained a Dutch translation of Vasari's *Lives* but also documented the biographies of a number of Dutch artists. In Germany, Joachim von Sandrart wrote *Die Deutsche Akademie* (1675), chronicling leading German painters of his era, while in England the English physician and amateur art historian William Aglionby produced a similar book, *Painting Illustrated in Three Diallogues* (sic) in 1685. This book featured a selection from

Vasari's *Lives* while also including Northern European artists such as Dürer, Holbein, Rubens, and van Dyck, much beloved in Britain, as well as English painters including Riley and Gibbons. Spain, which had become an important center of art in the wake of the Counter-Reformation, also produced its own "Vasari" in the form of Antonio Palomino, who wrote a book about Spanish artists in 1724.

In Italy proper, however, many authors may have been intimidated by Vasari's success. No Italian historian tried to undertake a comprehensive new biography of Leonardo da Vinci until 1804. But incidental references were made, notably by two authors of the latter part of the 16th century: Matteo Bandello and Paolo Giovanni Lomazzo.

Matteo Bandello was a nephew of Vincenzo Bandello, the prior of the Dominican monastery of Santa Maria delle Grazie, who supervised Leonardo's *Last Supper* project. In 1495, at age fifteen, Matteo was placed in the care of his uncle, and soon came into contact with the Leonardo, who was then laboring on a large fresco in the convent's refectory. In his book *Novelle*, published in Lucca in 1554, Bandello describes how he observed Leonardo "hastily mounting the scaffolding," whereupon the master worked "diligently until the shades of evening compelled him to cease, never thinking of taking food at all, so absorbed was he in his work." And yet, at other times the young Matteo was astonished to see Leonardo come and stand before the unfinished fresco "for a few hours . . . without touching his picture . . . with folded arms, gazing at his figures as if to criticize them himself."[99] This story further added to the legend of Leonardo's famous obsession with verisimilitude, as well as his slow, deliberate way of trying to match the wondrous ideas of his imagination in paint.

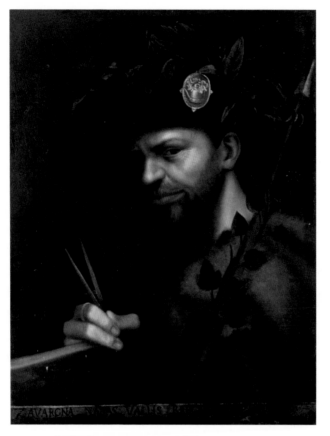

Paolo Giovanni Lomazzo, *Self-Portrait*, ca. 1565

Bandello's *Novelle* became incredibly popular. Modeled on Boccaccio's *Decameron*, the book was a collection of stories, gossip, and risqué tales, notwithstanding the fact that the author was a priest and later became the bishop of the town of Agen. What's more, the author freely borrowed material from other sources, including the Roman historian Livy, Dante's *Purgatory* (the second part of his *Divine Comedy*), and Petrarch's *Triumph of Love*.

That the book was widely read is attested by William Shakespeare, who used the *Novelle* as a source for his plays

Twelfth Night, Cymbeline, Much Ado about Nothing, and even *Romeo and Juliet.* Thus, while the story of Leonardo painting the *Last Supper* was less than a page long, it was nonetheless influential in sustaining the legend of the master, perfectly in parallel with other developments that we shall see in the next chapter.

Paolo Giovanni Lomazzo, by contrast, was not an author or a cleric but an artist who was active in the second half of the 16th century. Born in Milan in 1538, he trained in the studio of Gaudenzio Ferrari and Giovan Battista della Cerva, where he quickly absorbed the dominant styles of Lombardy at the middle of the cinquecento. Some of his works, including *Madonna and Saints*, reveal a strong influence from Venetian artists such as Titian and Tintoretto, though with a sensitivity to optical effects that borrows freely from both Leonardo and Andrea del Sarto.

Lomazzo achieved such success that in 1562, the Milanese sculptor Annibale Fontana produced a medal showing the artist as the protégé of Fortune. This came on the heels of what was probably his most ambitious project: to paint a copy of Leonardo's *Last Supper* for the refectory of the Santa Maria della Pace in Milan. The project gave the artist a deeply intimate understanding of Leonardo's thought processes, style, and technique, which served him well in the years to come. Lomazzo's fresco was transferred to canvas in 1880 and hung, together with other notable copies, in the refectory of the Santa Maria delle Grazie, in close proximity to Leonardo's original. Regrettably, this and other copies in the hall were lost in World War II.

Soon after Lomazzo completed this fresco, disaster struck: he began to lose his eyesight. Determined to stay active in his field, he decided to switch hats and become an art historian, producing two academic treatises that set a new standard for art criticism in Italy. Whereas Vasari's stories were leavened with anecdotes

of often-questionable origin, Lomazzo committed to document the development of Renaissance art in Italy on a sound scholarly basis. His first work, *Treatise on the Art of Painting, Sculpture and Architecture*, also known as *The Paragone*, was published in 1584. In it, Lomazzo made what was perhaps the first attempt to establish a systematic inventory of art theory, aesthetics, and techniques related to the Renaissance.[100] As such it had a profound influence on the development of academic art in the Baroque. A second book, *The Ideal Temple of Painting* of 1590, went even further and proposed an analysis of the role of individual genius in the development of new movements in art.

In one chapter of his *Treatise*, Lomazzo rekindled the debate, initiated by the humanist Leon Alberti a century before, about which of the creative arts is superior—a discussion captured by Horace's famous dictum *ut pictura poesis*—"as is painting, so is poetry." It reflected the urgent struggle by Early Renaissance painters to cast off the medieval stigma of being mere artisans with dirty fingers, and to aspire to the same lofty status that Florentine poets such as Petrarch and Dante enjoyed.

In one chapter of his *Treatise*, Lomazzo quotes Leonardo da Vinci on the subject, citing his unpublished *Treatise on Painting*, which he most likely consulted in Melzi's collection. "Leonardo states," Lomazzo wrote, "that the more an art requires fatigue and sweat, the lower it is and less to be valued. . . . This is clearly the case with Sculpture, which is all dependent on marble, iron, and other matters of bodily labor and noisy activity; all things which hinder study." Therefore, Lomazzo continues, still quoting Leonardo, it should be evident that sculpture "is clearly inferior to Painting, which is instead an art well far from toil and rough materials and far more apt to express the forms of whatsoever can be imagined."[101]

Both Bandello and Lomazzo thus emphasize Leonardo as a theoretician, rather than an artist of splendid works. Whereas Vasari interpreted Leonardo's interest in intellectual and scientific pursuits as a fatal distraction from his true calling as a painter, Lomazzo presented Leonardo in an entirely different light: as an authority on the theory of art, whose judgment and observations continued to have great relevance for Italian painting. Fatefully, however, Lomazzo still conferred the by now inevitable *non finito* judgment: "Whenever he began to paint, it seemed that Leonardo trembled, and he never finished any of the works he commenced because, so sublime was his idea of art, he saw faults even in the things that to others seemed miracles." This paragraph is so similar to Vasari's that it seems largely inspired by *Lives of the Artists*, even though some historians continue to claim that Lomazzo never read the book.

Lomazzo did, however, add one other intriguing detail about Leonardo that had considerable impact on the modern debate about the *Mona Lisa*. While discussing exemplary portraits of women in his *Treatise*, Lomazzo wrote:

> Among these [portraits], we see those by the hand of
> Leonardo, adorned in the guise of spring, like the portrait of
> the Gioconda, and of the Mona Lisa, in which he marvelously
> expressed, amongst other features, the mouth in the act
> of smiling.[102]

The use of the conjunction "and" in this phrase does not seem to be a grammatical error but a deliberate interpolation, given the use of the plural in "which:" "*come il ritratto della Gioconda, e di Mona Lisa, ne' quali ha espresso tra le altre parti mara Vigliosamente*" Lomazzo was an extremely scrupulous and

dedicated historian who strove for the greatest possible accuracy in his research. To suggest that Lomazzo could commit as grave a blunder as to erroneously credit Leonardo with two, rather than one, *Mona Lisa* portraits, as a recent publication has argued, is difficult to accept.[103]

The most obvious solution is that there were indeed *two* autograph portraits of the *Mona Lisa,* and that both Lomazzo and his source, Francesco Melzi, were sufficiently informed to distinguish Leonardo's hand from any of the *Mona Lisa* copies that soon entered circulation. The term "Gioconda" is probably inspired by the French *La Joconde,* as the Louvre *Mona Lisa* came to be known in France, and in fact still is today.

We have dwelled on this subject at some length for one simple reason: in the centuries to come, the *Mona Lisa* became a vital factor in the growing legend of Leonardo da Vinci—a subject to which we will turn in Chapter 7.

6.

THE LEONARDO LEGEND AND THE ART OF ENGRAVING

Anyone who visits Rome today is sure to head toward Vatican City, there to admire the city's most prominent landmark: the imposing St. Peter's Basilica, with its pristine dome designed by Michelangelo. But what few visitors realize is that the construction of St. Peter's was one of the fuses that lit the Protestant Reformation in Europe.

The reason is that the enormous effort required to build this massive church—which consumed architects from Bramante and Michelangelo to Maderno and Bernini for more than 120 years—was also a fantastically expensive undertaking. It was, in fact, well beyond the financial ability of the Renaissance papacy, which was busy with military exploits while underwriting scores of other art projects. That meant that the papal court was perennially in want of cash.

In fact, for much of the Middle Ages the Church had found itself in growing conflict with the secular powers of the Holy Roman Emperor, with the latter steadily gaining power at the

Vatican's expense. The papacy fought back by flexing its financial muscle, raising funds by selling important benefices, such as estates, offices, and even the sees of bishoprics. When in the latter part of the 15th century, a small group of powerful Roman families—principally the della Rovere, the Borgia, and the Medici—gained control of the College of Cardinals through threats and bribery, corruption in the Holy See became endemic. Soon, it became clear that the papacy's vast expenditures in the military and the arts went well beyond what it could expect in income, largely dependent as it was on contributions from the faithful in the same countries where it competed for power with the secular rulers. This drove the need to find new financial instruments, some of which would make modern Wall Street titans blush. In 1492, shortly after his coronation, the Borgia pope Alexander VI came up with an especially outrageous investment vehicle: the sale of indulgences.

In theory, an indulgence was an instrument that, while not granting a Christian *forgiveness* of his sins, purported to *shorten* the penance that he would have to suffer for his misdeeds, either during his lifetime or during his stay in purgatory. Purgatory, which features so prominently in Dante's *Divine Comedy,* was an ingenious product of medieval Christian theology. It surmised that there was an intermediate state between death and admission to heaven. By inserting this probationary period between a believer's life and his expectation of a heavenly reward, the Church developed a very powerful instrument with which it could exert immense control over the faithful. Over the years to come, the clergy carefully abetted the public's fear of purgatory, even suggesting that no one quite knew how long one was destined to remain in this spiritual limbo. Some texts spoke of hundreds, even thousands of years! As a result, the European populace

harbored a strong anxiety about their afterlife prospects, and eagerly sought to minimize what they believed was an inevitable stay in this dark and scary place.[104]

The Renaissance popes were well aware of this fear, and decided to exploit it by selling indulgences that promised to limit one's stay in purgatory, rather than granting relief on the basis of good deeds. Once it was launched by Alexander VI, the merchandising continued under Pope Julius II for the stated purpose of funding the construction of St. Peter's Basilica. Leo X, who was in even greater need of funds, even expanded the papal sales network by assigning a large number of special commissioners authorized to sell the documents throughout Europe. One of these vendors was a Dominican friar named Johann Tetzel, who in 1516 began to offer indulgences—fatefully, as it turned out—for sale in Germany.

A priest who taught theology at the University of Wittenberg happened to observe this commerce, and was outraged. His name was Martin Luther. Why does the pope, Luther asked, whose wealth today is greater than the wealth of the richest Crassus, build the basilica of Saint Peter's with the money of poor believers? Why can he not use his own resources? In response, Luther developed a manifesto, the *Ninety-Five Theses,* that attacked indulgences as theologically invalid. Only God had the power to remit sins, Luther argued, not the pope. To underscore his point, Luther nailed his *Theses* to the door of the castle church at Wittenberg.

This was the beginning of the Reformation, which ultimately tore the seams of the Church in Europe, and split the continent into a largely Protestant North and a predominantly Catholic South—a situation that largely exists to this day. It also led to an era of religious wars, including the notorious Thirty Years War,

A Renaissance printing press from the late 16th century

which by some estimates killed off between 20 and 30 percent of the population in Central Europe.

What does this have to do with Leonardo's legacy? The answer is simple: the religious conflict of the 16th century was not only fought by the sword, but also with the pen and the brush, boosted by the development of the printing press. Until the 15th century, books were essentially written and bound originals, laboriously copied by hand from their sources, as had been the case since Antiquity. But in 1450, a German goldsmith known as Johannes Gutenberg developed a special mold to rapidly produce movable metal type in a uniform style—what today we call a "typeface." The result was the Renaissance printing press. It revolutionized the distribution of religious and political ideas, and broke the monopoly on knowledge held by the titled and wealthy classes.

One press could produce some thirty-five hundred pages a day, enabling publishers to produce both books and pamphlets

Albrecht Dürer, *St. Jerome in His Study*, engraving of 1514

cheaply by the thousands. According to some estimates, by 1500—only fifty years after the invention of the printing press—there were already some twenty million printed books in circulation. As a result, the Reformation spread more rapidly than any other previous movement in European history. For example, John Calvin's book *Institutes of the Christian Religion*, published in a French edition in 1541, was a key factor in establishing Calvinism in French-speaking Geneva and its francophone region.

The first printed books were relatively crude affairs that harked back to models of handwritten manuscripts. But soon, printed books began to incorporate another German invention from the 15th century, the engraving. Middle Age goldsmiths had long used sharp tools to adorn metal objects, such as parts of a harness, with decorative motifs.

Around the 1430s, this technique led to the invention of copperplate engraving, whereby the artist could create a drawing by incising it in a copper plate with a burin, a sharp cutting tool. Once the design was finished, the engraver used a press to push ink into the incisions, and then reproduce the image on the plate on any number of paper sheets. Copper engraving held a major advantage over an older form of printing, the woodcut, for it allowed the artist to produce images with much greater precision and detail. Scores of artists, not only goldsmiths but also North European painters, such as Martin Schongauer, Albrecht Dürer, and Lucas van Leyden, discovered that this process enabled them to produce high-quality reproductions of their art for sale, thus greatly multiplying their revenue.

Dürer in particular became extremely adept at this technique, as evidenced by his marvelously detailed engraving of *St. Jerome in His Study* of 1514. In the process, Dürer perfected the hatching or crosshatching technique, which allows an engraving to suggest shading by creating highly concentrated areas of thin lines, which the human eye interprets as a darker tone.

Publishers soon recognized the immense potential of printed books that contained illustrations as well as text. For the first time, this allowed the dissemination of famous works of art throughout Europe. The impact of this breakthrough can scarcely be imagined. Heretofore, the only way an artist outside Italy could see the work of painters such as Michelangelo, Raphael, or Leonardo da

Vinci was to physically travel to Italy, which involved the dangerous crossing of the Alps. By the 17th century, however, a great number of art books were in circulation throughout Europe. This allowed many artists, including the Dutch artist Rembrandt van Rijn, to absorb the stunning developments of Italian Baroque, even though they never set foot in Italy.

Last Supper Prints in Italy

The development of the printing and engraving press is crucial for the legacy of Leonardo da Vinci because, for reasons never fully explained, one of the earliest engravings to be published in Italy depicts Leonardo's *Last Supper*. According to a recent study by Pietro Marani, the first engraving of the *Last Supper* was completed in 1500, when the paint of the fresco was barely dry.[105] This was a print known as *The Last Supper with a Spaniel,* possibly executed by Giovanni Pietro da Birago, and so named because the artist decided to add a spaniel in the right bottom corner of the work. The print was immediately distributed in Northern Italy in three other engraved versions, which prompted a veritable wave in print publishing. As Leo Steinberg wrote, "In the immediate demand for copies, and in the promptness with which the demand was met, the case of Leonardo's *Last Supper* is the first of its kind."[106]

A close look at Birago's print reveals why the *Last Supper* lent itself so well to the technological possibilities of early 16th-century engraving. Apart from its great fame, the work featured large, monumental figures in a relatively simple setting that could be translated onto copperplate with relative ease. Leonardo's trademark chiaroscuro and sfumato, which would have been difficult to capture with the state of copper engraving at the time, are relatively absent in the *Last Supper*; indeed, the scene is lit

with fairly uniform lighting throughout. Similarly, there are few small details in the garments or architectural setting, with the exception of the plates, glassware, and bread on the table. In sum, the painting did not tax the early 16th-century engraver as much as other Leonardo works might have.

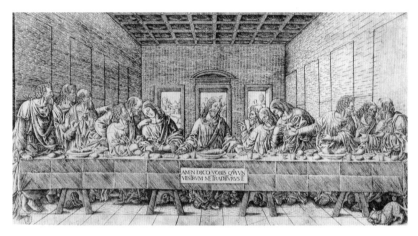

Giovanni Pietro da Birago, *The Last Supper with a Spaniel* (after Leonardo), ca. 1500

Of course, the overriding motive for creating such prints was the virtually instantaneous popularity of the work, given the highly original treatment of its subject. Most depictions of the *Last Supper* in Northern Italy show the moment when Christ breaks bread as described in the Gospel of Mark, thus instituting the sacrament of the Eucharist. As celebrated during Mass, the Catholic doctrine of transubstantiation posits that during the consecration, the substance of bread and wine is transformed into the body and blood of Christ. As a result, Italian *Last Supper* paintings illustrated the most sacred moment in the Gospels except for the Crucifixion, and consequently needed to correspond to a strict iconography through many centuries of Byzantine, medieval, and early Renaissance art.

Leonardo, however, recognized the key problem with this iconographic convention: while Christ is breaking bread, all of the other twelve figures have very little to do. This is why in the versions by Ghirlandaio, Castagno, and other quattrocento artists, the Apostles are essentially passive actors, inevitably cast in various poses of contemplation. Some observe the actions of Christ in awe, while others raise their eyes heavenward, or appear to mutter to those seated closest to them. Such a treatment militated against Leonardo's desire to capture the "motions of the mind" of his characters, and to try to animate his scenes with the dynamic complexity of human response. His solution, therefore, was not to choose the moment of the Eucharist as described in Mark at all, but to turn to an entirely different scene in this episode, as provided by the Gospel of John. In this Gospel, Jesus washes the feet of his disciples, and then, when everyone is back at the table, makes a shocking announcement:

> "Very truly, I tell you, one of you will betray me." The
> disciples looked at one another, uncertain of whom he was
> speaking. One of his disciples—the one whom Jesus loved—
> was reclining next to him; Simon Peter therefore motioned
> to him to ask Jesus of whom he was speaking. So while
> reclining next to Jesus, he asked him, "Lord, who is it?" Jesus
> answered, "It is the one to whom I give this piece of bread
> when I have dipped it in the dish." So when he had dipped
> the piece of bread, he gave it to Judas son of Simon Iscariot.
> After he received the piece of bread, Satan entered into him.
> Jesus said to him, "Do quickly what you are going to do."

(John 13:21–27)

This account, so imbued with dramatic tension, served as the catalyst for Leonardo's composition. In his version of the Last Supper, the shock of Jesus' declaration explodes outward from the center and provokes the men around Christ to erupt in indignant denials and debate. Accordingly, the painting gave Leonardo the opportunity to do what he had first attempted with *The Adoration of the Magi*: to depict the full repertoire of human emotions in response to the message of Christ.

It is the radical quality of this message, and its stunningly realistic depiction using larger-than-life figures, that made such a deep impression on Leonardo's contemporaries. It explains why within mere decades, other monasteries insisted on having a copy of this magnificent work in their refectories, and why engravers rushed to publish this revolutionary painting in print.

In the process, Leonardo's *Last Supper* became an iconic work. It is as if this painting, with its expressive gestures and dramatic composition, struck a deep chord in the collective European sense of what Christendom was about. In fact, the *Last Supper* may have been a critical factor in the growing popularity of reproductive engraving as a medium in itself, since as Steinberg suggests, "The need (was) instantly felt far and wide to have a version of this picture always at hand." As such, he adds, "We know of no earlier instance where the design of one monumental painting, locked in its proper place, was almost immediately disseminated on paper."[107]

Because of their inherently fragile nature, very few of the designs used by these engravers have survived. The Louvre has several, mostly in very poor condition. Some appear to have been made directly from the fresco, whereas others seem to have been made from painted copies. Some are drawn, while a later technology, known as an etching, enhanced the line drawing with

an acid wash in an attempt to recreate Leonardo's dramatic cast of shadow and light.

The *Last Supper* in Northern Europe

As its popularity spread, the *Last Supper* also found its way into an entirely different medium: the tapestry. This art form was the preserve of Flemish weavers, though their designs could be obtained from artists throughout Europe. Raphael's famous seven cartoons of scenes from the Gospels and Acts of the Apostles, for example, now in the Victoria and Albert Museum in London, were destined for tapestries to be produced by weavers in Brussels. Such tapestries were among the few Gothic formats that continued to enjoy favor in the Renaissance, perhaps because of their dual purpose: they retained the warmth in a room (an important consideration in Northern Europe) while offering a rich decorative scheme in color. What's more, they could be rolled up and moved quite easily. Especially when enriched with gilt thread, tapestries often served in the 16th century as the dominant decorative element in the homes of the affluent elite, both in the religious and secular spheres.

Tapestries were nonetheless technically complex products that required a close collaboration of artists, dyers, and weavers. Flanders, which had always enjoyed a dominant role in the trade of dyed wool, therefore became a natural center of tapestry manufacturing, centered in Brussels. Partly under the influence of the *Last Supper*, however, the design of tapestries changed. The miniature-like depiction of multiple scenes on one field, the dominant format in the Middle Ages, was abandoned in favor of large designs in which a single composition unfolded across the full breadth of the work. Thus, with its monumental composition and strong horizontal sweep, the *Last Supper* was ideally suited

for tapestry development. Moreover, it was a perfect motif for a nobleman's or bishop's banqueting hall.

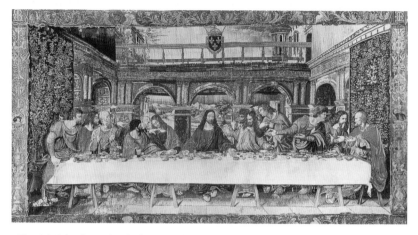

Flemish School or School of Fontainebleau, *The Last Supper* after Leonardo, ca. 1525

The first *Last Supper* tapestry was commissioned by King François I, the same king who had presented Leonardo with a property and stipend in Amboise for his retirement. As it happened, the king did not intend to use the tapestry for his own pleasure, but as a gift to Pope Clement VII, to mark the wedding of his niece, Catherine de' Medici, to François's son, the future King Henri II. This tapestry, as shown here, is currently in the collection of the Vatican Museums in Rome. While the arrangement of the Apostles is largely accurate, the artist chose an entirely different setting for the scene. He added a Renaissance loggia surmounted by a coat of arms with the fleur-de-lis, the emblem of the French Royal House. This tapestry was then copied in other woven versions, presumably using the same source cartoon.

The fame of the *Last Supper*, avidly distributed by presses throughout Europe, then led to the next stage of Leonardo's

legacy, when artists outside Italy got involved in trying to capture the timeless quality of Leonardo's *Last Supper*.

This phase began in 1600, when a young Flemish artist, Peter Paul Rubens, decided to make a journey to Italy. He had enjoyed a classical education in the humanities and had trained under several of Antwerp's leading artists of the time. He first traveled to Venice, where he fell under the spell of the bright palettes of Titian and Veronese, before moving on to Mantua and the court of Duke Vincenzo I Gonzaga. With the duke's support, he continued on to Florence and Rome, where he immersed himself in the works of Leonardo, Michelangelo, and Raphael. One of the most tangible results of this journey is his now-famous copy of Leonardo's *Battle of Anghiari*, a virtuoso drawing in black chalk and brown ink, enhanced with soft washes in brown, gray, and white.

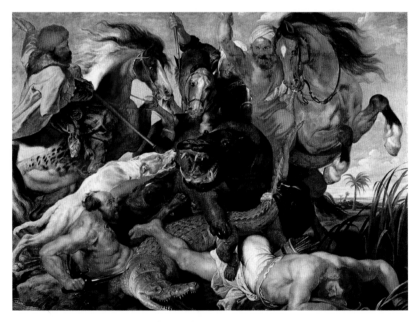

Peter Paul Rubens, *The Hippopotamus Hunt*, 1616

Pieter Soutman, *Last Supper* (after Rubens), ca. 1620

We might think that this drawing gives us a perfect impression of what the fresco may have looked like, except for one caveat: Leonardo's fresco was no longer visible in 1601. As we saw, it had been overpainted by Giorgio Vasari after the hall was enlarged in the 1550s. Rubens must therefore have used a copy, which was either a drawing by Lorenzo Zacchia, made in 1553 just before the fresco was destroyed, or—as some have suggested—Leonardo's original cartoon for the fresco. Whatever the case may be, the work made a deep impact on the Flemish painter. Echoes of the *Battle of Anghiari* are clearly visible in Rubens's *Hippopotamus Hunt* of 1616, now in the Alte Pinakothek in Munich.

Rubens also made a detailed study of two figures in the *Last Supper*, Christ and Simon, as well as a copy of the *Last Supper*, now lost, which formed the basis for a highly influential etching, made in 1620 by one of his pupils and associates, Pieter Soutman.

Like many other engravings, this copy dispenses with the architectural setting of Leonardo's original. Instead, the work unfolds in an extraordinarily long, panorama-like sheet, 98.8 by 29.4 cm, which required two separate plates. As is often the case with engravings, the print depicts the familiar scene in a mirror image, though with a typical Flemish flair for texture.

Several historians have speculated whether Rubens could have used the *Last Supper* copy in Tongerlo, painted by Andrea

Anthony van Dyck, *Self-Portrait with a Sunflower,* ca. 1633–1640

Solario and others, as his source. Tongerlo was only half a day's ride away from Antwerp. What's more, the large canvas copy was acquired by the Abbot Streyters for the choir of the Tongerlo monastery church as early as 1545.[108] According to a handwritten account from the late 16th century, this canvas was considered an autograph work by Leonardo and his school. This would undoubtedly have attracted Rubens's attention, as well as that of other Flemish painters.

Soutman's print was hugely popular. It enjoyed at least five reprints and was assiduously copied, with various degrees of success, by other engravers, including Andreas van Rymsdyck and Hermann Heinrich. It also inspired a painting by another Flemish artist, Anthony van Dyck.

A prodigy who was admitted to Antwerp's guild at the age of nineteen, van Dyck was trained in Rubens's large studio and eventually became the master's chief assistant. By the early 17th century, however, Antwerp's role in trade was in decline and its prosperity was fading—largely due to the resumption of the Eighty Years War. In response, van Dyck accepted an invitation by the Marquess of Buckingham in 1620 to travel to England. This was an inspired choice, for the artist soon caught the eye of King James I.

After a six-year sojourn in Italy, where like his master he studied the artists of the High Renaissance, van Dyck returned to London and became the official painter to the Court of St. James. Though he never lost his Flemish touch, particularly in the treatment of texture, van Dyck outshone his master by embracing a more refined classicism that was then becoming the rage in England.

Van Dyck is believed to have painted his copy of the *Last Supper* in 1618. An inscription in Spanish on the lower left of the panel credits both Rubens and van Dyck ("Pedro Pablo Rubens inventor, Antonio Vanding F[ecit]"). This inscription was probably added at some time in the 18th century, after the painting made its way to Spain and was hung in a convent in Madrid. But it does suggest that the artist used the drawing by Rubens as his source. The work is now in a private collection in Spain, which has made access difficult, but photographs indicate a painting of very high quality that appears to be deeply indebted to the Soutman engraving as well as the Tongerlo canvas, notably in the treatment of the Apostle John.

The impact of Soutman's print on the artistic milieu of Northern Europe is difficult to overstate, particularly because heretofore Italian art was mostly known of in the forms of

copies and occasional engravings. Among others, it reached the studio of a twenty-eight-year-old Dutch artist who had recently moved from his native Leiden to Amsterdam. Amsterdam was the political and economic center of the Dutch Republic of the Seven United Provinces, which were then embroiled in the final stage of their revolt against Spain. While the motives for this revolt were mostly political, there was also a strong religious undercurrent: Holland had decided to join the Reformist movement of Calvin, whilst the territories under Spanish sway remained resolutely Catholic.

Rembrandt van Rijn, *The Storm on the Sea of Galilee,* 1634

Rembrandt van Rijn, *Study for a Last Supper*, 1638

Known as De Hervormde Kerk or "The Reformed Church," Dutch Calvinism did not tolerate any form of religious art, which it considered a form of idolatry, in its churches. In the early years of the Eighty Years War, during a phase known as the Beeldenstorm, mobs had stormed local churches and smashed sculptures, defaced paintings, and even destroyed stained glass windows. By the 1630s, however, this reformist fervor had abated, and Amsterdam was known around the world for its tolerant attitude in religious matters. So was the depiction of religious themes in art—albeit for the purpose of private reflection in the home, rather than the church.

Rembrandt saw this as an opportunity. He believed there was a great demand among the faithful—Calvinists, other Protestants such as Remonstrants, and even Catholics—for Andachtsbilder,

Rembrandt van Rijn, *The Conspiracy of Claudius Civilis,* 1662

portraits of biblical figures and scenes to be used for private contemplation and prayer. Breaking with the tradition of 17th-century Dutch art—which focused on secular subjects such as genre scenes, portraits, and landscapes—he devoted himself to depicting scenes from the Hebrew Scriptures and the New Testament as few of his compatriots would care to do.

In 1634 Rembrandt had just finished an ambitious work, *The Storm on the Sea of Galilee.* It showed the boat of the Apostles beset by foamy seas and lit by a dramatic spotlight, which revealed the influence of the Dutch Caravaggisti, imitators of Caravaggio. Regrettably, this painting was stolen from the Isabella Stewart Gardner Museum in Boston in 1990, and is today considered lost.

In that same year, Rembrandt prepared three drawings loosely inspired by the Soutman engraving, freely exploring new possibilities in the arrangement and gestures of Leonardo's *Last Supper* figures. Two of these three—now in the British Museum and the

207

Kupferstichkabinett in Berlin—are really studies "of the Apostles' states of mind," while the third, now in the Metropolitan Museum in New York, is truly a "copy" in the sense that it attempts to evoke Leonardo's full composition.[109]

Drawn in bold, robust strokes, the drawing follows Leonardo's example in isolating the figure of Christ, and by arranging the Apostles in individual groups that each respond to Christ's announcement in alternating expressions of shock and dismay. The elaborate baldachin over Jesus is either inspired by the drapery in the Soutman etching or, as some have suggested, by the early Birago engraving, which likewise features an elaborate cloth canopy.

These studies had a major impact on Rembrandt's work, including his *Incredulity of St. Thomas*—executed in that same year and now in the Pushkin Museum in Moscow—and particularly the *Wedding Feast of Samson* of 1638, now in the Gemäldegalerie Alte Meister in Dresden, which faced a similar problem of how to arrange a large group of figures around a dining table.

These are just a few examples; as Egbert Haverkamp-Begemann has shown, there is now considerable research on the frequency with which Rembrandt returned to Leonardo's solutions of the *Last Supper* throughout his subsequent career.[110] Particularly *Christ at Emmaus* (1648) and *The Conspiracy of Claudius Civilis* (1662) are often cited as examples of the pervasive influence of Leonardo on Rembrandt's historical and biblical oeuvre.

As engraving technology and its distribution systems became more widespread in the 17th and 18th centuries, reproductions of the *Last Supper* continued to proliferate, producing more versions than can be identified in this volume. A heroic attempt to

produce an inventory of these prints was made by Clelia Alberici and Mariateresa Chirico De Biasi in 1984.[111] In England, the popularity of such prints spawned the birth in many homes of the so-called "print room," the bourgeois equivalent of a painting gallery in the houses of the nobility. Here, fine prints were kept in cabinets, on tables, or framed and hung on the wall. The purpose of the print room, like the art gallery, was to impress visitors with the connoisseurship of the host, and to offer conversation pieces for a leisurely afternoon. Many ladies found time to create collections of prints and paste these in bound albums. Some enterprising souls even colored these prints with a soft wash, greatly enhancing their appeal.

But *Last Supper* prints were not the only conduit by which the memory of Leonardo's art was sustained during the Baroque era. Another of his masterpieces, the *Mona Lisa,* played a key role as well—though in an entirely different fashion.

7.
THE *MONA LISA* AND THE *LAST SUPPER* IN THE BAROQUE ERA

For those of us who have visited the Louvre Museum in Paris in recent years, it has become a familiar sight. Busloads of tourists surge through the glass pyramid and up the sweeping staircase of the Denon Wing with only one objective in mind: to see the *Mona Lisa*. And invariably, as they crowd into the 19th-century Salle des États, they are disappointed. Here, hung on a freestanding wall, is a tiny portrait protected by a thick pane of glass, barely visible behind the crowd of humanity and a clutter of cell phones trying to take a picture.

What is it about this portrait of a Florentine housewife that keeps the world in thrall? And why is it the most famous work by Leonardo da Vinci, together with the *Last Supper* fresco in Milan?

At first glance, the two works could not be more different. One is a large, monumental composition, 15 by 29 feet; the other a small, intimate portrait of no more than 30 by 21 inches.

One is a religious painting; the other, a secular portrait of a matronly woman. So what is it that binds these two works together? Why does the *Mona Lisa* hold so many generations in thrall? Or to phrase the question differently, why have so many artists, from the 16th century onward, wanted to try to produce a faithful copy of this painting, even though the sitter was neither an important historical figure nor a particularly beautiful one? This is the essential mystery of the *Mona Lisa*,

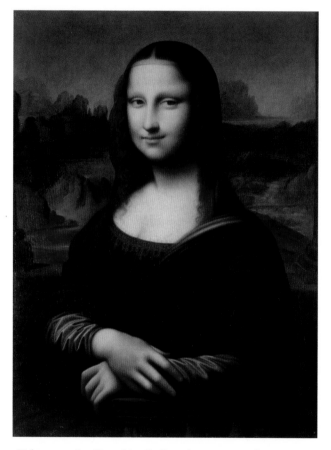

Unknown artist, *Mona Lisa* (St. Petersburg copy), 16th century (?)

and by extension, a core element of the mystery of Leonardo's mystique itself.

In 1952, to mark the 500th anniversary of Leonardo's birth, a group of French art historians undertook the task of creating an inventory of all copies of the *Mona Lisa* from the 16th to the 19th century. They came up with an astounding sixty-one copies that, in the words of Roy McMullen, are "worthy of scholarly attention."[112]

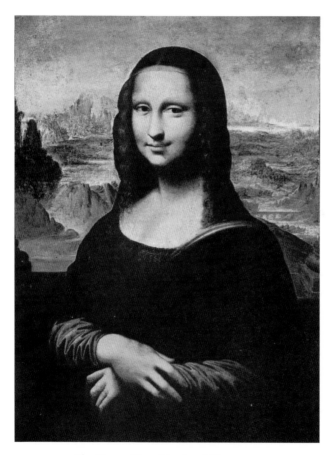

The *Vernon Mona Lisa*, late 16th century

Some of these works, dated to the first part of the 16th century, continue to be sources of speculation. Could they, as some hopeful authors suggest, have emanated from Leonardo's studio? Could they have been painted by his trusted Leonardeschi under his personal supervision, as in the case of Salaì's Prado copy? Announcements such as these are always guaranteed to rock our modern art world, perhaps for no other reason than to try to increase the estimated value of the painting in question.

One example is the *Mona Lisa* copy that was "discovered" in a private collection in St. Petersburg in December 2015, and featured in a BBC TV documentary in 2016. That this is a high quality painting is obvious. The work is a very faithful replica, but the position of the eyes, the poorly executed sfumato of the face, and the lack of detail in the treatment of the hair clearly point to a talented copyist working in Flanders around 1600. The dark tones of the portrait, and the evident decay of the sky, may reflect the fact that—for reasons we shall see shortly—the *Mona Lisa* original had suffered some deterioration.[113]

Another work that has sometimes been proposed as a product of Leonardo's workshop—albeit with a much weaker claim—is the mysterious *Vernon Mona Lisa*, which was sold at auction by Sotheby's in 1995 for $552,500. The painting was brought to the United States in 1797 by William Vernon, heir of a wealthy family in Newport, Rhode Island. His art collection was originally put up for sale in the 19th century, but the family retained the *Mona Lisa* copy, perhaps in view of the growing fame of the original at the time. What's more, the work was once owned by the French royal family, which greatly increased the speculation about its authorship; one touching but probably apocryphal legend has it that Queen Marie Antoinette sold the painting to Vernon just before her execution in 1793.[114]

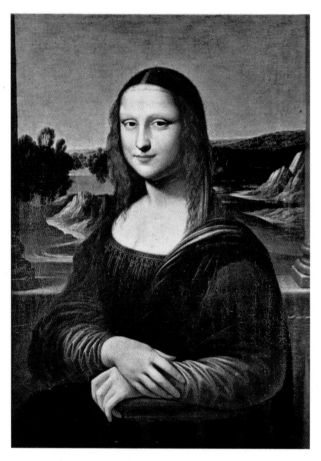

Unknown artist (Flemish School?), *Oslo Mona Lisa*
(after the *Isleworth Mona Lisa*), 17th century

But a close look clearly shows that this is a much less accomplished work than the St. Petersburg copy. The mechanical treatment of the face and the thick folds of the lady's garment suggest an artist who may have had access to the original, but certainly had few talents to match its master.

Nonetheless, a 1981 book, *The Day They Stole the Mona Lisa* by Seymour Reit, insists that the portrait is an autograph,

and that it was "held hostage" in a vault at a New Jersey bank. The book created an uproar and sold a large number of copies, which may have been the purpose of the exercise. Today the book is largely forgotten.

Another interesting copy is now on display at the Walters Art Museum in Baltimore. The museum has made no claim that it originated from Leonardo's studio, and dates it to "between 1630 and 1660"—well over a century after Leonardo created the original portrait. One critic assessed the portrait's sfumato technique and noted that "the copyist has tried to imitate this effect, but without the subtlety of the original."[115] Interestingly, a recent X-ray suggests that the copy was painted over a portrait of what may be St. Veronica. Curator Joaneath Spicer has tentatively identified this shadowy image as a work that could be related to a painting by the French artist Simon Vouet.[116]

Another copy that was once thought to have been an autograph is the so-called Reynolds *Mona Lisa*, once the property of the highly esteemed English painter Sir Joshua Reynolds. The artist was so taken with this work—reportedly given to him by the English Foreign Secretary, the Duke of Leeds—that at one point he inquired whether the French court still possessed its *Mona Lisa* painting. Apparently, Reynolds genuinely believed that he could have the original. Regrettably, the French answered that their *Mona Lisa* was alive and well, thank you very much. Earlier in this century, the Reynolds *Mona Lisa* underwent a thorough examination, which revealed that the support was made of oak panel, using wood that was harvested in the Baltic some time after 1602. That put an end to the speculation about its authorship.

Earlier in this book, we summarized the evidence that suggests that the *Isleworth Mona Lisa,* acquired by a British art collector

named Hugh Blaker in 1913 from a stately mansion in Somerset, is Leonardo's earlier version of the *Mona Lisa*, painted directly from its model, Lisa del Giocondo; and that the Louvre *Mona Lisa* is a second, more penetrating version. The Louvre version no longer seeks a likeness of the young lady, but rather tries to produce a composite of Leonardo's ideal of motherhood. That this was already suspected in the 17th century is suggested by the fact that no less than two copies were made of the *earlier* version of the portrait as well.

One is the so-called *Oslo Mona Lisa,* which replicates the *Isleworth Mona Lisa* in remarkable detail, but adds a blue sky that in the original is still missing (which is probably the reason why Vasari, in his famous description of the *Mona Lisa,* calls the work "unfinished"). The Oslo painting includes a signature, "BERNdo LUINI MDXXV," which was probably added at some point in the 17th century in an effort to establish the work as painted in 1525 by Bernardino Luini—who, as we saw, was one of Leonardo's most accomplished pupils.[117] However, the painting is almost certainly a product of the 17th century, and may even be of Flemish origin.

The *Mona Lisa* Original in France

So what propelled this frenzy of *Mona Lisa* copies? Some believe it is the visceral and perhaps subconscious response it elicits in us, the beholders, which may be exactly the effect that Leonardo was seeking. We are attracted to this portrait because it exemplifies the kindness, the compassion, and the selfless love that we associate with motherhood. Vasari's detailed, almost breathless description of the portrait in his *Lives of the Artists* certainly served to bolster that idea. The fact that the original—that is to say, the Louvre version—was no longer in Italy but in a royal

collection in France also helped to augment the mysterious aura surrounding Leonardo, just as the rapidly deteriorating condition of the *Last Supper* fresco merely served to increase the public appetite for painted copies and printed engravings of this work.

This is illustrated by a wonderful story told by Cassiano dal Pozzo, a leading Italian classicist and art collector who was also the secretary of the highly influential Cardinal Francesco Barberini, nephew of Pope Urban VIII. At one point, Cassiano was invited to go to France and visit the French court. He accepted, particularly because he was eager to see the legendary *Mona Lisa* that he knew was on display in the palace at Fontainebleau. When he was finally ushered into the room where the portrait was on display, he was overwhelmed by the experience. "This is the most finished work of the painter that one could see," he wrote later, "and lacks only speech for all else is there The hands are extremely beautiful, and, in short, in spite of all the misfortunes that this picture has suffered, the face and hands are so beautiful that whoever looks at it with admiration is bewitched."[118]

What is interesting about this story is the reference to "misfortunes." What could have happened to the *Mona Lisa* that we do not know about today? Perhaps Cassiano was writing about the fact that King François had decided to place the portrait—as well as many other works—in his Appartement des Bains, which today we would probably call his "private spa." Modeled on the Roman baths, the suite of bathrooms obviously produced a lot of humidity that would have been quite detrimental to the painting, which was painted on poplar wood. It was not until the end of the 16th century that the *Mona Lisa* and other works were rescued from the dampness of the king's bath and placed in a newly built Cabinet des Tableaux. Cassiano refers to the work as "a life-size portrait, half-length, of a certain

Gioconda," since the work was called *La Joconde* in France, and is still so named to this day. But his claim that anyone who looks at the portrait would be "bewitched" is certainly apt, because it was true: Europe was bewitched by the *Mona Lisa*. When the first edition of Leonardo's *Treatise on Painting* was published at last in 1651, in Paris, in both Italian and French, the book included only one illustration of Leonardo's work: an engraving of the *Mona Lisa*.

The *Last Supper* in the Baroque Era

After the Thirty Years War between Catholic and Protestant nations—the deadliest conflict on the Continent to date—came to an end in 1648, large areas of Europe were left in ruins. By some calculations, poverty, disease, and malnutrition in Europe were worse in the latter part of the 17th century than at any time during the High Middle Ages and the Renaissance.

The profound change to Europe made a deep impression on the leading thinkers of the time. To some, it seemed that humankind was moving backward. If the purpose of Christendom was to advance love and human compassion, they asked, how then could Christians engage in such wholesale slaughter against one another? Why, the French philosopher Voltaire asked, are Christians "the most intolerant of men?"

In response, he and other philosophes began to look for another set of ethical principles that could govern human affairs. Thus was born an age that became known as the Enlightenment, or more appropriately, the Age of Reason. The term tries to capture various movements in the late 17th and 18th centuries that sought to create a new moral foundation for humankind, using the humanist principles first developed in the Renaissance. While this activity was largely limited to intellectual and literary

salons, the influence of the Enlightenment was vast. Holland had the philosopher Baruch Spinoza, England had the physicist Isaac Newton, and Germany had Immanuel Kant. But the Enlightenment found a particularly strong center in France, where its philosophes embarked on an ambitious project to catalog the world's knowledge in science, physics, and technology. Thus was born the enterprise known as the *Encyclopédie*, led by Denis Diderot.

Much of Europe's royalty flirted with these new ideas, confident in the belief that they posed no threat to the established monarchial order. But when the first volume of the *Encyclopédie* was published, it was met with dismay among the French aristocracy, who saw its grip on French society threatened by the encyclopedists' call for equality, intellectual liberty, and anticlericalism.

Initially, King Louis XVI was receptive to the Enlightenment. He considered abolishing serfdom and lifting the restrictions on non-Catholics. But when France's debt began to skyrocket, in part because of its active military support of the American Revolution, the king withdrew from day-to-day government and surrendered himself to more pleasurable pursuits, including music, ballet, and art.

This also stirred a new royal interest in Leonardo da Vinci, since the court still possessed three of the artist's most important works. As a devout Catholic the king was familiar with depictions of Leonardo's *Last Supper*, but was told by his advisors that, given the wide disparity between extant prints, it was difficult to determine what the real fresco had once looked like. For whatever reason, this gripped Louis's imagination, just as his nation was sliding into chaos. As a result, in 1789, mere months before the storming of the Bastille and the start of the French Revolution, the king ordered a major scientific undertaking to

create a detailed and accurate reconstruction of the painting, to be undertaken in situ in Milan.

What Louis XVI had in mind was a publication that would seek to reestablish France as the leading cultural light of Europe. This publication would not only try to recreate the original composition but also provide detailed studies of each of the figures, using the highest level of fidelity that late 18th-century engraving technology could provide.

The Dutertre Commission

The man chosen for this royal commission was the painter and draftsman André Dutertre, charged with creating an original set of drawings, drawn in situ at the refectory in Milan, which would then be converted into engravings by the master engraver Raphael Morghen. Delighted with this important task, Dutertre left for Italy and spent the next five years researching his subject, not only in Milan but also visiting Giampietrino's copy at the Certosa di Pavia and Solario's copy at Castellazzo. His drawn reconstruction of the *Last Supper* is therefore important, since this is our last recorded observation of the fresco before the damage inflicted during the Napoleonic Wars between 1796 and 1801.[119] Of course, by that time the *Last Supper* had already been mutilated by repeated efforts to "restore" the fresco, given that by the 18th century the work was in very bad shape. Nevertheless, it was hoped that Dutertre's in-depth research would, once and for all, settle some vigorous disputes that had arisen in art circles, given that there were wide discrepancies among the various *Last Supper* engravings then in circulation. For example: what was the exact position of the dishes, cutlery, and glasses in Leonardo's original vision? Had the left hand of Thomas always been visible, or not? And most importantly, was the knife in Peter's hand unsheathed, or not?

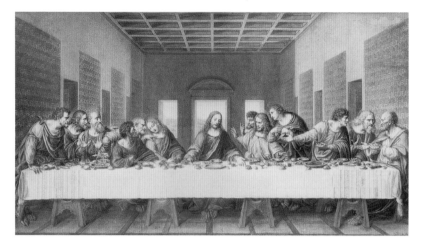

André Dutertre, *Reconstruction of the Last Supper*, 1793

Dutertre faithfully recorded these and many other details with an obsession to detail that one would expect from the age of the *Encyclopédie*. But while he labored in Italy, the forces unleashed by the Enlightenment finally succeeded in staging the French Revolution and toppling his patron, King Louis XVI. Louis XVI and his Austrian-born wife, Marie Antoinette, were arrested and tried by the newly formed National Convention; Louis was executed by the guillotine on January 21, 1793, and Marie Antoinette only months later. Dutertre returned to France later that same year.

Fortunately, despite the violent upheaval of this revolutionary regime and its strong anti-monarchical policy, Dutertre was invited to exhibit the fruit of his labors in 1794. Of course, any idea of a grant, royal or otherwise, to actually *publish* his drawings was now out of the question. The cost of such, given the sheer size of the drawings, would have been astronomical, and the new French National Assembly had more important things to worry about. Thus it looked as if Dutertre's labors were for naught,

until, four years later, another prominent French personage came to his rescue. This was none other than a young brigadier general in the French Revolutionary forces by the name of Napoleon Bonaparte. In 1798, Napoleon decided to embark on his ill-fated campaign to Egypt with a force of thirty-eight thousand, and also insisted on bringing along a large retinue of scholars and artists, tasked to document all of the ancient Egyptian wonders they might encounter. In this, Napoleon certainly proved himself to be a worthy follower of the age of the *Encyclopédie*. Dutertre found himself marching alongside the French army as it fought its way into Egypt, and distinguished himself by drawing 184 portraits of prominent officers, painters, and scholars who accompanied the expedition. Upon his return to France, several of these portraits—notably of the generals Louis Desaix and Jean-Baptiste Kléber—were exhibited at the Paris Salon of 1804 to considerable acclaim. They were later published in Louis Reybaud's famous chronicle of the Egypt Campaign, the *Histoire scientifique et militaire de l'expédition française en Égypte* of 1836.

The acclaim enabled Dutertre to once again raise the abandoned project of documenting the *Last Supper*. During Napoleon's invasion of Northern Italy in 1796, then ruled by the Austrians, a French cavalry detachment had used the refectory of the Santa Maria delle Grazie in Milan as a stable for their horses. As Stendhal later wrote, "worse than the steam from monastic meals, the perspiration of the horses permanently coated the walls, generating further mold over the picture."[120] Adding insult to injury, the dragoons had amused themselves by taking potshots at Leonardo's fresco, further inflicting irreparable damage.

Whether Dutertre was aware of this disaster is unclear, but in 1808, he succeeded in convincing a group of investors to commission a series of highly detailed, folio-sized etchings of his

drawings of the *Last Supper*, specifically his detailed studies of the thirteen heads. Surprisingly, Dutertre did not include his pièce de resistance, his drawing of the complete composition as it existed prior to 1796 (and greatly enhanced by his observations of the copies then on display in Italy). That was left to the engraver who had originally been tapped for the project, Raphael Morghen. When in 1794 he was shown Dutertre's original drawing of the *Last Supper*, he was reportedly moved to tears. He vowed to see it published, no matter the cost. But nothing came of this, and Dutertre himself was shortly thereafter dispatched to Egypt.

In the meantime, other developments were taking place in Italy proper. One of the principles of the Enlightenment was that rulers had a special responsibility as custodians of a nation's wealth to safeguard the art treasures that past ages had bequeathed it. This is how, for example, the Louvre Museum came into being, even though the idea for a national art collection had already been suggested by King Louis XVI. Inspired by this example, a group of Italian artists went to Ferdinand III, Duke of Tuscany, and appealed to him to finish what Louis XVI had started: to publish a comprehensive reconstruction of Leonardo's fresco. The duke accepted and provided the financing, so that, this time, it was an Italian draftsman, Teodoro Matteini, who made the pilgrimage to Milan as well as to Castellazzo. Matteini was wise enough, however, to ask the engraver Morghen, the man originally tapped for the French project, to execute the engravings. This work was then published, at long last, in 1800. But as Leo Steinberg, who has painstakingly documented this sequence of events, notes regretfully, "the twentieth century has not looked kindly on Matteini and Morghen."[121]

Indeed, when compared with Dutertre's original, Morghen's version is stilted, academic, and devoid of any warmth or expres-

siveness. This became evident when the exquisite collection of Dutertre's engravings, printed on thick creamy folios, found its way to private collectors, museums, and art schools throughout Europe.[122] But, as we saw, this folio lacked a complete reconstruction of the fresco; it merely contained detailed studies of the heads. Therefore, a truly authoritative reconstruction of Leonardo's masterpiece was still missing. It would take a new century, and new technology, to realize such an effort.

8.
LEONARDO'S LEGACY
IN THE 19TH CENTURY

Up to this point, as we have seen, the interest in Leonardo da Vinci was mostly limited to Europe's elites. This included members of the aristocracy and the haute bourgeoisie, the upper middle class, who could afford to buy copies or engravings of Leonardo's art. Outside of these perfumed salons, few people in Europe or North America knew about Leonardo or the range of new ideas he had brought to the Renaissance.

All that changed in the 19th century, which saw a dramatic transformation in almost every aspect of human endeavor, including manufacturing, transportation, science, education, and mass media. As a result, the 19th century, and particularly the Victorian Era, saw itself as being at the pinnacle of Western civilization, and believed that its artistic achievements effectively summarized all that had gone before. Much of this optimism was propelled by profound social, economic, and political changes taking place on the continent. To illustrate this transformation, just imagine that at the beginning of the century, during the Napoleonic era, most people lived much as they had during the Renaissance, or even in

the time of the Roman Empire. The horse was still the primary mode of transportation. The principal source of illumination was the wax candle. At night, most of Europe's cities were plunged into darkness, as had been the case since Roman times. Information was transmitted by handwritten mail, with transit times measured in the distance a horse could travel in a day—usually between 15 and 20 miles. Seaborne traffic was dependent on favorable winds.

By the end of the 19th century, however, all of these essential markers of human life had been transformed by technological advances. Major cities were now lit at night by gaslight, led by Paris, which had installed the first gas lamps as early as 1820. For the first time in history, rail networks and the steam-driven locomotive made long-distance travel affordable for millions, allowing them to escape the confines of their villages or townships, if only for the weekend. At the same time, the steam-driven turbine transformed seagoing traffic. This brought the art treasures of Italy, long the exclusive preserve of the European nobility, within the reach of middle-class travelers, including authors, poets, historians, critics, and simply tourists. It is this sudden zest to travel to Italy that inspired E. M. Forster's famous 1908 novel *A Room with a View,* which in 1985 was adapted into an Academy Award-winning film by Merchant Ivory Productions.

Milan was a key railway terminus for European visitors traveling to Florence and Rome, and many travelers made use of the opportunity to visit the Santa Maria delle Grazie. Most, however, were dismayed to see the severe decay of the *Last Supper*; indeed, the figures of the fresco were now barely visible. The dismay was shared by a young Italian artist named Giuseppe Bossi. He set out to do what Duterte and Matteini had attempted before him: to create the most accurate and the most definitive copy of the *Last Supper.*

Bossi was perfectly suited for the task. A product of the Napoleonic era and its penchant for a new, austere classicism, he had attended the Brera Academy of Fine Arts in Milan. Here he met and befriended Canova, who became the greatest and most influential sculptor of the first half of the 19th century. Bossi and other graduates then formed a movement to try to preserve Italian art, which eventually resulted in the foundation of the Pinacoteca di Brera, the museum that still exists today.

In 1804, Northern Italy had moved from Austrian to French rule as a result of Napoleon's conquests, a development that many Italians, including Bossi, wholeheartedly supported. Italy at that time, it should be remembered, was still an aggregate of various independent city-states, most of which had neither the vision nor the funds to invest in the preservation of their awesome cultural heritage.

Fortunately, the new ruler of Italy was Prince Eugène de Beauharnais, who was the son of Napoleon's first wife, Joséphine, by an earlier marriage, whom Bonaparte had decided to adopt. Given that the Napoleonic rule of Europe was largely a family business, able sons were always in short supply. For Bossi, this did not matter. What did matter was that Napoleon and his viceroy had a keen sense of the importance of the arts. Under their enlightened leadership, Italy could finally begin to take stock of its tremendous artistic treasures. This included the work of Leonardo da Vinci, who in Bossi's eyes embodied all the classical ideals that he and his age held dear.

In this, de Beauharnais did not disappoint. It was he who commissioned Bossi to make a detailed and scientifically accurate copy of the *Last Supper*, using not only the gravely damaged fresco in Milan but also the copies in Certosa di Pavia and Castellazzo. The young artist set about his project with a vengeance. He

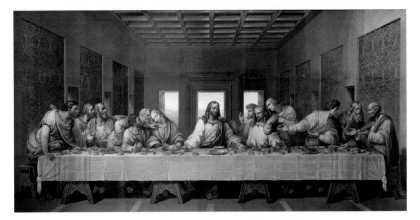

Giacomo Raffaelli, *Last Supper* (mosaic), Minoritenkirche in Vienna, 1804

cleared out the refectory—which was still a functioning monastic dining hall—and set about to reduce the abominable dampness of the space. A ditch was dug to drain the moisture, and the floor was raised by laying a new pavement of dry brick. Windows were added to increase ventilation, and an open stove was installed, though less with an eye on drying out the room than for Bossi's own comfort, so that he could execute his work through the winter. The result of all this work was, surprisingly, not only a drawing or a canvas, but even a mosaic. Using Bossi's drawing (which no longer exists), the Roman artist Giacomo Raffaelli painstakingly recreated the *Last Supper* in a vast mosaic, some 30 feet wide, which was installed in the Minoritenkirche in Vienna. Of course, Bossi himself did not hesitate to make a copy on canvas, which was proudly installed in the Pinacoteca di Brera.

But the artist made his greatest impact with the book that documents his research, *Del Cenacolo di Leonardo da Vinci* (*"The Last Supper of Leonardo da Vinci"*). Written under the strong influence of French Revolutionary ideology ("liberté, égalité, fraternité!") and its attendant anti-Church sentiment, the

One of the most influential publications on Leonardo da Vinci in the 19th century:
Joseph Bossi's *The Last Supper of Leonardo da Vinci*, published in Milan in 1810

book strove to depict the *Last Supper* as an exceptional humanist study of passion and expression, rather than as an illustration of the Gospel of John. The "divine" Leonardo, Bossi declared, "was not content to win the approval of religious souls . . . rather, he wished to engage the spirits of all men capable of feeling."[123]

For many European intellectuals, this classicist and thoroughly secular analysis of Leonardo da Vinci was a breath of fresh air. In fact, Bossi's idea of looking at the *Last Supper* from a psychological rather than a religious perspective, as an instance of pure human drama, resonated not only with the French novelist Stendhal, author of *The Charterhouse of Parma* (1839), but also with the German poet Wolfgang Goethe.

At age thirty-nine, Goethe had also taken the obligatory grand tour of Italy, and had come away deeply impressed. He was not

Joseph Karl Stieler, *Johann Wolfgang von Goethe*, 1828

only taken by Italy's classical heritage but also the work of the Renaissance, and Leonardo da Vinci in particular. Shortly after Bossi's book was published, Goethe was busy himself writing and editing his collection of short travel stories, known as *Italienische Reise* ("Italian Journey"), with its famous preamble "Et in Arcadia ego" ("Also I in Arcadia"). The Bossi book struck a deep chord—so much so that Goethe decided to write a commentary on it.[124] While writing this work, he drew not only from his (then diminishing) impressions of his 1787 visit to the *Cenacolo*, but also of the ubiquitous Morghen print, then enjoying wide circulation in Europe.[125]

232

Not be outdone, in that same year Stendhal published *his* impressions of Leonardo's *Last Supper* in several chapters of his *Histoire de la Peinture en Italie*.[126] It is Stendhal who documents the fact that in 1652, "the Dominicans found the entrance to their refectory too small and so unashamedly cut off the legs of the Savior and the apostles next to him in order to enlarge the door." Goethe, meanwhile, heaps scorn on the efforts of a would-be restorer named Giuseppe Mazza, who "botched [the work] in masterly fashion" by washing the *Last Supper* painting with lye, in the mistaken assumption that this was a fresco, and then proceeded to overpaint it with a mixture of tempera and oil pigments, using his imagination as he went along. Sharp protests ensued, which convinced Mazza to suspend his "restoration" efforts. "Since then, after many a consultation, nothing more has been undertaken," Goethe adds mournfully, "and for sure, what more might have been done to embalm a three-centuries-old corpse?"[127] Regrettably, this was not the last attempt to restore the mural.

And so, some 250 years after the publication of Vasari's *Lives of the Artists*, Leonardo da Vinci was once again an eagerly debated subject in the literary salons of Europe. A steady stream of prominent intellectuals and artistic dilettanti made the pilgrimage to the Milanese refectory, doing little but documenting the fresco's continuing decay. In 1836, the director of the Brera Academy petitioned the Habsburg government in Vienna, which had once more taken charge of Lombardy after the defeat of Napoleon, to try to preserve the painting; his petition was ignored. In 1859, the art historian Franz Kugler described the painting as "a pathetic, ghostly ruin." Another historian, Carl Justi, deplored its "devastation" in 1859. In the 1870s, a call arose urging the authorities to take the fresco off the wall and transfer it to canvas—a technique

that had only just been developed. All to no avail. In 1899, the director of the Brera Academy pronounced the painting "entirely ruined . . . so that today, even the most careful restoration would have little success."[128]

The *Mona Lisa* in the 19th Century

In the meantime, the fame of the *Mona Lisa* had undergone a transformation as well. Throughout much of the 17th and 18th centuries, her admirers were limited to those who had seen copies, or who had been fortunate enough to see the original itself. This included much of the French aristocracy, for in the 1650s the portrait had been moved from Fontainebleau to the royal palace at the Louvre, and subsequently to the Petite Galerie of Louis XIV's sprawling new pleasure palace of Versailles. It briefly returned to Paris, in the palace of the Tuileries, before reclaiming its place in the Petite Galerie, together with hundreds of other works. In 1750 and again in 1779, a selection of the French royal art collection was exhibited in the Palais de Luxembourg. This public exhibit was so successful that it prompted a demand for a permanent location of these works, open to the public. Thus, as we saw, the idea of the Louvre Museum was not the product of the French Revolution's egalitarian fervor, as is often thought, but of a royal initiative that predates the revolution by several decades. However, that idea did not come to fruition until the early months of the 19th century, following a thorough renovation of the Louvre palace by Hubert Robert, who designed the magnificent Grande Galerie of Italian art that visitors see today.

But then, surprisingly, the *Mona Lisa* lapsed into relative obscurity. It appears that between 1760 and 1788 the portrait was no longer on display anywhere in the royal palace. Inventories

from this time report that the painting had been exiled to the back rooms of the *Direction des Bâtiments*, the supervisor of royal buildings.[129] Fortunately, Napoleon Bonaparte came to the *Mona Lisa's* rescue—perhaps because of their shared Italian ancestry. Calling her the "Sphinx of the Occident," as a counterpoint to the sphinx he had seen in Giza, Egypt, he put the *Mona Lisa* in his private bedroom at the Tuileries Palace.

In one other respect, however, Napoleon had a very negative impact on fostering the Leonardo legend. For more than a decade, his officials had been busy looting the museums, libraries, and collections in the lands under his sway. As a result, several of Leonardo's notebooks were brought to Paris, including the Codex Atlanticus and other da Vinci manuscripts from the Biblioteca Ambrosiana in Milan. Fortunately, most of the Codex Atlanticus was returned to Milan in 1815, but other sections, including Manuscript B, which included the Codex on the Flight of Birds, were pulled apart and sold by unscrupulous art sellers in single lots, so as to fetch a higher price. Thus, pages from this Codex wound up in collections all across Europe. It was not until the end of the 19th century that an immense curatorial effort was launched to track down the various pages, and to reunite them in the Biblioteca Reale in Turin.[130]

Outside of the Napoleonic court, however, the *Mona Lisa* was virtually unknown, largely because there were few, if any, prints of the work in circulation. The opaque sfumato of the *Mona Lisa*, the subtlety of lady's smile, and the mysterious optical effects of its background were extremely difficult to reproduce in the engraving techniques of the 17th and 18th centuries, quite in contrast to the robust masculinity and bold monumentality of the *Last Supper*. But that changed with the advent of a new technology, steel engraving.

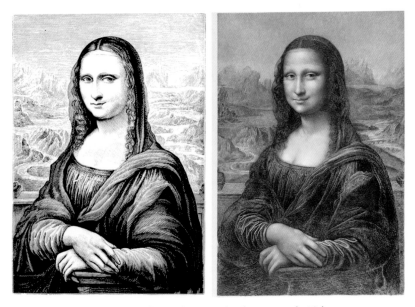

The transformation of reproductive technology: an early 19th-century
copper engraving (left) vs. a mid-19th-century steel engraving (right)

The steel plate had been developed by Jacob Perkins in
1792 for the purpose of producing detailed bank notes in very
large quantities. The principal advantage of using steel, rather
than copper, is that steel is much harder and more durable, and
capable of producing hundreds, even thousands of imprints
without any deterioration of the plate. This hardness also made
it easier to produce subtle gradations in the line or, if acid was
used, the etching, allowing the engraver to create shades of gray
that had long been difficult to do with copper. In 1818, after
Perkins moved to London, which was then the burgeoning
center of the world's publishing industry, the technology was
perfected by master engravers Charles Warren and Charles
Heath. The timing was spot on, because mechanization, made
possible by the invention of steam power, had obliterated the

centuries-old apprentice model of production. As the machines of the Industrial Revolution became more prevalent and efficient, manufacturing increased tenfold, then a hundredfold. The result was a perfect marriage with the growing popularity of books and its attendant demand for high quality illustrations. Vastly improved educational opportunities—a consequence of the Age of Reason—produced a new middle class of professionals while boosting literacy rates to unprecedented heights. It also created a tremendous appetite for illustrated books—particularly plates of Europe's greatest masterpieces, from which Victorian artists could draw inspiration.

Early 19th-century engravings of the *Mona Lisa*, such as a copper print from the 1810s, clearly show the limitations of the old technique. By comparison, a steel engraving created in mid-century gives an idea of the astounding effects that this new technology could yield in the hands of a capable engraver. The most famous prints of *La Joconde* were made by the Italian master engraver Luigi Calamatta, who produced a stunning, almost photographic image of the *Mona Lisa* in 1847, and continued to try to perfect his prints of the portrait until his death in 1857.

Inevitably, these prints, mass-produced in illustrated books, rekindled the fame of Leonardo da Vinci and the *Mona Lisa* for the 19th-century public, thus expanding its appeal well beyond the small group of collectors and cognoscenti who previously had only known about the portrait from copies in oil.

As a corollary, *Mona Lisa's* character underwent a major literary shift. As Europe passed into the Romantic Era, the nubile young woman of Vasari's *Lives*, the bewitching courtesan of Cassiano dal Pozzo, became more mysterious, more sensuous—even more erotic. In the novel *Elle et Lui* by the French author Amantine Lucile Dupin, better known as George Sand, a sultry

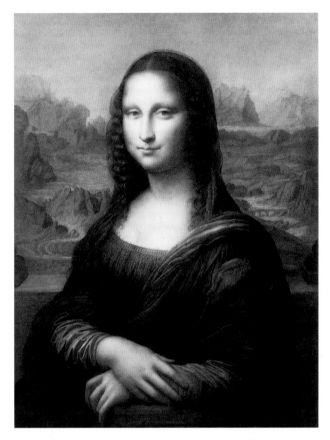

Luigi Calamatta, *Mona Lisa*, 1857. One of the last Calamatta prints,
the engraver used both line and wash to create a remarkable facsimile
of the atmospheric effects of the original.

mistress is compared to "a beautiful sphinx" with a certain smile, "mysterious like that of *Mona Lisa*, which she had on her lips and in the corner of her eye."[131] The French author and art critic Théophile Gautier agreed. "You discover that your melancholy arises from the fact," he wrote in 1857, "that [the *Mona Lisa*], three hundred years ago, greeted your avowal of love with the same mocking smile which she retains even today on her lips."

The work even bewitched the otherwise sober-thinking Jules Michelet. "This painting attracts me, calls me, invades me, absorbs me," the French historian lamented in his towering work *Histoire de France*; "I go to it in spite of myself, as the bird goes to the serpent."[132] The Florentine housewife had become the perfect femme fatale. But her greatest fame was yet to come.

It is therefore not surprising that in this general upswing of interest in all things da Vinci, Leonardo's notebooks were finally brought to print, some 350 years after they had been written. As we saw, Raffaelo du Dufresne had published an initial selection of Leonardo's *Treatise on Painting* in 1651. Between the 17th and 18th centuries, the book was reprinted no less than twenty-two times, in six different languages. But most of these editions were derived from copies of the texts, rather than from the original Italian manuscript.[133] It was therefore left to Jean Paul Richter to try to systemically organize Leonardo's thoughts in his famous 1883 publication of *The Notebooks of Leonardo da Vinci*. These volumes were based on Leonardo's *Trattato,* then in the collection of Lord Ashburnham, as well as the manuscripts at the Royal Library at Windsor, the Napoleonic collections in France, and other sources throughout Europe. Richter's landmark publication revealed, for the first time, the astonishing depth of Leonardo's scientific observations, using the new photogravure technique to reproduce Leonardo's sketches and drawings with great fidelity.

The Era of French Academic Painting

As the 19th century progressed, all these developments conspired to increase interest in the art of the Renaissance, and particularly the work of Leonardo da Vinci, as never before. This was especially true for the art schools in France, Britain, and elsewhere in

Lawrence Alma-Tadema, *Expectations*, 1885. Idealized imagery from classical Antiquity offered an escape from the drudgery of late-19th-century urbanization during the Industrial Revolution.

Europe. Since the Napoleonic Era, most nations in Europe had established their own academies where budding talent could be nurtured and educated, to produce the masters of the future. In France, this led to the formation of the École des Beaux-Arts; in Italy, the Accademia di Belle Arti; and in England, the Royal College of Art, in addition to the Royal Academy of Arts, which was established as early as 1768.[134]

The style of art taught in these schools advocated a return to the primacy of drawing, color, and perspective established by Leonardo, Raphael, Michelangelo, and other leading Renaissance artists, enhanced by new techniques of optical realism made possible by the invention of photography. In France, artists found another major impetus during the restoration of the Napoleonic Empire by Napoleon III, nephew of Napoleon Bonaparte.[135]

The result was a style of breathtaking technical ability and almost photographic realism that became known as 19th-century

Raphael, *The Triumph of Galatea*, 1514 (left) and William-Adolphe Bouguereau, *The Birth of Venus*, 1879 (right)

academic painting. At the same time, these academic institutions tried to move their students away from themes that had gained much currency in the 19th century in favor of uplifting scenes that celebrated great moments in the nation's history. Throughout much of the 18th century, artists had maintained a strong tradition in the depiction of landscapes and genre scenes, which accurately documented the social conditions of their society. Academic art, by contrast, resolutely turned away from contemporary subjects and toward fictional themes. Another favored motif was the world of Greek mythology, in part because it gave artists license to depict female nudes. These works in particular were much sought after by the nouveaux riches, the wealthy barons who had made their fortunes in the Industrial Revolution, and had now replaced the aristocratic class as the primary patrons of contemporary art. This escapist form of art may have served

Jean-Auguste-Dominique Ingres, *Death of Leonardo in the Arms of François I*, 1818

as an antidote to growing urbanization, which brought millions to the (largely medieval) city centers of London and Paris, and produced a wide disparity between rich and poor.

Works by William-Adolphe Bouguereau, Alexandre Cabanel, and Thomas Couture, often dripping with patriotic sentimentalism, ruled supreme in the annual Salons (the official exhibits of the French art academy), virtually the only conduit through which aspiring French artists could gain recognition and patronage. Scores of wealthy buyers invariably took their cue from what Napoleon III and his wife, Eugénie, considered great art, exemplified by Bouguereau's *Birth of Venus,* which manages to blend its Raphaelesque conception with a sly, almost shocking eroticism.[136]

Although Raphael was cited as the most perfect embodiment of the classical ideal, Leonardo da Vinci was a close second. One subject that achieved almost instant popularity was the legend that Leonardo had died in the presence of the French king. According to Vasari, an inveterate font of gossip and tall tales, Leonardo had actually died in the arms of King François I. An enterprising French researcher, Léon de Laborde, discovered that on the day after Leonardo's death, François I was actually in Saint-Germain-en-Laye to sign an edict.[137]

Nevertheless, the legend persisted. François-Guillaume Ménageot, a pupil of Boucher, painted an affectionate scene of Leonardo's death in 1781, entirely based on Vasari's description. This was followed in 1828 by a similarly sentimental, Biedemeier-like depiction by Italian academic painter Cesare Mussini. In this dramatization, a priest checks the pulse of the aged artist, sagging forward in the bed, while the king moves over to embrace the old master once more.

But by far the most famous depiction of Leonardo's passing was painted by the ruling leader of French Neoclassicism, Jean-Auguste Dominique Ingres. Commissioned by the Comte de Blacas, the French Ambassador to Rome, the painting shows the king cradling the frail old artist in his arms as Leonardo breathes his last.

What few modern observers realize, however, is that the painting was a not-so-subtle exercise in monarchist propaganda. De Blacas served the reign of Louis XVIII, the corpulent king who had been foisted onto the French throne by the European powers after the defeat of Napoleon at Waterloo. By restoring the rule of the French House of Bourbon after the havoc of the French Revolution and the Napoleonic Wars, Europe's kings hoped to stabilize France and bring it once again into the family

Jean Alaux, *François I with Leonardo on His Deathbed*
(stained glass), ca. 1840

of nations. The Ingres painting was therefore meant to convince the people of the innate compassion of the French monarchy, exemplified by a king who went out of his way to comfort a legendary painter in the hour of his death. Lest that message not be properly understood, the French government rushed out prints of the scene, including a superb rendering by Joseph Théodore Richomme.

Paintings such as these raised an important question: if Leonardo had indeed spent his final years in the loving care of the French king, then where was his grave? Shouldn't there be a tomb of some sort, in or around Amboise? This prompted an anguished search for the master's grave, which led to the distressing discovery that the church of St. Florentin, where Leonardo had been interred, was demolished in 1802 on the orders of a Napoleonic official.

Joseph Théodore Richomme, *Death of Leonardo in the Arms of François I* (after Ingres), ca. 1820

All of the lead coffins buried under its pavement were melted down for the war effort, while their contents were thrown in the dirt. But—and there is always a "but" in these legends—fortunately there was a local gardener who had observed the whole thing. Deeply distressed by this sacrilege, he had gathered up the bones as best he could and buried them in a mass grave.

In 1862, this tale inspired a poet named Arsène Houssaye, editor of the journal *L'Artiste,* to go digging in and around the remains of the church, in the hope of finding something useful. And of course, he did: he stumbled on fragments of a tombstone with the letters "EO DUS VINC," which, quite possibly, could once have spelled out "LEONARDUS VINCIUS."[138] He immediately started digging, and voilà: he found several skulls, one of which was so large that Houssaye was instantly convinced that

The tomb containing the presumed remains of Leonardo da Vinci in
the Chapel of Saint-Hubert of the Château of Amboise

it once contained the brilliant mind of Leonardo da Vinci. After
several more mishaps, these presumed remains were finally rein-
terred in a tomb in the chapel of Saint-Hubert, on the grounds of
the Château of Amboise, where visitors have come to pay their
respects to Leonardo da Vinci ever since.

Thus, the mystique of the elusive Leonardo endured, and
entered into the modern age of the 20th century.

9.

LEONARDO DA VINCI IN THE 20TH CENTURY

The comforting Victorian concept of history as an unwavering ascent of Christian civilization was brought to a crashing halt by the violence of World War I, the first war to be conducted on an industrial scale. It left the world bereft of many of its cherished beliefs, and adrift in search of a new purpose for mankind. It also destroyed the aesthetic theories that were the foundation of Victorian optimism, and the idea that contemporary art should be the pinnacle of all that had gone before it. Neoclassicism, and other idealistic revivals of the past—Neo-Romanesque, Neo-Gothic, Neo-Baroque—all perished amid the rubble and destruction of the Great War. Europe was once again a tabula rasa, on which artists, sculptors, and architects struggled to come up with something new that could capture the anxiety of the postwar world.

The result was an era of confusion in which artists struck out on their own, singly or in small groups, thus prompting a great variety of movements, many of which failed to outlast their

principal creators. The only thing these artists had in common was a complete rejection of traditional academic art, now utterly delegitimized by the failure of the Victorian political system that had sustained Europe for much of the 19th century. New ideas flooded the continent, some of which traced their origins to the prewar era, such as Dada, Cubism, Futurism, and Expressionism, sometimes in concert with the late flowering of post-Impressionist strands such as Fauvism and Pointillism. Modern art, it seemed, had resolutely turned its back on the Old Masters and the principles of realism. From this moment onward, it was guided by nothing but the artist's own conviction, his imagination, and his beliefs.

As the titans of this bygone age—from Botticelli to Boucher, from Cabanel to Leighton—were toppled from their pedestals, one artist remained upright. His name was Leonardo da Vinci. If anything, da Vinci's fame only continued to grow as the 20th century progressed, even though European art moved ever deeper into non-figurate experimentation. How to explain this paradox? What did Leonardo have that the other Old Masters, including his rivals Raphael and Michelangelo, did not have?

The answer is twofold. Among the art intelligentsia, Leonardo retained his good name because of the astonishing detail of his scientific observations, which clearly marked him as a maverick, an outlier of his time. That resonated with artists who themselves felt out of joint with their era. He also struck a chord with an age that became increasingly enamored with technology, and with the conviction that only new technology could rescue humanity from the abyss in which it found itself. The bicycle, the airplane, the ball bearing, the diving suit, even the automobile—the "self-driving cart"—were all unique inventions of the 20th century that Leonardo had anticipated some 450 years earlier. In response,

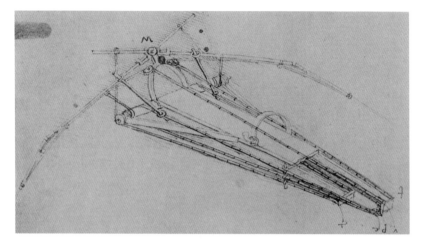

Leonardo da Vinci, *Design for a Flying Machine*, first published in 1883

his notebooks, first published by Jean Paul Richter in 1883, were now translated and republished around the world. It was as if da Vinci had suddenly become the Nostradamus of the modern technical world. Noted authors such as Sigmund Freud, the British art historian Walter Pater, the French poet Charles Baudelaire, and the Italian writer Gabriele D'Annunzio were all moved to address the boundless imagination of Leonardo da Vinci.

On a more public level, Leonardo's name was catapulted into newspaper headlines around the world in 1911 as a result of a rather curious incident. On August 21, in the midst of a hot summer when *tout Paris* was enjoying its annual month-long sojourn on the Côte d'Azur, an Italian house decorator named Vincenzo Peruggia entered the service entrance of the Louvre, wearing a white smock that marked him as one of the museum employees. During previous months, he had indeed worked at the museum as a handyman, making protective glass cases for the Louvre's most important works. In this capacity he had come across the *Mona Lisa*, and had plotted his moves, even as he was

Vincenzo Peruggia, the man
who stole the *Mona Lisa*

making the glass case that was supposed to protect her. And so, as much of Paris was still waking up to another hot summer day, Peruggia calmly walked to the Salon Carré where the *Mona Lisa* was on display, lifted the panel from the four pegs that supported it, and carried it to a nearby service exit, where he quickly removed the portrait from its frame and glass case. He then wrapped the painting in his white smock, tucked it under his arm, and walked out of the museum, quite undisturbed, using the same service door through which he had entered. From there he made his way back to his apartment, where he hid the priceless portrait under his bed.

Eventually the theft was discovered and the police were summoned. The gendarmes duly went through the motions of conducting an investigation, though few could bring themselves to show any great enthusiasm for the problem. This was not a murder, after all, but simply the theft of an old painting, from a museum that had hundreds, if not thousands of such works.

All that changed, however, when the French newspapers, desperate for news in the doldrums of summer, got hold of the story. Screaming headlines announced the theft. Editors declared a national emergency. The fact that it took twenty-four hours before anyone even noticed that the *Mona Lisa* was missing only added to the outrage. Newsprint had become the most powerful new medium of the 20th century, and as the news ricocheted between Paris, London, Berlin, and Rome, the *Mona*

Lisa suddenly became a global cause célèbre. The Louvre tried to defend itself, noting that it only had two hundred guards to guard four hundred rooms, but to no avail. The French gendarmerie, feeling the heat, questioned all of the Louvre's workers, on or off duty—including Peruggia. But when the Italian told the police that he had been working at another site on August 21, they believed him.

When the painting still hadn't been recovered by 1913, it was universally believed that Leonardo's signature portrait had been lost to humankind. Editors mourned the loss of so great a work of art, and its image—now printed using the new technology of photographic plates—was seen in newspapers, magazines, and journals around the globe.

Meanwhile, Peruggia had returned to Italy, taking the *Mona Lisa* with him. He settled in an apartment in Florence, while toying with the idea of selling the painting to a rich collector. He had, in fact, already approached the owner of a local gallery, Alfredo Geri, in the hope of selling the work on the underground art market. If that didn't work, he planned to offer it to a museum, such as the Uffizi, in exchange for a big reward, of course. Five hundred thousand lire seemed no more than an appropriate sum. After all, Peruggia saw himself as a savior who had committed an act of patriotism; after five hundred years, he had finally brought the *Mona Lisa* back to the city where she was born.

He was therefore pleased but not surprised when the gallery owner, Geri, agreed to consider the sale. What Geri did not tell the thief is that he had promptly contacted a curator at the Uffizi, Giovanni Poggi, who was eager to see and authenticate the panel. This trio, then, met up in a local Florence hotel, where Peruggia pulled the panel out of his suitcase. Poggi was astonished. Here indeed was the original *Mona Lisa*, identified by the Louvre

The English collector and connoisseur
Hugh Blaker

inventory number on the back of the painting. They persuaded Peruggia to allow them to take the panel back to the Uffizi, "for further tests," and then promptly called the police. Peruggia was arrested on the spot.

This left the Italians with a dilemma. Should they keep this work, as reparation for the untold number of Italian works that Napoleon had carted off to Paris? Or should they return it, in the interest of international good will? In the end, a compromise of sorts was reached: the *Mona Lisa* would be taken back to the Louvre, but not until she had completed a triumphant, two-year exhibit tour across Italy.

In 1913, just one year before the outbreak of World War I, the portrait was returned to its rightful place in the Louvre. In Italy, meanwhile, the press hailed the thief as a hero who had "brought our Gioconda home"—just as Peruggia had hoped. For the sake of appearances, he was tried and sentenced to prison, but public opinion ensured that his incarceration was mercifully brief. He then served in the Italian forces during World War I (when Italy fought on the side of the Allies against Austria and Germany), survived, and married, after which—surprisingly—he moved back to France, where he died in 1925.

In the same year that the *Mona Lisa* was hung once again in the Louvre, the English art connoisseur Hugh Blaker decided to visit a stately home in Somerset. He often visited such homes

of the aristocracy, in the hope of finding a long-lost French or Italian masterpiece, acquired by an 18th-century ancestor during the habitual grand tour of Europe. In this manner he had discovered quite a few interesting pieces, but nothing prepared him for what he found in the Somerset home. Here was a version of the *Mona Lisa*, of such beauty and in such a pristine condition, that he immediately wondered whether this could, in fact, have been painted by Leonardo or his workshop. He promptly acquired the work and added it to his private collection, located in Old Isleworth, in the London Borough of Hounslow, close to today's location of Heathrow Airport. As a result, this portrait has been known as the *Isleworth Mona Lisa* ever since, and believed by some historians, including these authors, to be the first and original portrait of Lisa del Giocondo.

European Art after World War I

Even though the theft of the *Mona Lisa* had set the portrait on its inexorable course to stardom, a reaction was building, particularly in French art circles. Dadaists denounced the hullabaloo surrounding the *Mona Lisa* as a bourgeois infatuation, and the painting became the target of parody.

Already in 1883, Eugène Bataille had depicted the *Mona Lisa* smoking a pipe, calling it *Le Rire* ("A Good Laugh"). It was then included in a Paris exhibition of a short-lived art movement called Les Arts incohérents, "Incoherent Arts," founded by Parisian satirist and publisher Jules Lévy. The French artist and author Marcel Duchamp, who is often regarded, together with Picasso and Matisse, as one of the founders of Modern art, was particularly affronted by the attention lavished on the *Mona Lisa*. In 1919, he created another satirical version of the portrait, giving the lady a goatee and upturned mustache of the type later

affected by Salvador Dalí—who himself later subjected the portrait to parody. The title of this work, *L.H.O.O.Q.*, only makes sense in French: when reading these initials out loud, the speaker essentially paraphrases the sentence "Elle a chaud au cul," which, roughly translated, means "she's got a hot ass."

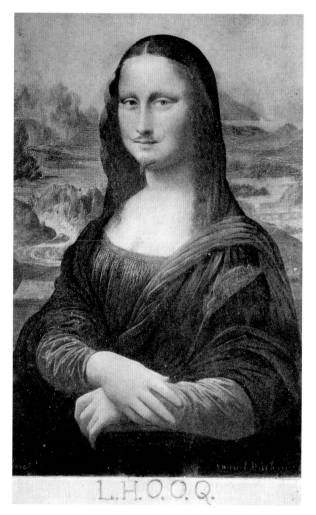

Marcel Duchamp, *L.H.O.O.Q.*, 1919

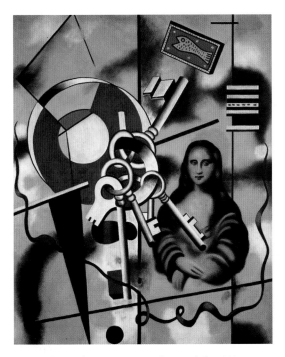

Fernand Leger, *La Joconde aux clefs,* 1930

Meanwhile, the Russian artist Kazimir Malevich included her in a cubist montage, *Composition with Mona Lisa* (1914), in which her features are crossed out with a red X, as if she were a demon to be excised. In 1930, Fernand Léger included her in a Surrealist collage with keys, entitled *La Joconde aux clefs.* He had been looking for something appropriate to add to this painting of his house keys, of all things, and couldn't come up with an idea. Eventually, he wrote, he went out for a walk, and what did he see in a shop window? "A postcard of the *Joconde*! I understood at once," Léger declared. "This is what I needed. What could be of greater contrast to the keys?"[139]

Unwittingly, however, these and other forms of caricaturizing the *Mona Lisa* pulled the work from its elitist pedestal and fed it

into the mainstream of popular consciousness. The more modern artists ridiculed the portrait, the more Leonardo da Vinci retained a vivid presence in the public's mind, even as 20th-century artists resolutely steered away from figurative art and into the uncharted waters of new artistic movements.

Indeed, by the 1920s, the European art scene had disintegrated into a wide variety of individual movements, some of which seemed to spend more time defending their theories than producing any artistic expression of merit. What these strains had in common was a resolute rejection of the type of academic realism that had ruled the Salons and art markets in the prewar era. This 19th-century style, once considered to be at the pinnacle of artistic expression, was now derisively referred to as *l'art pompier* ("the fireman art" after the quasi-classical helmets worn by French firemen at the time).

There was one exception, and that was Surrealism—or more accurately, a certain current within the Surrealist movement that stubbornly refused to surrender the vocabulary of figurative art, so as to better express its ideas. Surrealists sought inspiration in dreams, the subconscious, and the irrational. Coined by the French poet Guillaume Apollinaire in 1917 (three years before the official birth of the movement), and later adopted as an art movement by André Breton and Philippe Soupault, Surrealism was driven by the idea that an overreliance on rationalism and materialism, shaped by bourgeois values, had led to the outbreak of World War I.[140] It followed that redemption lay in the opposite, the world of spiritualism, of the spontaneous, or what its adherents called *l'automatisme*: the unrepressed, intuitive thought or vision, whether expressed in poems, novels, music, or paint. Or as Breton put it in 1924:

> Surrealism is based on the belief in the superior reality of
> certain forms of association heretofore neglected, in the
> omnipotence of the dream, and in the disinterested play of
> thought. It leads to the permanent destruction of all other
> psychic mechanisms and to its substitution of them in the
> solution of the principal problems of life.[141]

Sigmund Freud's discovery of the power of dreams in the human psyche served as a major tonic for the Surrealist movement, by legitimizing the subconscious mind as a fertile source of inspiration.

One of the most influential Surrealist painters was the Italian artist Giorgio de Chirico. Raised in Greece, he attended the Athens School of Fine Arts, where he was thoroughly immersed in classical art, before moving to the Academy of Fine Arts in Munich, Germany. Even before the war, de Chirico found himself attracted to metaphysical themes. One day, while walking on the piazza facing the Santa Croce in Florence, he experienced a powerful epiphany that inspired his subsequent work, including *The Enigma of an Autumn Afternoon* (1910) and *Song of Love* (1914).

The *Song of Love* (1914), now in the Museum of Modern Art in New York, established the canon of Surrealist art: brooding landscapes or classical piazzas, painted in late-summer sienna tints under peerless blue skies, with various, seemingly incongruous objects strewn about. Particularly his use of classical statuary, and his penchant for substituting eggs for human faces, later made a deep impression on Salvador Dalí.

In the early 1920s, Surrealism had begun to coalesce in Paris around artists including Breton; Tristan Tzara, one of the founders of Dada in Zürich; the Spanish Symbolist painter Joan Miró; the

Giorgio de Chirico, *Song of Love*, 1914. The painting became a
canon of motifs for the Surrealist movement.

German artists Paul Klee and Max Ernst; and even, briefly, Pablo
Picasso. A group portrait entitled *A Friends' Reunion*, painted
by Max Ernst in 1922, brings some of these artists together,
not unlike the way that Henri Fantin-Latour immortalized the
Impressionists in *A Studio at Batignolles* some fifty years earlier.

But already, fissures were rippling through the group. Giorgio
de Chirico, who visited Paris in 1924 and was promptly adopted
by the Surrealists, had decided to return wholeheartedly to the
figurative art of the Renaissance and the Baroque. It is true that
the Surrealists had never rejected the Old Masters as fervently

Max Ernst, *A Friends' Reunion*, 1922
Seated from left to right: René Crevel, Max Ernst, Dostoyevsky, Theodore Fraenkel,
Jean Paulhan, Benjamin Peret, Johannes T. Baargeld, Robert Desnos. Standing: Philippe
Soupault, Jean Arp, Max Morise, Paul Eluard, Louis Aragon, Andre Breton, Giorgio
de Chirico, Gala Eluard. Next to Max Morise is Raphael, as a token of the Surrealist
allegiance to the Old Master vernacular.

as other avant-garde painters had; in Ernst's group painting,
even Raphael has pride of place. But in the eyes of the Paris
Surrealists, de Chirico went too far in his embrace of Leonardo
da Vinci, Raphael, and even Rubens. They were particularly
affronted when the Italian artist published an article, *The Return
of Craftsmanship*, which called for an end to modernist experi-
ments and a return to the traditional methods and iconography
of European art.[142]

Though rejected by most Surrealists, de Chirico's Old Master
manifesto resonated with many artists, including the Belgians
René Magritte and Paul Delvaux, as well as a young Catalan
painter named Salvador Dalí.

Salvador Dalí, *Figure on the Rocks*, 1926

Dalí was introduced to Surrealism by Joan Miró, who himself had begun to paint his intimate visions as poems of color, using a fluid interplay of lines, shapes, and colors. Like many other painters of his era, Dalí had diligently worked his way through the various forms of modern art, including Divisionism, Fauvism, and Cubism, largely through contact with Spanish artists such as Juan Gris. But in 1927, one year after he was expelled from the Madrid Academy of Art, Dalí experienced an epiphany: he met in Paris with the most influential paragon of European 20th-century art: his fellow Spaniard Pablo Picasso. Picasso revealed that he had turned his back on Cubism and embraced a highly individual neoclassical style that blended Renaissance and Post-Impressionist influences. This immediately struck a chord with Dalí, as evidenced by his *Venus and Amorini* (1925) and *Figure on the Rocks* (1926).

Soon thereafter, Dalí fell under the spell of Surrealism. He collaborated with Luis Buñuel on a film, and began to paint in the Surrealist vein, with works such as *Apparatus and Hand* (1927) and *Senicitas* (1928), which reflect the influence of Miró's works. By this time, Miró had persuaded Dalí's father to send his son to Paris, so as to fully integrate him into the movement. But Dalí soon became disillusioned with the group, and the increasingly fragmented nature of its ambitions. Indeed, over the next decade many different artists moved in and out of the Surrealist stream, including Victor Brauner, Paul Delvaux, Wolfgang Paalen, Kurt Seligmann, and Richard Oelze. Soon, the very term Surrealism lost its cohesive meaning altogether, and became merely, in Herbert Read's words, a "local and temporary concentration of forces."[143] This may be the reason why Dalí later wrote that his parents had named him Salvador ("Savior") because "he was the chosen one who had come to save painting from the deadly menace of abstract art, academic Surrealism, Dadism, and any kind of anarchic 'ism' whatsoever."[144]

Between 1926 and 1929, Dalí followed de Chirico, Miró, and Ernst in plumbing his inner subconscious. In his case, this involved his disturbing childhood memories prompted by the loss of his mother, to cancer, when he was sixteen; and a fraught relationship with his father and sister; as well as a frenzied auto-eroticism inspired by his reading of Freud's *The Interpretation of Dreams*.[145] Surrealism, Dalí declared, paraphrasing Breton, "no longer involves the representation of the external world, but that of the intimate and personal world of the artist."[146] He even developed a theoretical basis for mining his troubled psyche and fevered fantasies, calling it the "paranoic-critical method." A typi-cal painting from this period is *Le Jeu Lugubre*, "The Lugubrious Game," which caused consternation among his close circle of

Salvador Dalí, *The Great Masturbator,* 1929

friends for its overt use of scatological imagery and references to obsessive masturbation.

A major turning point was his encounter with the Russian Elena Ivanovna Diakonova, also known as Gala, who remained his muse throughout his life. Her influence is reflected in Dalí's *The Great Masturbator,* exhibited at the Goëmans Gallery in Paris in November 1929. The amoeba-like shape in center, vaguely reminiscent of a face looking downward, has been alternatively identified with Hieronymus Bosch's *Garden of Earthly Delights,* or with a rock at Cullero on Cape Creus, or with a whale that Dalí found stranded on the beach.

The painting marked the end of Dalí's frenetic wandering through the chaotic vocabulary of early 20th-century art, in favor of embracing traditional realism as articulated by Renaissance and Baroque art. Or perhaps "magic realism" is a better term, for

Dalí's use of the classicist grammar always went hand in hand with the emotional charge of French Symbolism and the continued impulses from fellow artists in the Surrealist movement. It is, however, that very classicist idiom that, together with de Chirico and Magritte, set him apart. While all of his contemporaries moved forward into the mists of an uncertain future, Dalí returned to the past, to the palette and technique of the Old Masters, to explore Surrealist ideas. This perhaps explains his famous dictum: "The difference between the Surrealists and me is that I am a Surrealist."[147]

Another possible impulse to Dalí's return to classical realism that modern historians often overlook is the Noucentisme of his native Catalonia. This movement was grounded in the idea that Mediterranean culture had always been essentially Greco-Roman in nature, and that classicism was therefore a natural model for local artists seeking an authentic depiction of modern subjects. Key exponents of this movement are Joaquim Sunyer, Francesc Domingo Segura, and Roberto Fernández Balbuena.

In many ways, the career of René Magritte paralleled Dalí's development as an artist. The son of Belgian parents, living in the francophone region of Hainaut, Magritte also experienced the tragedy of losing his mother, at age thirteen. In Magritte's case, however, his mother committed suicide by drowning herself in the Sambre River. When she was found, her dress was covering her face—an image that recurred in several of Magritte's paintings, in which people's faces are often covered.

In 1920, Magritte met *his* Gala, a young woman named Georgette Berger, who became both his muse and favorite model. He exhibited his first Surrealist works, *The Threatened Assassin* and *The Lost Jockey*, in 1927. After they were savaged by Belgian critics, Magritte and Georgette moved to Paris, where Magritte

Roberto Fernández Balbuena, *Woman Ironing*, 1930

became an active member of the Surrealist group. Unfortunately, his gallery, the Galerie le Centaure, closed in 1929, depriving Magritte of his main source of income. He moved back to Brussels and found work in advertising, but remained active as an artist due to the patronage of the same man who supported Dalí for many years: Edward James.

Like de Chirico and Dalí, Magritte often placed objects in unusual, even dreamlike contexts, rendered in a precise, realist style. But unlike Dalí, Magritte's inspiration did not derive from the turmoil of an inner subconscious but from a love for irony, contradiction, and the absurd—qualities that can endow ordinary objects with a new and provocative meaning. Magritte's art is a search for mystery and the unfathomable. "Indeed," he wrote,

René Magritte, *The Threatened Assassin*, 1926

"when one sees one of my pictures, one asks oneself this simple question, 'What does that mean?' It does not mean anything, because mystery means nothing either, it is unknowable."[148]

Magritte and de Chirico had a profound influence on two other artists of the Low Countries, Paul Delvaux and Carel Willink. Both sought inspiration in classical motifs. Delvaux's paintings often feature nudes wandering about in dreamlike states in what appear to be ancient agoras, surrounded by temples. Delvaux credited his fascination with "the climate of silent streets, with shadows of people who can't be seen," to de Chirico.[149] The same hallucinatory mood imbues Willink's most famous painting, *Simon the Stylite,* which shows a half-nude man seated on a weathered column in Pompeii, while fires rage behind him. Executed in an academic realism reminiscent of

Carel Willink, *Simon the Stylite*, 1939

the 19th-century French artist Ernest Meissonier, the work has sometimes been interpreted as a prophecy of World War II, and the great destruction that Europe would suffer.

European Art During World War II

In the 1930s, European art circles experienced another reaction, this time fueled by the political changes sweeping across the continent. The Soviet Union, formed after the fall of Imperial Russia in 1917, originally proved fertile ground for modern art. Russian avant-garde artists such as Vasiliy Kandinsky, Vladimir Tatlin, Alexander Archipenko, and the aforementioned Kazimir Malevich experimented with Suprematism, Productivism, and Constructivism from a uniquely Russian perspective that in some ways went beyond similar movements in the West. But in the 1920s, the Soviet government began to signal that these

experiments were going too far, and that Soviet art was increasingly losing touch with the proletariat and the Revolution it was meant to serve. In 1932, the Central Committee of the Communist Party formally decreed that artists should henceforth follow the precepts of Socialist Realism. This art form was meant to inspire the working masses with uplifting scenes of Soviet social harmony, using the vocabulary of academic neoclassical realism.

As it happened, Russia had a rich tradition of 19th-century art that explored social themes. Just as France had its Gustave Courbet, so too did Russia have Ilya Repin, an artist who created astonishingly realistic scenes that exposed the hardship of rural and village life to the urban elites of St. Petersburg. But the attempt to create an authentic form of Soviet social realism achieved little more than a numbing stream of genre depictions, many of which sought to raise the achievements of Soviet workers and farmers to "heroic" levels.

I. Brodsky, *Lenin in Smolny,* 1930

The formulaic representation of heroic soldiers, farmers, and factory workers developed by Socialist Realism soon found a fertile ground in Nazi Germany as well. During the interbella period, Germany, too, had a burgeoning avant-garde community, particularly in German Expressionism. But in 1934, Chancellor Adolf Hitler proposed an Ermächtigungsgesetz (Enabling Act), which gave him full dictatorial powers. All avant-garde movements, including German Expressionism, were now ruthlessly suppressed. Instead, artists were called upon to serve the Nazi cult with imagery that extolled the virtues and patriotism of the Aryan race. In this, Nazi art deliberately harked back to classical and early Christian models, as shown in the work of sculptors such as Arno Breker, Fritz Klimsch, and Josef Thorak. Other favored artists of the Third Reich, including Adolf Wissel and Sepp Hilz, used medieval motifs in their depictions of simple farm folk, while painting young maidens as innocent, pious Madonnas.

These images were meant to replace Christian devotion with piety and reverence for the Nazi state. Some authors, such as Hans Hofstätter, believe that Hitler's Third Reich realism was a direct outflow of the Surrealism of the 1920s, since it signaled "an emotional intensification" of these movements. Others have cited the sympathy that Salvador Dalí initially harbored for Adolf Hitler and the Nazi regime.

While that argument may be difficult to accept for German art, it may be appropriate for the Italian art scene. Indeed, the only totalitarian regime that continued to tolerate avant-garde movements was Mussolini's fascist government. Here, a group of Italian artists, poets, and musicians had developed their own vision of Futurism. More of a political manifesto than an aesthetic doctrine, Futurism resolutely rejected all of the traditional forms of the past in favor of an art form that was always modern,

Adolf Wissel, *The German Family*, 1939

dynamic, and experimental, driven by anything that promised speed and disruption—such as a car, an airplane, or even a gun. This dovetailed with fascist ideology, which saw itself as a deeply progressive force in all levels of society.

The looming tensions between fascism and the Western democracies finally erupted in September 1939, when Hitler invaded Poland, prompting the Second World War. Over the next three years, the world was convulsed by the conquests of the Axis forces of Germany, Italy, and Japan. This involved the wholesale looting of art treasures in Nazi-occupied territories. By some estimates, nearly 30 percent of all art works in private and public European collections were displaced. Many were confiscated outright by Reichsmarschall Hermann Goering for his private art collection at his Carinhall estate, while other works—mostly Old Masters—were destined for a Führermuseum that Hitler himself

The *Cenacolo*, the *Last Supper* Hall at the Santa Maria delle
Grazie in Milan, after the bombing of August 16, 1943

planned to build in Linz, in his native Austria. But after an almost
uninterrupted string of victories, the German army was finally
checked at the Battle of Stalingrad, the gateway to the oil fields of
the Caucasus, in early 1943.

That same year, after Allied forces landed in Sicily, Mussolini
was toppled as dictator, and Italy sued for peace. Hitler responded
by occupying the Italian peninsula in a lightning strike. Since
Allied forces were initially slow to resist, it fell on American
and British bombers to target key centers of Italian industry,
including Milan, which served as a major rail interchange. On
August 16, 1943, a Royal Air Force bomber targeting Milan's
rail network happened to drop a bomb on the convent of Santa
Maria delle Grazie.

The explosion demolished the famous refectory, including
all copies of the *Last Supper* that were on display in the room.
Fortunately, the north wall with Leonardo's *Last Supper* had

been reinforced and protected with sandbags. Thus, miraculously, Leonardo's fresco, as well as Montorfano's *Crucifixion* on the south wall, were left relatively intact.

The Postwar Art Scene

Hitler's rule came to an end with the defeat of Nazi Germany. But most of Europe's vibrant prewar art movements had been destroyed as well. Pablo Picasso was one of very few modern artists who had been allowed to continue to paint, relatively undisturbed, during the Nazi occupation of Paris. Elsewhere in Germany and France, many avant-garde artists had either been killed or fled to the United States, where a new movement was gaining ground. Often called New Realism, it included artists such as Grant Wood, Charles Sheeler, Georgia O'Keeffe, and Edward Hopper, who blended impulses from European realism with the growth of modern photography.

As a result, the postwar European art scene once again resembled a tabula rasa, much as it did after the First World War. Throughout the late 1940s and 1950s, art curators, collectors, and critics were primarily focused on trying to track down looted art works across Europe and returning them to their original owners.

This included Leonardo's *Lady with an Ermine*, which had been seized from the Czartoryski estate in Kráków immediately following the Nazi conquest of Poland in 1939. In 1940, the German Governor General of Poland, Hans Frank, ordered it to be brought back to Kráków so it could be hung in his office. When in 1945, Soviet troops were poised to overrun the Nazi forces in Poland, Frank fled to his home in Bavaria, taking the painting with him. Fortunately, a diligent US Army platoon found the painting while conducting a thorough house search after Frank's arrest.

Leonardo da Vinci, *Lady with an Ermine*, ca. 1490

From a creative point of view, however, Nazi propaganda and its obsessive use of stylized realism had now fully delegitimized any form of academic naturalism. In contrast to American artists, who had not been exposed to Socialist Realism, European painters sought to define new forms of expression that resolutely avoided the tainted vernacular of figurative art. A notable exception, once again, was Salvador Dalí. Whereas most of his contemporaries shunned figurate art, Dalí embraced it with greater enthusiasm

than ever before, albeit with a twist. His art became even more monumental and classicist, emulating the sharply drawn, brightly lit realism of *les Pompiers*: Meissonier, Bouguereau, and Couture. At the same time, Dalí found himself attracted to the style and motifs of Leonardo da Vinci. As early as 1919, he had written an essay in a student magazine, *Studium*, in which he described Leonardo as "The greatest master of painting, a soul that knew how to study, to invent, to create with ardor, passion and energy, which was how he lived his whole life." "His paintings," Dalí added, "reflect his constant love, dedication and passion for his work."[150]

But it was only in the late 1930s that Dalí and Gala had the financial resources to actually travel to Italy and see the art of Renaissance masters in Florence and Rome. This shift did not escape his fellow Surrealists, including Breton, who derided Dalí's embrace of "the lesson of Cosimo and da Vinci."[151]

Religion also played an important role in Dalí's shift to a more deliberate classicism. In 1940, he and Gala had been fortunate to escape to the United States, using visas issued by the Portuguese consul in Bordeaux. They spent the next eight years dividing their time between New York and Monterey, California. In the process, Dalí rediscovered his spiritual roots and became a practicing Catholic. This inspired a number of paintings with Catholic themes, such as the Madonna and the Crucifixion. At the same time, Dalí continued to wrestle with erotic themes. His interest in phallic symbols inspired the motif of a rhinoceros horn, which he associated with divine geometry and even chastity. It also brought him to a motif previously explored by Leonardo, his Leonardeschi, and other 16th-century artists: that of Leda and the Swan.

In Dalí's interpretation, entitled *Leda Atomica*, Gala (as Leda) is not shown in physical contact with the swan, as the traditional

Renaissance depiction would have it; they merely hover. This mysterious levitation reflects Dalí's view that the atomic age had upended the earth's natural harmony. The painting, he wrote, reveals a "libidinous emotion, suspended and as though hanging in midair, in accordance with the modern 'nothing touches' theory of intra-atomic physics."[152]

The painting also reflects the artist's growing interest in geometry as the framework for his creative conceptions. It was an interest shared by Leonardo, who was firmly convinced, like Luca Pacioli and ancient authors before him, that nature corresponds to a fundamental set of laws.

Further, they believed that these laws appear in their most perfect, their most *ideal* form in a human being. This idea is what inspired Leonardo to draw his famous *Vitruvian Man*. It also prompted him to collaborate with Luca Pacioli on the latter's book *De divina proportione*, for which Leonardo provided the illustrations. Dalí was likewise convinced that nature is governed by perfect proportions, drawing his inspiration from the work of a Romanian mathematician named Matila Ghyka. As several preparatory drawings show, for example, *Leda Atomica* is based on a perfect pentagon.

Unfortunately, these and other works were often savaged by art critics in the 1960s and 1970s, who saw in Dalí's postwar oeuvre little more than a relentless pursuit of publicity, fame, and commercial success, by cynically exploiting the now discredited vernacular of classical realism.[153] The fact that, unlike Picasso, Dalí was quite content to return to his native Spain in 1948 and settle in his house in Port Lligat, under the quasi-fascist Franco regime, did not help matters. Yet in recent decades, and especially in the wake of the exhibit *Dali: The Late Work* in Atlanta in 2010, critics have begun to reassess Dalí's role in 20th-century art, and

Salvador Dalí, *Study for Leda Atomica*, 1949, and the finished painting at right, 1949

indeed the role of Neorealism altogether. It is now acknowledged that his late work introduced many new ideas and techniques that became hallmarks of the op-art and pop-art movements of the 1960s, including the use of trompe l'oeil effects such as negative space, halftone dot-art (later popularized by Roy Lichtenstein), and even holography.

It was with his adaptation of Leonardo's *Last Supper*, however, that Dalí achieved his greatest fame. It is, as the Atlanta exhibit already suggested, the perfect synthesis of Dalí's interest in the "intersection of science and mathematics with the subconscious mind." As curator Elliott King wrote, Dalí's late work reflects his conviction that science, and in particular, nuclear physics, offered proof for the existence of God—a thesis that Dalí referred to as "nuclear mysticism."[154]

According to an article in a 1958 edition of the *New Yorker*, after the arts patron Chester Dale acquired Dalí's *Crucifixion*,

Salvador Dalí, *Study for The Sacrament of the Last Supper*, 1954–1955

now in the Metropolitan Museum of Art in New York, he asked Dalí to execute one more monumental religious painting: one that would match the work of the Renaissance masters. "After the *Crucifixion* I told him he had to do one more religious picture—*The Sacrament of the Last Supper*," Dale said; "He didn't do anything else for a whole year." The work shows the twelve Apostles leaning across a table, as if immersed in prayer, while Christ, located in the center, appears to address them.

As in the case of Leonardo's *Last Supper*, Jesus's gestures appear to have some special significance. With his left hand, he points to himself, while with his right hand he points upward, to a heavenly torso floating above the scene. The background consists of a seascape with a pair of small, unoccupied boats, bordered by mountains, with echoes of the panorama of *Persistence of Memory*. Unlike Leonardo's version, however, the faces of the

Salvador Dalí, *The Sacrament of the Last Supper*, 1955

Apostles are hidden, so that all attention is focused on the figure of Jesus. What's more, the scene is set in a vast dodecahedron, a twelve-sided geometric model that, according to Plato, symbolizes the universe. Leonardo drew a dodecahedron for Luca Pacioli's *De divina proportione*. It also appears in Jacopo de Barberi's 1495 portrait of Luca Pacioli as a model made of glass, suspended on a string. Given the sheer complexity of its shape, it has been suggested that Leonardo painted the dodecahedron..

But Dalí's *Last Supper* isn't a depiction of Christ's Last Supper in a conventional sense. Instead it depicts, as the title suggests, the institution of the sacrament of the Eucharist, whereby, according to Catholic doctrine, the substance of bread and wine is *transformed* into Christ's body and blood. This explains the prominent placement in the composition of the glass of wine and the two halves of bread, at the exclusion of everything else. It also explains the meaning of the torso floating above, for this is the

ekklesia, the Church representing the body of Christ on earth. As Dalí himself wrote:

> The first holy Communion on earth is conceived as a sacred rite of the greatest happiness for humanity. This rite is expressed with plastic means and not with literary ones. My ambition was to incorporate to [17th-century painter Francisco de] Zurbaran's mystical realism the experimental creativeness of modern painting in my desire to make it classic.[155]

Soon after Chester Dale donated the picture in 1956 to the National Gallery in Washington, DC, it became the museum's most popular work. But modern curators appear to disagree about the work's merits. Today it hangs in a corner near the stairwell on the mezzanine, where the East Building connects with the complex to the West. Few visitors are aware it's even there.

The *Mona Lisa* after World War II

The other constant of Leonardo's legacy, the *Mona Lisa,* emerged relatively unscathed from her postwar slumber after the liberation of France in 1944. Unfortunately, she then suffered considerable damage in 1956, when a visitor threw acid at the painting, severely damaging the lower part of the panel. Incredibly, on December 30 of that same year, a Bolivian tourist threw a rock at the portrait, chipping the area near the left elbow. Heroic restoration efforts were undertaken, but the area in the lower right of the portrait is now irreversibly damaged. As a result of these attacks, the portrait once again commanded headlines around the world.

This time, however, she was more than a news story; she had become a 20th-century icon. While the *Last Supper* will always

be an object of reverence, the *Mona Lisa* is now irretrievably objectified. As an image in the public domain, she is fair game, and can therefore be ruthlessly exploited in advertising and other commercial exploits. Indeed, today parodies and caricatures flourish once more. Even Dalí, who later criticized Marcel Duchamp for giving the *Mona Lisa* facial hair, was persuaded in 1953 by his favorite photographer, Philippe Halsman, to create a photo montage that superimposed his features on the *Mona Lisa*'s face. Today, the *Mona Lisa* is reproduced on anything capable of bearing photographic reproduction, including postcards, notebooks, posters, jewelry boxes, T-shirts, shopping bags, and even umbrellas, screen savers, and mouse pads.

An important moment in the *Mona Lisa*'s postwar history arrived in 1960, when a new president was elected in the United States. His wife, Jackie, a glamorous First Lady, vowed to bring culture back to White House. In 1961, after a successful visit by the Kennedys to Paris, Jackie decided to use her fluency in French to appeal to André Malraux, the French minister of culture, with

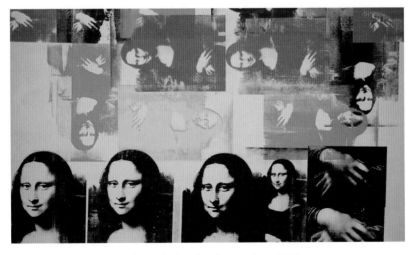

Andy Warhol, *Colored Mona Lisa*, 1936

279

a stunning request: would he allow the *Mona Lisa* to go on a tour of the United States? Malraux—and the government of Charles de Gaulle—were too smitten with Jackie to refuse, and thus the *Mona Lisa* crossed the Atlantic in 1963 on board the SS *France*, in her own suite, protected by an unsinkable waterproof case. Upon arrival in the United States, both the Lincoln and Baltimore tunnels were closed to traffic in order to allow the lady to travel unimpeded, in an ambulance, from New York to the National Gallery in Washington, DC.[156]

Here, over a million and a half visitors patiently stood in line to gawk at *La Joconde*, thus anticipating the blockbuster exhibits of our modern era. Soon thereafter, other nations clamored for a tour by the new pop star of the modern age. In 1974, she was put on view in Tokyo, followed by an exhibit in Moscow during the Brezhnev era. Thus, the contagion spread to Asia, where it launched a thousand jets full of tourists heading to the Louvre in the years to come.

The fame of the *Mona Lisa* was now without parallel. Scores of artists, both in and outside the United States, found themselves compelled to come to terms with her iconic fame. Fernando Botero painted her as a twelve-year-old child in 1959, and again as a grotesque doll in 1963. In 1952, Robert Rauschenberg produced his *Untitled (Mona Lisa),* while Alfred Gescheidt returned to the motif of the *Monna Vanna* in 1972 by showing the *Mona Lisa* with her breasts bared. Jasper Johns included the *Mona Lisa* in a 1968 lithograph, *Figure 7* from *Color Numeral Series.* But no postwar artist made a greater impact with his *Mona Lisa* variations than Andy Warhol.

As a former advertising designer, Warhol grasped the potential of blending pop art with the cult of celebrity. Having staged his first solo exhibition in New York in 1920—which featured

René Magritte, *Mona Lisa*, 1962

such iconic works as *Marilyn Diptych*, *100 Coke Bottles*, and *100 Soup Cans*—he became infatuated with the *Mona Lisa* after the 1963 National Gallery exhibit. Warhol then produced seven canvases, including one of his largest works, *Colored Mona Lisa*, as well as a multiplication treatment entitled *Thirty are Better than One*. Warhol's art signaled that the *Mona Lisa* had now become an everyday cliché of consumer culture—not unlike, say, a can of Campbell's Soup. Another artist who grasped this

281

was René Magritte, who painted *La Joconde* in 1960. The work shows the view of a typical Surrealist sky, framed by curtains. There is no image anywhere of the *Mona Lisa*, which was exactly Magritte's point: she is now so famous, he appears to say, that no one needs to be reminded what she looks like.

10.
THE LEGACY OF
LEONARDO

How was the legacy of Leonardo da Vinci nurtured and maintained across the span of five centuries, from 1519 to 2019? That was the essential question with which we started this book. Now that we have completed our five hundred-year survey, perhaps we can begin to draw some conclusions.

The first is that Leonardo's fame was not sustained by his pupils and followers, even though there were many who strenuously sought to imitate the master's technique, compositional style, and atmospheric effects. The reason, as we saw, is that while some of these Leonardeschi gained some renown in their own right, they operated on too small a scale, mostly in Lombardy, to have a major impact on 16th-century art. By that time, the zenith of the Italian Renaissance had moved away from the North, indeed away from Tuscany, to settle in Rome, where it stayed for the next two centuries. And though Leonardo's breakthrough discoveries in style, composition, and technique were avidly imitated and absorbed by painters who did achieve fame, including del Sarto and Correggio, they did not give Leonardo due credit

for the highly personal style they were able to forge. They took what they could learn, as artists had done for centuries. Similarly, Leonardo's astounding scientific observations and anatomical studies, which by themselves could have secured his place in history, were not published until the late 19th century.

Instead, it was Italian literature, from Giovio to Vasari and Lomazzo, that kept the name of Leonardo da Vinci alive, even as the artist's oeuvre was vastly overshadowed by Raphael and Michelangelo. At the same time, two of Leonardo's works, the *Mona Lisa* and the *Last Supper*, began their long journeys through time to serve as vivid testimony of the tremendous revolution that Leonardo had brought to Italian art. The *Last Supper*, Leonardo's greatest masterpiece, found distribution through the new technology of copperplate engraving, while the enigmatic mystery of the *Mona Lisa* ensured that she would be copied time and again, fully robed or half-nude, on panel or canvas, through much of the 16th century and into the Baroque era.

It was only in the 18th century that Leonardo's legacy experienced what was perhaps its greatest crisis, as the influence of Italian art itself suffered a rapid decline. For the first time in three hundred years, it was eclipsed by new, daring art movements in France and Britain, including Classicism and Rococo. Italy never recovered from that eclipse, and never regained its commanding presence on the European stage of art.

Then, in 1789, the French Revolution broke out, changing everything in France and, eventually, all of Europe. Art was no longer considered to be the exclusive preserve of the titled classes, but part of a national *patrimoine* to be shared by all. The Louvre Museum was established, which for the first time brought the *Mona Lisa* out of the cloistered shadows of a royal collection and into the daylight of public view. At the same time, the principles

of the Enlightenment demanded that governments take a stronger curatorial role, take responsibility for the treasures that the past had bestowed upon them, and replace the Church as the principal commissioning agent in their domains. This is what inspired many official attempts in the 19th century to restore or reconstruct Leonardo's *Last Supper* fresco, virtually destroyed by that time, by relying on the extant copies by Andrea Solario and Giampietrino.

As a result, by the 19th century, safeguarding the legacy of Leonardo had, ironically, become a French affair. It picked up where Italian literature of the 16th and 17th centuries—both in fiction and nonfiction—had left off, using the great improvements wrought by the development of the steel engraving, photography, and rotary press that spawned the newspaper industry. In the 19th century, as Donald Sassoon wrote, Leonardo was better known in France than in any other country in Europe, including Italy.[157] This is perhaps fitting, for whereas Leonardo never enjoyed the sustained support of a patron in Italy—Sforza was fickle, and the Medicis largely ignored him, regardless of what Medici apologists like Giovio or Vasari might claim—he did find such a patron in France, in the person of the French king.

French patronage of Leonardo suddenly gained great propaganda value after the restoration of the Bourbon monarchy following the fall of Napoleon. The Bourbons were desperate to convince the French nation of their legitimacy, as well as their traditional role as leaders of French culture, in contrast to the upstart claims of the House of Bonaparte. This is what motivated the sudden rush in sentimental prints and paintings that depicted Leonardo expiring peacefully in the arms of François I. The pious presence of a priest in many of these scenes also squelched the idea that Leonardo's ideas might have flirted with heresy, and

affirmed that he was a "good Catholic" in the end—exactly as Vasari had tried to claim.

The 1911 theft of the *Mona Lisa* then catapulted this portrait of a Florentine housewife to megastardom around the world. The painting, long the preserve of elitist connoisseurship, became a mass icon, a pop idol. Artists, both before and after World War II, lampooned her mercilessly, not only because she was famous, but also because she was safely in the public domain, fair game for anyone wanting to take a stab at her. Today, over nine million visitors to the Louvre rush to the room off the Grande Galerie to gawk at this surprisingly small painting, prey to a thousand mobile phone flashes, protected by a double layer of bulletproof glass.

Leonardo's other great masterpiece, the *Last Supper,* likewise underwent a transformation. After its long slow-motion decay, prompted by Leonardo's use of unconventional, oil-based pigments on dry gesso, as well as the high humidity of the wall that bordered the refectory's kitchen, the painting was little more than a ruin by the end of the 19th century. Nearly a century later, a team of restorers led by the Italian curator Pinin Brambilla Barcilon attempted to return the fresco to something resembling its original state. Rather than "restoring" the painting in the true sense of the word, this involved removing all previous attempts to "repaint" the work, including the disastrous intervention by Giuseppe Mazza in 1770 and the even more damaging attempts by Stefano Barezzi in 1821 to transfer the mural to canvas.

In 1947, a first attempt was made to remove the damaging effects of these efforts, under the leadership of Mauro Pellicioli, who then covered the pigments with a colorless shellac resin. But the technology to truly reconstruct the *Last Supper*—a goal that had remained elusive for at least two centuries—only arrived in 1978. Working with a microscope, inch by inch, Barcilon

meticulously removed all the resin, as well as the accumulated pigments, dirt, and soot from Leonardo's fresco. Pressure on the project escalated dramatically when a restoration of Michelangelo's Sistine Chapel ceiling, financed by the Nippon Television Network of Japan, was roundly criticized in 1994 as a catastrophic misinterpretation of the artist's original color palette. Was the same in store for the *Last Supper*?

When in 1997 the results of Barcilon's restoration were revealed, the world breathed a sigh of relief—and recoiled in shock. Her restoration effort—or perhaps "cleaning" effort is a better term—certainly returned the painting to a closer facsimile of Leonardo's original palette. As she wrote in her book,

> Numerous and unexpected recoveries of original material emerged from beneath the blanket of repaint, especially in the face and the hair. The hair reacquired its initial volume, modulated by wavy locks threaded with subtle highlights and delicate white brushstrokes, while a soft gray glaze skillfully emphasized the hairline. The facial features proved leaner and purer, even on a chromatic level.[158]

Two models of Leonardo's designs, a bicycle and a machine gun, now on display at Clos Lucé, Amboise

But at the same time, without the additional touches of past ages, it became clear that much of the fresco has been destroyed. Only some 20 percent of Leonardo's original vision is still visible today.

At the dawn of the 21st century, public fascination with Leonardo da Vinci took another turn—this time, with a focus on the artist as a maverick scientist and brilliant engineer, light-years ahead of his time. Perhaps the reason is that in a world saturated with digital media, very few Leonardo autograph works are actually on public display. In fact, the United States has only one, the portrait of *Ginevra de' Benci* in the National Gallery in Washington, DC. Another factor is the fascination of our age with the so-called STEM disciplines—Science, Technology, Engineering, Math—usually at the expense of the humanities, including the arts, which today are in decline across the United States.

This obsession with Leonardo as, above all, a scientist, has produced a veritable wave of exhibits and "museums" showing models of his imaginative ideas. One such is the Grande Exhibitions' *Da Vinci*, now touring the world, which attempts to "reinforce the fundamental connection between creativity, critical thinking and problem-solving," in the words of one of its curators, Boston Museum of Science's Ioannis Miaoulis.[159] Many of these exhibits feature models of Leonardo's designs for a car, bicycle, helicopter, glider, parachute, scuba gear, submarine, and even an armored vehicle.

At the same time, Leonardo is also a vivid presence in our entertainment media. An acclaimed historical drama series, starring Philippe Leroy, aired in the 1970s. From 2013 to 2015, a highly fictionalized series called *Da Vinci's Demons* aired on the STARZ Channel, starring Tom Riley as Leonardo da Vinci. In

2017, Walter Isaacson's biography *Leonardo da Vinci* reached the number one spot on the *New York Times* nonfiction best-seller list, prompting a new slew of TV specials in the United States and the rest of the world. This frenzy for all things Leonardo then reached its stunning crescendo on November 15, 2017, in an auction room in New York, when a newly discovered Leonardo painting, the *Salvator Mundi*, came under the hammer while the world held its breath.

The Auction of the *Salvator Mundi*

Bidding for the work, known as "Lot 9B," started at $90 million. Over the next nineteen minutes, the bidding steadily increased, propelled in part by four anonymous buyers who were connected to the auction room via telephone. And then suddenly, at $140 million, the bidding stagnated. It was as if the crème de la crème of the world's art market needed time to reflect, and decide how far they should go. Everyone knew that the attribution to Leonardo was not without controversy. To begin with, it had been in British hands for centuries, and even hung in Buckingham Palace at one point. But most British connoisseurs, including the early 20th-century collector Sir Francis Cook, who bought the painting in 1900, tended to regard the work as a copy by one of Leonardo's followers—possibly Luini, or perhaps Boltraffio. True, they said, the face of Christ is reminiscent of the *Last Supper*, just as the delicate curls hark back to the Louvre *Mona Lisa*. But on the other hand, look at the rather hesitant execution of Christ's face, the poorly executed sfumato, the dullness of the eyes, and the uneven treatment of the neck and breast! What's more, the figure utterly lacks the contrapposto posture and the psychological depth, the "motions of the mind" that were the hallmarks of Leonardo's portrait style. In

sum, no one thought that this could be a work by the master himself.[160]

The Cook family seemed to agree. When, at the outbreak of World War II, the Luftwaffe appeared over the skies of London and the Blitz began, the Cook family evacuated their art treasures to Wales. The *Salvator Mundi*, however, was left in the basement. It wasn't believed to be worth the hassle of crating it up for transport. Sure enough, the street where the Cook house was located received a direct hit from a German bomb, but miraculously, the painting was unscathed. Finally, in 1958, the family sold the work to a collector in Louisiana, as a work by Boltraffio. The price: the grand sum of $90 (that's right: *ninety* dollars).

In the decades to come, the *Salvator Mundi* remained as unloved and unappreciated as in the centuries before. As late as 2005, a New York art collector named Alex Parish bought the piece for a song, even though Boltraffio himself was enjoying a reappraisal at that time. The purchase price was $10,000.

Parish, however, had begun to suspect that there was more to this painting than met the eye. He started doing the rounds of New York-based curators, soliciting their opinions. In 2007, art conservator Dianne Dwyer Modestini was hired to remove the layers of overpainting and to see what could be underneath. The result was publicly exhibited in 2011, during the famous Leonardo exhibit at the National Gallery in London. It was here that the work was suddenly pronounced to be a "genuine Leonardo da Vinci." The world gasped. A newly discovered painting by Leonardo? How did that happen?

Regardless, the art collectors now moved in high gear. With interest in da Vinci at a fever pitch, there was money to be made. And so it was: in 2013, Parish sold the painting to a Swiss art dealer named Yves Bouvier for $80 *million*—eight thousand

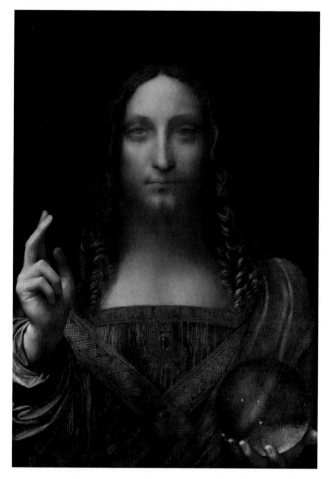

Leonardo da Vinci (?), *Salvator Mundi*, ca. 1500 (?)

times the price he had paid for it.[161] Bouvier "flipped" the painting and sold it, that very same year, to a Russian billionaire, Dmitry Rybolovlev, for $127 million. But when Rybolovlev found out how much Bouvier had paid for it in the first place, he flew into a rage. Russian oligarchs don't like to be ripped off, and Rybolovlev was no exception. He sued the Swiss art dealer, and decided to get rid of the work by putting it up for auction at Christie's, in the

hope of recouping his losses. The asking bid: $100 million.

All that must have gone through auctioneer Pylkkänen's mind as the bidding paused at $140 million, and the billionaire collectors of the world took stock. They knew that the authentication of the painting was not an open and shut case, that there were numerous experts who believed the work was too damaged from overpainting to make any reliable attribution. And if that was true, was the painting really worth $140 million? Did Parish himself not sell the work for little more than half that price, just four years ago?

"At 140 holding at the moment," Pylkkänen intoned.

And then an anonymous bidder, linked to the auction room via the clutch of phone bidders to the left of the stage, came to his rescue. "150, welcome," the relieved auctioneer replied. From there it rapidly went to 160, 190, and finally, $200 million.

At that point, the room erupted in gasps and cries. As the audience well knew, the highest price ever paid for a work of art up to that time was Picasso's *Les Femmes d'Alger* (Version O), which was sold for just under $180 million in that very same auction hall. What's more, the $200 million bid had also shattered the record price for an Old Master painting, which was the *Massacre of the Innocents* by Peter Paul Rubens, sold in 2002 for 49.5 million pounds sterling (or $76.7 million, adjusted for inflation).

In the span of a few seconds, history had been made. Leonardo had just become the most valuable artist in human history.

If the bidding had stopped right there, the evening would have been one for the record books. No one had ever paid such a vast sum for a painting—certainly not for a painting whose authentication was still in question. But it didn't. Much to Pylkkänen's surprise, two anonymous telephone bids raced in,

each determined to have a da Vinci, even if the work in question was perhaps a flawed one. As the race grew tighter, the millions flew across the room as if such numbers no longer seemed to matter, sometimes in increments of ten million at a time. Near the end of this eighteen-minute stretch, with the audience in the room barely daring to breathe, the hammer finally came down. The price: $400 million—or $450.3 million including fees. The room erupted in applause and cheers.

No one knew the identity of the anonymous buyer, but that did not remain a mystery for long. He was Prince Badr bin Abdullah bin Mohammed bin Farhan, the minister of culture of Saudi Arabia. One month later, the *Wall Street Journal* broke the news that the prince was acting on instructions from Saudi Arabia's de facto ruler, Crown Prince Mohammed bin Salman. He intended to give the painting on loan to the Louvre Abu Dhabi.

Thus ended one of the strangest episodes in the history of the world's continuing love affair with Leonardo da Vinci. The story of the *Salvator Mundi* reminds us of the incredible fascination that Leonardo still exerts on our modern world, some five hundred years after his passing. No one but Leonardo da Vinci could have compelled the ruler of the strictest Islamic nation in the world, where public Christian worship is outlawed, to pay nearly half a billion dollars for a portrait of Jesus Christ.

SELECT
BIBLIOGRAPHY

Alberici, Clelia, De Biasi, Mariateresa Chirico, and Castello, Sforzesco. *Leonardo e l'incisione: Stampe derivate da Leonardo e Bramante dal XV al XIX seciolo*. Milan: Electa, 1984.

Atalay, Bülent. *Math and the Mona Lisa: The Art and Science of Leonardo da Vinci*. New York: HarperCollins Publishers/Smithsonian Books, 2006.

Barcilon, Pinin Brambilla and Marani, Pietro. *Leonardo: The Last Supper*. Chicago: University of Chicago Press, 2001.

Baskins, Wade. *The Wisdom of Leonardo da Vinci*. New York: Barnes & Noble, 2004.

Baxandall, Michael. *Painting and Experience in Fifteenth Century Italy*. Oxford: Oxford University Press, 1974.

Bora, Giulio et al. *The Legacy of Leonardo: Painters in Lombardy 1490–1530*. Milan: Skira, 1998.

Bramly, Serge. *Leonardo: The Artist and the Man*. New York: Penguin Books, 1994.

Burke, Peter. *The Italian Renaissance: Culture and Society in Italy*. London: B. T. Batsford, 1972.

Carminati, Marco. *Leonardo: Mona Lisa*. Milan: 24 ORE Cultura, 2012.

Chambers, David S. *Patrons and Artists in the Italian Renaissance.* Columbia, SC: University of South Carolina Press, 1971.

Clark, Kenneth. *Leonardo da Vinci: An Account of his Development as an Artist,* Cambridge: Cambridge University Press, 1939.

Clayton, Martin. *Leonardo da Vinci: A Singular Vision.* Exhibition catalog, Queen's Gallery, Buckingham Palace. New York: Abbeville Press, 1996.

Dalí, Salvador. *Journal d'un genie.* Paris: 1964.

Dalí, Salvador and Pauwels, Louis. *Les Passions selon Dalí.* Paris: 1968.

Delieuvin, Vincent. *Saint Anne: Leonardo's Ultimate Masterpiece.* Paris: Exhibition catalog, Musée du Louvre, 2012.

Ekserdjian, David. *Correggio.* New Haven: Yale University Press, 1997.

Etherington-Smith, Meredith. *The Persistence of Memory: A Biography of Dalí.* New York: Da Capo Press, 1992.

Fanés, Fèlix. *Salvador Dalí: The Construction of the Image, 1925–1930.* New Haven: Yale University Press, 2007.

Farago, Claire J. (Ed.), *Biography and Early Art Criticism of Leonardo da Vinci.* New York: Garland Publishing, 1999.

Farago, Claire J. (Ed.). *Leonardo da Vinci, Selected Scholarship: Leonardo's Projects, c. 1500–1519.* United Kingdom: Taylor & Francis, 1999.

Feldman, Stanley et al. *Mona Lisa: Leonardo's Earlier Version.* Zurich: The Mona Lisa Foundation, 2012.

Frasnay, Daniel. *The Artist's World: Magritte.* New York: Viking Press, 1969.

Heydenreich, Ludwig H. *Leonardo: The Last Supper.* London: Allen Lane, 1974.

Isaacson, Walter. *Leonardo da Vinci.* New York: Simon & Shuster, 2017.

Isbouts, Jean-Pierre and Brown, Christopher Heath. *The Mona Lisa Myth: How New Discoveries Unlock the Final Mystery of the World's Most Famous Painting.* Los Angeles: Pantheon, 2014.

Isbouts, Jean-Pierre and Brown, Christopher Heath. *Young Leonardo: The Evolution of a Revolutionary Artist*. New York: St. Martin's Press, 2017.

Kemp, Martin. *La Bella Principessa: The Story of the New Masterpiece by Leonardo da Vinci*. London: Hodder & Stoughton, 2010.

Kemp, Martin. *Leonardo da Vinci: the Marvelous Works of Nature and Man*. Oxford: Oxford University Press, 2006.

Kemp, Martin (Ed.). *Leonardo on Painting*. New Haven: Yale University Press, 1989.

Kemp, Martin and Pallanti, Giuseppe. *Mona Lisa: The People and the Painting*. Oxford: Oxford University Press, 2017.

Ladwein, Michael. *Leonardo da Vinci, the Last Supper: A Cosmic Drama and an Act of Redemption*. United Kingdom: Temple Lodge Publishing 2004.

Levey, Michael. *The Early Renaissance*. London: Penguin Books, 1967.

MacCurdy, Edward. *The Notebooks of Leonardo da Vinci*. New York: George Braziller, 1954.

Marani, Pietro C. *Leonardo da Vinci: The Complete Paintings*. New York: Harry N. Abrams, 2000.

Marijnissen, R. H. *Het Da Vinci Doek van de Abdij van Tongerlo*, Abdij Tongerlo, Belgium, 1959.

McMullen, Roy. *Mona Lisa: The Picture and the Myth*. Boston: Houghton Mifflin Co., 1976.

Melani, Margherita. *The Fascination of the Unfinished Work: The Battle of Anghiari*. Italy: CB Edizioni, 2012.

Mohen, Jean-Pierre et al. *Mona Lisa: Inside the Painting*. New York: Harry N. Abrams, 2006.

Nicholl, Charles. *Leonardo da Vinci: Flights of the Mind*. New York: Penguin Books, 2004.

O'Malley, Charles D. *Leonardo on the Human Body*. New York: Dover Books, 1983.

Pallanti, Giuseppe. *Mona Lisa Revealed: The True Identity of Leonardo's Model*. New York: Rizzoli, 2006.

Pedretti, Carlo. *Leonardo, a Study in Chronology and Style*. Los Angeles: University of California Press, 1982.

Pedretti, Carlo. *Leonardo: Studies for the Last Supper from the Royal Library at Windsor Castle*. Cambridge: Cambridge University Press, 1983.

Read, Herbert, *A Concise History of Modern Painting*. Oxford: Oxford University Press, 1959.

Richer, Paul (Ed.). *The Notebooks of Leonardo da Vinci* (Vols. I and II). New York: Dover Books, 1970.

Rombaut, Marc. *Paul Delvaux*. New York: Rizzoli, 1990.

Rubin, Patricia Lee. *Giorgio Vasari: Art and History*. New Haven: Yale University Press, 1995.

Sassoon, Donald. *Becoming Mona Lisa: The Making of a Global Icon*. San Diego: Harcourt, 2001.

Schmalenbach, Werner. *Fernand Léger*. Paris: Édition Cercle d'Art, 1977.

Steinberg, Leo. *Leonardo's Incessant Last Supper*. New York: Zone Books, 2001.

Suh, Anna (Ed.). *Leonardo's Notebooks: Writing and Art of the Great Master*. New York: Black Dog & Leventhal Publishers, 2005.

Syson, Luke et al. *Leonardo da Vinci: Painter at the Court of Milan*. Exhibition catalog. London: National Gallery Company, 2011.

Taglialagamba, Sara and Pedretti, Carlo. *Leonardo & Anatomy*. Italy: CB Publishers, 2010.

Vezzosi, Alessandro. *Discoveries: Leonardo da Vinci*. New York: Harry N. Abrams, 1997.

Zöllner, Frank and Johannes, Nathan. *Leonardo da Vinci: Sketches and Drawings*. New York: Taschen, 2006.

NOTES

Introduction

1. Giorgio Vasari, "Lionardo da Vinci," in *Le Vite de' più eccellenti pittori, scultori e architetti*; 1568 Edition.

1. Leonardo in Amboise

2. Jean-Pierre Isbouts and Christopher Heath Brown, *Young Leonardo*. Tomas Dunne Books/St. Martin's Press, 2017.

3. See Carlo Pedretti, *Leonardo da Vinci: The Royal Palace at Romorantin*.

4. The *écu au soleil* was a gold currency established by Louis XI in 1475 to replace the *écu à la couronne*.

5. Rather than seventy, Leonardo was actually sixty-five at the time, though with his flowing beard and long hair, he may have looked older to his visitors.

6. Antonio de Beatis, "Account of the Visit of Cardinal Louis d'Aragon paid to Leonardo, at the Château de Cloux, October 10, 1517," in Vincent Delieuvin, *Saint Anne: Leonardo da Vinci's Ultimate Masterpiece*, p. 199.

7. "Leonardo's Will" (1566), in Jean Paul Richter, *The Notebooks of Leonardo da Vinci*, pp. 468–469.

8. Giorgio Vasari, "Lionardo da Vinci," in *Le Vite de' più eccellenti pittori, scultori e architetti*; 1568 Edition.

2. The Legacy of Leonardo's Studio

9. Serge Bramly, *Leonardo: The Artist and the Man*, p. 106. Leonardo later described this technique in his *Treatise on Painting*.

10. Peter Burke, *The Italian Reanaissance: Culture and Society in Italy*, p. 69.

11. Manuscript MS C, fol.15 r., Institut de France.

12. Jean Paul Richter, *The Literary Works of Leonardo da Vinci*, 1883, p. 439.

13. Paolo Giovio, "The Life of Leonardo," in P. Barocchi (Ed.), *Scritti d'arte del Cinquecento*. Milan and Naples: 1961, pp. 20–21.

14. *Libro di Pittura*, in manuscript A, folio 113, Institut de France.

15. Frank Zöllner, "Leonardo's Portrait of Mona Lisa del Giocondo," in *Gazette des Beaux-Arts,* 121 (1993), pp. 115–138.

16. Stanley Feldman, *Mona Lisa: Leonardo's Earlier Version*, p. 66.

17. For more information about the *Battle of Anghiari* project, see the new study by Margherita Melani, *The Fascination of the Unfinished Work: The Battle of Anghiari*. CB Edizioni, 2012.

18. Adding further to the mystery surrounding the *Anghiari* project, the *Tavola Doria* copy was stolen in 1940 and only recently emerged in a Japanese collection; as announced on December 3, 2012, the painting will now be exhibited in Japan and Italy on a rotating basis.

19. The king, says Vasari, "tried by any possible means to discover whether there were architects who, with cross-stays of wood and iron, might have been able to make it so secure that it might be transported safely; but the fact that it was painted on a wall robbed his Majesty of his desire, and so the picture remained with the Milanese."

20. It took some doing, however, to release Leonardo from his obligation to complete the *Battle of Anghiari* for the Signoria in Florence. There now followed an increasingly acrimonious exchange of letters between Soderini, the Florentine gonfaloniere, and the new governor of Milan, Charles d'Amboise, acting on instructions of the French king, to release Leonardo from his obligations in Florence. Soderini fired off a letter on October 9, all but accusing Leonardo of bad faith. "He received a large sum of money and has

only made a small beginning on the great work he was commissioned to carry out," the gonfaloniere charged, adding that "we do not wish further delays to be asked for on his behalf, for his work is supposed to satisfy the citizens of this city." Any more delay, he charged, would "expose ourselves to serious damage." Louis XII then took the extraordinary step to write a letter to the gonfaloniere, personally. "Very dear and close friends," the king began, "As we have need of Master Leonardo da Vinci, painter to your city of Florence, and intend to make him do something for us with his own hand, and as we shall soon, God helping us, to be in Milan, we beg you, as affectionately as we can, to be good enough to allow the said Leonardo to work for us such a time as may enable him to carry out the work we intend him to do." This may be the first time in history that a demand for a painter prompted what amounted to a political crisis between two heads of state. Of course, when confronted with the might of France, Florence had no choice but to accede to the king's wish.

21. Janet Cox-Rearick, Dynasty and Destiny in Medici Art: Pontomo, Leox, and the Two Cosimos. Princeton University Press, 1984, p. 150.

22. Vincent Delieuvin, "A Saint Anne, but for Whom?" in *Saint Anne Leonardo's Ultimate Masterpiece*. Exhibition catalog, Musée du Louvre; 2012.

23. Not even a special symposium, held at the Louvre in 2012, has been able to resolve the issue.

24. The original Italian text is as follows: "Et così li tenne in pratica lungo tempo, né mai cominciò nulla. Finalmente fece un cartone dentrovi una Nostra Donna et una s.Anna con un Christo . . ." From Vasari, *Le Vite de' più eccellenti pittori, scultori e architetti*; 1568 Edition.

25. Michael Baxandall, *Painting and Experience in Fifteenth Century Italy*, p. 41.

26. Vasari, "Lionardo da Vinci," in *Le Vite de' più eccellenti pittori, scultori e architetti*; 1568 Edition.

27. Fra Pietro Novella to Isabella d'Este, dated Florence, 3 April 1501, in Luca Beltrami, *Documenti e memorie riguardanti la vita e le opere di Leonardo da Vinci*. Milan, 1919: doc. 17.

28. Delieuvin, *Saint Anne: Leonardo's Ultimate Masterpiece*; Exhibition

catalog, Musée du Louvre, 2012, p. 166.

29. Delieuvin, *Saint Anne*, p. 163.

30. Delieuvin, *Saint Anne*, p. 164.

31. Delieuvin, *Saint Anne*, pp. 162–169.

3. The Leonardeschi after Leonardo

32. Though the literature refers to it as the Certosa di Pavia ("Charterhouse of Pavia") copy, this particular monastery did not list the work in its inventory until 1626—over a century later. It is possible that it was originally ordered by a smaller Carthusian convent, and later claimed by the Certosa when Leonardo's original in Milan had become famous throughout Italy and beyond.

33. Long consigned to a dusty place in the vaults, Giampietrino's copy of the *Last Supper* was shipped to the chapel of Magdalen College at Oxford in 1973. It was still there in 2014, when this author saw it hanging against a damp wall in semidarkness, high above the main entrance. Fortunately, we have been assured by Helen Valentine, director of the Royal Academy of Arts, that the painting will once again have pride of place at Burlington House after its current renovation is finished in 2018.

34. See Isbouts and Brown, *Young Leonardo, The Evolution of a Revolutionary Artist*, St. Martin's Press, 2017.

35. Maria Teresa Fiorio, "Giovanni Antonio Boltraffio," in *The Legacy of Leonardo: Painters in Lombardy 1490–1530*, Skira Editore, 1998. Fiorio adds that apparently, Boltraffio never faced any economic hardship, which suggests that he received financial assistance in the pursuit of his career as an artist.

36. Martin Kemp, ed., *Leonardo on Painting*, p. 144.

37. Aulus Gellius, "Attic Nights," 18:3; in *Loeb Classical Library*, Vol. II, 1927, p. 263.

38. Antonio Mazzotta, "Portrait of a Young Woman as Artemisia," in *Leonardo da Vinci: Painter at the Court of Milan*; Exhibition catalog,

National Gallery of London, 2011, p. 128.

39. The problem with this identification, however, is that in 1495, the Duchetto was only four years old. In fact, Boltraffio's close collaborator, Marco d'Oggiono, *did* paint a portrait of this child around 1492–1493, which is now in the Bristol Museum and Art Gallery, and this painting clearly depicts a toddler of around two or three years of age. So if Boltraffio's painting does represent the young Francesco (who died in 1512 at age twenty-one), then this portrait should be dated much later, arguably after 1500.

40. The younger Casio sat for several portraits by Boltraffio, including the painting currently in the Pinacoteca di Brera, though he is also believed by some to be the subject of the *Portrait of a Young Man with an Arrow* in the Timken Museum of Art in San Diego, as well as the *Portrait of a Young Man* in the Devonshire Collection in Chatsworth House.

41. Guilio Bora, "Bernardino Luini," in *The Legacy of Leonardo: Painters in Lombardy 1490–1530*, p. 356.

42. Some have suggested that if indeed there was such a drawing, it could have been made in response to a request by Isabella d'Este, Marchioness of Mantua, who asked Leonardo to paint "a portrait of Jesus as a young man, of about twelve years old, at the age when he disputed in the Temple." What she was particularly looking for, the Marchioness wrote, was "that sweetness and soft ethereal charm, which is the peculiar excellence of your art." If Luini's painting is any guide, the drawing must certainly have met the noblewoman's request.

43. E. Möller and J. Martin-Demezil, "L'art et la Pensée de Léonard de Vinci, Communications du Congrès International du Val de Loire," in *Etudes d'Art* (Paris-Algiers: 1953–1954), p. 263.

44. R. H. Marijnissen, *Het Da Vinci Doek van de Abdij van Tongerlo*, 1959, p. 4. That the friars took the preservation of their valuable canvas seriously is attested by the fact that in 1594, special curtains were procured and dyed to serve as protection against the sun.

45. In 1840, after the abbey was restored, it strenuously petitioned the Belgian crown to reclaim the painting, ostensibly to place it in the Tongerlo convent church once more. But after the painting was duly returned to

Tongerlo, the abbot put it up for sale as part of a fundraising effort. The large canvas was shipped to Spalding, Lincolnshire, but no buyer materialized in the end. In 1902 the work was returned to Belgium.

46. David Alan Brown, "Andrea Solario," in *The Legacy of Leonardo: Painters in Lombardy 1490–1530*, p. 234.

47. Kenneth Clark, *Leonardo da Vinci: An Account of His Development as an Artist*, 1939, p. 109.

48. Janice Shell, "Marco d'Oggiono," in *The Legacy of Leonardo: Painters in Lombardy 1490–1530*, p. 166.

49. We know that the Château d'Écouen was acquired in 1515 by le Connétable, Anne de Montmorency, and then vastly expanded from 1538 onward by the architect Jean Bullant. Documents indicate that Montmorency was indeed interested in obtaining a copy of Leonardo's *Last Supper* for his chapel at the Château d'Écouen. The constable had been an important councilor at the court of François I, and had accompanied his sovereign to Milan in 1515, when he must have seen the original fresco in the Santa Maria delle Grazie. He then served the king faithfully as grand master and governor of Languedoc, until he failed to forge a peace treaty between François and Emperor Charles V in 1541. As a result, he fell from royal favor, was forced to retire from court, and settled in his chateau at Écouen. Here, he supervised the start of work on the chapel, which was not completed in 1547. And therein lies the problem: although the circumstances of his death are uncertain, d'Oggiono is believed to have passed away in 1524 during an outbreak of the plague. His assistants may have finished the work, perhaps aided by French artists. Nonetheless, though it is unsigned, Marco d'Oggiono had long been identified as the artist, beginning with Seidlitz's analysis of 1909.

50. The first author to identify Caprotti with Salaì was Gerolamo Calvi, "Il vero nome di un allievo di Leonardo: Gian Giacomo de' Caprotti ditto 'Salaj'", in *Rassegna d'Arte*, 1919, pp. 138–141.

51. Richter, *The Literary Works of Leonardo da Vinci*, 3rd ed., London 1970 (1st ed., 1883), vol. II, p. 363.

52. Sigmund Freud, *Leonardo da Vinci and a Memory of his Childhood* (English translation). New York: Norton, 1964, p. 19.

Notes

53. As cited in Sigmund Freud, (1909–13) in *"Eine Kindheitserinnerung des Leonardo da Vinci," Gesammelte Werke* VIII.

54. Vasari, *Le vite de' più eccellenti pittori, scultori e architettori*, ed. Bettarini & Barocchi, Florence 1976 (1550 ed.), vol. IV, pp. 28–29.

55. J. Shell and G. Sironi, "Salaì and Leonardo's legacy," in *The Burlington Magazine*, vol. CXXXIII, no. 1055, February 1991, p. 106.

56. Suzanne Daley, "Beneath That Beguiling Smile, Seeing What Leonardo Saw," in the *New York Times,* April 13, 2012.

57. As reported in Tom Gross, "Mona Lisa Goes Topless," in *Art Index*, March 20, 2001.

58. See *New York Times*, "Did Leonardo da Vinci Sketch the 'Nude Mona Lisa'?" Elian, Peltier, September 29, 2017, https://www.nytimes.com/2017/09/29/arts/design/mona-vanna-lisa-louvre.html?_r=1.

59. "Leonardo's Will" (1566), in Richter, *The Notebooks of Leonardo da Vinci*, pp. 468–469.

60. Shell and Sironi, 1992, pp. 134–136.

61. Delieuvin, *Saint Anne,* p. 205.

62. Janice Shell, "Gian Giacomo Caprotti, detto Salaì," in *The Legacy of Leonardo: Painters in Lombardy 1490–1530*, p. 399.

63. "Salaì's Probate Inventory, April 21, 1525," in Delieuvin, *Saint Anne,* p. 282.

64. Charles Nicholl, *Leonardo: Flights of the Mind*, p. 411.

65. Marrion Wilcox, "Francesco Melzi, Disciple of Leonardo," in *Art & Life*; December 1919, Vol. XI, Nr. 6, p. 295.

66. Martin Kemp, *Leonardo on Painting*. Yale University, 1989; republished in 2001.

67. The only other work that has been credibly attributed to Melzi is the *Nymph of the Spring,* also known as the *Venus*, now in the National Gallery of Washington, DC. While the National Gallery itself ascribes the painting to Bernardino Luini, its resemblance to the seminude females of *Flora* and *Vertumnus and Pomona* is readily apparent. It is also a late work, dated around 1530, in which Melzi's virtuosity with the female form,

no doubt informed by his work on the *Spiridon Leda*, is on full display. It is this delicacy that prompted Venturi to marvel at "the lustrous and polished marble-like flesh" of Melzi's figures. Venturi was talking about the *Vertumnus and Pomona*, but the verdict certainly suits this work as well. There is a persistent tradition that suggests that the model for the painting was none other than Melzi's wife, Angiola Landriani, who was considered one of the great beauties of her time. Another strand claims that the *Nymph* is the Countess Challant, who was imprisoned in the Sforza Castle in 1528. If that is true, then the date would obviously be well before that year, perhaps in the mid-1520s.

68. Paolo Giovio, *Leonardi Vincii Vita*, in Claire Farago (Ed.), *Leonardo da Vinci: Selected Scholarship*. New York: Garland Publishing, 1999, p. 70.

4. Leonardo and the Artists of the High Renaissance

69. We should, however, mention that Vasari claims Raphael and Taddeo Taddei were good friends, and that Taddei "would have him ever in his house and at his table," so perhaps the proximity of Raphael's rooms in the Palazzo Taddei to the Giocondo home was purely coincidental.

70. Even a decade later, in 1516, Raphael fell back on the *Mona Lisa* paradigm to create his now-famous portrait of Baldassare Castiglione, this time with a keener interest in the sitter's state of mind.

71. Michael Levey, *The Early Renaissance*. London: Penguin, 1967, p. 197.

72. Michelangelo's cartoon for the *Battle of Cascina* was reportedly torn to pieces by an envious artist, Bartolommeo Bandinelli, in 1512. Fortunately, this cartoon was copied by several artists, most notably by Michelangelo's pupil Sangallo. It is doubtful that any of it ever made it to the wall of the Council Chamber, and if it did, it too would have been obliterated as part of the chamber's renovations after 1540.

73. In 2015, the J. Paul Getty Museum in Los Angeles staged an exhibit of Andrea del Sarto's drawings. See *Andrea del Sarto: The Renaissance Workshop in Action*, published online 2015, the J. Paul Getty Museum, Los Angeles, http://www.getty.edu/art/exhibitions/del_sarto/.

74. *Andrea del Sarto: The Renaissance Workshop in Action.* The Frick Collection, New York, October 7, 2015 to January 10, 2016.

75. Giorgio Vasari, "Giorgione da Castelfranco," in *Le vite de' più eccellenti pittori, scultori ed architettori*, ed. Bettarini & Barocchi, Florence 1976 (1550 ed.).

76. Linda Murray, *The High Renaissance and Mannerism*, p. 71.

77. Written around 8 C.E., Ovid's *Metamorphoses* is a collection of 250 myths, often featuring startling transformations of gods and mortals. The book was wildly popular during the Renaissance, perhaps because of its scandalously overt depiction of unbridled sexual passion.

78. Egon Verheyen, "Correggio's *Amori di Giove*," in *Journal of the Warburg and Courtauld Institutes*, XXIX (1966), pp. 160–192. Another school of scholarship, citing Vasari, believes that the paintings were intended as a gift by Gonzaga to the Emperor, Charles V, in gratitude for Charles's decision to elevate Federico from marquess to duke. The fact that the paintings were executed on canvas (still a novel support in the early 16th century), rather than panel, may support this theory, since canvas was more easily transported over long distances.

79. David Ekserdjian, *Correggio*. New Haven: Yale University Press, 1998, pp. 279–284.

5. Leonardo in the Literature of the 16th Century

80. Richter, *The Literary Works of Leonardo da Vinci.* London: Sampson Low et al., 1883.

81. Carl Frey, *Il Libro di Antonio Billi: esistente in due copie nella Biblioteca nazionale di Firenze.* Berlin: G. Grote'sche Verlagsbuchhandlung, 1892.

82. Claire Farago (Ed.), *Biography and Early Art Criticism of Leonardo da Vinci.* New York: Garland Publishing, 1999, pp. 70–71.

83. At some universities and colleges, autopsies for educational purposes were limited to one per year. See Katharine Park, "The Criminal and the Saintly Body: Autopsy and Dissection in Renaissance Italy," in *Renaissance Quarterly* Vol. 47, No. 1 (Spring, 1994), p. 8.

84. Park, "The Criminal and the Saintly Body," p. 12.

85. Farago, *Biography and Early Art Criticism of Leonardo da Vinci*, p. 70.

86. It is possible that a bequest of the three paintings that Leonardo brought to Amboise to the French crown—including the *Saint Anne*, the *Mona Lisa*, and the *John the Baptist*—was a quid pro quo for the generous pension that François bestowed on Leonardo.

87. As Frank Zöllner has suggested, it is more likely that Piero was the source of the information about the *Mona Lisa* portrait, and that Gaddiano misunderstood him. See Frank Zöllner, "Leonardo's Portrait of Mona Lisa del Giocondo," in Farago, *Leonardo da Vinci, Selected Scholarship: Leonardo's Projects, c. 1500–1519*, p. 245.

88. Farago, *Biography and Early Art Criticism of Leonardo da Vinci*, p. 73.

89. Others believe the sitter may be Franchino Gaffurio, a Milanese composer and maestro di cappella at the Cathedral of Milan, who befriended Leonardo. Gaffurio was a key interpreter of the polyphonic Renaissance style then being developed by the Franco-Flemish School.

90. See Isbouts and Brown, *Young Leonardo*, pp. 57–61.

91. Farago, *Biography and Early Art Criticism of Leonardo da Vinci*, p. 74.

92. Jean-Pierre Isbouts and Christopher Brown, *The Mona Lisa Myth*. Los Angeles: Pantheon, 2014.

93. Farago, *Biography and Early Art Criticism of Leonardo da Vinci*, p. 88.

94. Giuseppe Pallanti, *Mona Lisa Revealed: The True Identity of Leonardo's Model*. New York: Rizzoli, 2006.

95. Patricia Lee Rubin, *Giorgio Vasari: Art and History*. Yale University Press, 1995, p. 123.

96. Farago, *Biography and Early Art Criticism of Leonardo da Vinci*, p. 88.

97. Farago, *Biography and Early Art Criticism of Leonardo da Vinci*, p. 73.

98. See Isbouts and Brown, *Young Leonardo*, p. 66.

99. Farago, *Biography and Early Art Criticism of Leonardo da Vinci*, p. 198

100. Gian Paolo Lomazzo, *Trattato dell'arte della pittura, scoltura et architettura* [Milano 1584] in *Scritti sulle arti* Vol. II, Roberto Paolo Ciardi, Florence 1974.

101. Farago, *Biography and Early Art Criticism of Leonardo da Vinci*, pp. 201–202.

102. Martin Kemp and Giuseppe Pallanti, *Mona Lisa: The People and the Painting*. Oxford University Press, 2017, p. 117.

103. Kemp and Pallanti, *Mona Lisa: The People and the Painting*, p. 117. Kemp and Pallanti dismiss this reference with various explanations, such as that the *e* ("and") should really be an *o* ("or"), or that Melzi may have used both names for the same painting. "In any event," is their verdict, "Lomazzo was not an eyewitness." But neither was Vasari.

6. The Leonardo Legend and the Art of Engraving

104. Jean-Pierre Isbouts, *The Story of Christianity*. National Geographic, p. 166.

105. Pietro Marani, "Il *Cenacolo* di Leonardo," in Brambilla et al., *Leonardo: L'Ultima Cena*, Milan 1999, pp. 15–95.

106. Leo Steinberg, *Leonardo's Incessant Last Supper*, New York 2001, p. 230.

107. Steinberg, *Leonardo's Incessant Last Supper*, p. 252.

108. Isbouts and Brown, *Young Leonardo*, p. 184.

109. Egbert Haverkamp Begemann, *Fifteenth- to Eighteenth-Century European Drawings*. Metropolitan Museum of Art, 1999, p. 207.

110. Begemann, *Fifteenth- to Eighteenth-Century European Drawings*, p. 209.

111. Clelia Alberici and Mariateresa Chirico De Biasi, *Leonardo e l'incisione: Stampe derivate da Leonardo e Bramante dal XV al XIX seciolo*, Milan: Castello Sforzesco, 1984.

7. The *Mona Lisa* and the *Last Supper* in the Baroque Era

112. Roy McMullen, *Mona Lisa: The Picture and the Myth*. Boston: Houghton Mifflin Co., 1976, p. 139.

113. An in-depth study by Salvatore Lorusso, Chiara Matteucci, Andrea Natali, Salvatore Andrea Apicella, and Flavia Fiorillo of the University of Bologna conducted a rigorous scientific examination of the fabric of the support and the pigments in 2013, and concluded that the work could only have been produced in Flanders between 1560 and 1620, with the early 17th century as the most likely date. We are grateful to Dr. Lorusso for sharing his study with us. See Salvatore Lorusso et al., "Diagnostic-Analytical Study of the Painting 'Gioconda with Columns'" in *Conservation Science in Cultural Heritage*, [S.l.], v. 13, pp. 75–102, Dec. 2013. ISSN 1973-9494.

114. As related in Donald Sassoon, *Mona Lisa: The History of the World's Most Famous Painting*, HarperCollins 2001, p. 204.

115. See http://art.thewalters.org/detail/6356/copy-of-the-mona-lisa/, retrieved October 13, 2017.

116. See http://articles.thewalters.org/the-walters-mona-lisa/, retrieved November 2, 2017.

117. Feldman, *Mona Lisa: Leonardo's Earlier Version*. Zurich: The Mona Lisa Foundation, 2012, pp. 198–205.

118. McMullen, *Mona Lisa: The Picture and the Myth*, p. 146.

119. Ludwig H. Heydenreich, *Leonardo: The Last Supper*, London 1974, p. 109. Leo Steinberg dismisses Heydenreich's claim that this was the most accurate depiction of the fresco before the Napoleonic Wars, pointing to the drawings made by Teodoro Matteini, arguably before 1796, which were subsequently published in 1800. Leo Steinberg, *Leonardo's Incessant Last Supper*, p. 268.

120. As cited in Michael Ladwein, *Leonardo da Vinci, the Last Supper: A Cosmic Drama and an Act of Redemption*, Temple Lodge, 2004, p. 96.

121. Steinberg, *Leonardo's Incessant Last Supper*, p. 269.

122. The authors were able to admire this work at the library of the Royal Academy of Arts at Burlington House in London, courtesy of Helen Valentine, its director.

8. Leonardo's Legacy in the 19th Century

123. Giuseppe Bossi, *Del Cenacolo di Leonardo da Vinci,* Milan, 1810. Translation in Leo Steinberg, p. 31.

124. Johann Wolfgang von Goethe, *Joseph Bossi über Leonardo da Vincis Abendmahl zu Mailand 1810* ("Joseph Bossi on Leonardo da Vinci's Last Supper in Milan, 1810"), published in 1817.

125. Johann Wolfgang von Goethe, *Leonardo da Vinci Abendmahl,* published in English as *Observations on Leonardo da Vinci's Celebrated Picture of the Last Supper,* London, J. Booth et al., 1821.

126. Stendhal, *Histoire de la Peinture en Italie.* Paris, Le Divan, 1817.

127. Stendhal, 1817, and Goethe, 1817, as quoted in Michael Ladwein, *Leonardo da Vinci, The Last Supper: A Cosmic Drama and Act of Redemption.* Forest Row, RH, 2006, pp. 95–96.

128. Ladwein, 2006, pp. 99–100.

129. McMullen, *Mona Lisa: The Picture and the Myth*, p. 161.

130. Peter Jakab, *An Extraordinary Journey: The History of Leonardo da Vinci's Codex on the Flight of Birds.* Smithsonian National Air and Space Museum, September 13, 2013.

131. George Sand, *Elle et Lui,* 1859; as quoted in McMullen, 1976, p. 168.

132. Jules Michelet, *History of France,* trans. G. H. Smith; New York, 1847. Quoted in McMullen, 1976, p. 170.

133. Not until 1817 did Manzi publish a full collection of Leonardo's essays on painting, based on the notebooks in the Codex Urbinas in the Vatican Library, but without any particular arrangement.

134. In England, the Royal Academy was governed—literally—by painters like Frederic Leighton and Lawrence Alma-Tadema, who sought their inspiration from classical and biblical texts, executed with an almost obsessive eye for archaeological detail.

135. Louis-Napoléon, as he was formally called, first ruled as President of France from 1848 to 1852, and then proclaimed a Second Empire that lasted until the outbreak of the Franco-Prussian War in 1870.

136. So pervasive was this academism that a reaction broke out in England early on that called itself, tellingly, the Pre-Raphaelite Brotherhood. Founded by Dante Gabriel Rossetti, John Everett Millais, and William Holman Hunt, this group devoted itself to finding the original, unmannered spirit of the Renaissance, before the art of Raphael and da Vinci became canonized as fixed doctrine. In France, the rule of the Academy elicited another reaction, that of the Impressionists, who instead sought inspiration in the motifs and travails of modern life.

137. St.-Germain-en-Laye, as modern commuters know all too well, lies northwest of Paris, at a distance from Amboise of some 165 miles; to cover the distance, the king would have had to race at a full gallop, straight through the night, which is unlikely. Some scholars now question whether the edict would have required the king to be present, since it doesn't bear his actual signature, merely his name. That could have placed him in Amboise on May 2. Nevertheless, the sentimentality of the scene makes it certainly suspicious.

138. Bramly, *Leonardo: The Artist and the Man*, p. 413.

9. Leonardo da Vinci in the 20th Century

139. Werner Schmalenbach, *Fernand Léger,* Édition Cercle d'Art, 1977, p. 130.

140. Nancy Hargrove, "The Great Parade: Cocteau, Picasso, Satie, Massine, Diaghilev—and T.S. Eliot" in *Journal for the Interdisciplinary Study of Literature*, 1998; Vol. 31 (1).

141. André Breton, *First Manifesto of Surrealism*, 1924; as quoted in Hans Werner Holzwarth (Ed.), *Modern Art,* Taschen, 2016, p. 337.

142. Giorgio de Chirico, *The Return of Craftsmanship,* as quoted in Magdalena Holzhey, *Giorgio de Chirico,* Taschen, 2005, p. 60.

143. Herbert Read, "The Influence of Surrealism," in *A Concise History of Modern Painting*. New York: Oxford University Press, p. 144.

144. Salvador Dalí, *Journal d'un genie*. Paris: 1964.

145. Meredith Etherington-Smith, *The Persistence of Memory: A Biography of Dali*. New York: 1992, p. 108.

146. Fèlix Fanés, *Salvador Dali: The Construction of the Image, 1925–1930*. New Haven, CT: 2007, p. 82.

147. Salvador Dalí and Louis Pauwels, *Les Passions selon Dalí*. Paris: 1968.

148. Daniel Frasnay, *The Artist's World: Magritte*, Viking Press, 1969, pp. 99–107.

149. Marc Rombaut, *Paul Delvaux*. Rizzoli, 1990, p. 11.

150. *Studium* was a monthly magazine published in January and June 1919 by Salvador Dalí, when he was in sixth grade at his high school, the Ramón Muntaner Institute. Dalí edited and published the magazine together with his friends Jaume Miravitlles, Joan Xirau, Juan Turró, and Ramon Reig. It featured illustrations, poetic texts, and a series of essays dedicated to painters like Goya, Velázquez, and Leonardo da Vinci.

151. André Breton, *Le Surréalisme et la peinture*, New York, 1945, p. 24.

152. As quoted in "And Now to Make Masterpieces," in *Time*, December 8, 1947.

153. As Herbert Read wrote in 1959: "[Dalí's] theatricality, which was always a characteristic of his behavior, is now at the service of those reactionary forces in Spain whose triumph has been the greatest affront to the humanism which, in spite of all its extravagance, has been the consistent concern of the Surrealist movement." Herbert Read, *A Concise History of Modern Painting*, Oxford University Press, 1959, pp. 141–142.

154. Elliott King, Curator, *Dalí: The Late Work, quoted* in *OSV Newsweekly*; November 10, 2010.

155. Elliott King, Curator, *Dalí: The Late Work*, unpublished curatorial file.

156. Donald Sassoon, *Mona Lisa: The History of the World's Most Famous Painting*. HarperCollins, 2001, p. 244.

10. The Legacy of Leonardo

157. Sassoon, *Mona Lisa: The History of the World's Most Famous Painting*, p. 81.

158. Pinin Brambilla Barcilon and Pietro Marani, *Leonardo: The Last Supper*, University of Chicago Press, 2001.

159. See http://grandeexhibitions.com/da-vinci-the-genius/, retrieved November 4, 2017.

160. More recently, Walter Isaacson agreed, pointing to the glass globe in Christ's hand and noting that the artist "failed to paint the distortion that would occur when looking through a solid clear orb at objects that are not touching the orb."

161. Max Jaeger, "How this $100 M da Vinci masterpiece flew under the radar for centuries," in the *New York Post,* November 14, 2017.

CREDITS

ACKNOWLEDGMENTS

This book is the sequel to our 2017 publication *Young Leonardo*. It is an attempt to reconstruct the process by which Leonardo gained the fame he enjoys today, and to dispel some of the misconceptions on the subject that have accumulated in both scholarly and popular literature over the past few decades. In doing so, we owe a debt to many scholars, past and present, whose research proved indispensable to our book, including Peter Burke, Claire J. Farago, Martin Kemp, Pietro Marani, Jean-Pierre Mohen, Charles Nicholl, Donald Sassoon, Leo Steinberg, and Frank Zöllner, as well as the titans of Leonardo connoisseurship, Kenneth Clark and Carlo Pedretti.

In addition, we are deeply grateful to several prominent art historians who agreed to share their thoughts with us, including Luke Syson (now Iris and B. Gerald Cantor Curator in Charge of European Sculpture and Decorative Arts at the Metropolitan Museum of Art in New York) and Larry Keith (Head of Conservation and Keeper at the National Gallery in London), who both curated the landmark 2011 exhibition *Leonardo da Vinci: Painter at the Court of Milan* at the National Gallery; Vincent Delieuvin, curator of Italian art at the Louvre Museum in Paris and editor of the 2012 exhibition *Saint Anne: Leonardo da*

317

Vinci's Ultimate Masterpiece; Arnold Nesselrath, deputy director of the Vatican Museums in Rome; and Andreas Schumacher, curator of Italian art at the Alte Pinakothek in Munich. We are also indebted to Giuseppe Pallanti for sharing with us the fruits of his research in the public and private archives of Florence; and for the research staff at several academic libraries, particularly the Charles E. Young Research Library at UCLA, Westwood campus; Oxford University's Bodleian Library; and the research library at Magdalen College, Oxford.

We must also thank Julia Abramoff and Alex Merrill at Apollo Publishers for their unfailing support in the development of this book, as well as Nena Rawdah for her superb edit and Doug Nielson for his incisive copyedit. We also owe a debt of gratitude to two graphic artists, Jesse Martino and Jason Clark, for their invaluable help in preparing the illustrations for this book.

Thanks are due to our literary manager, Peter Miller, and his staff at Global Lion Intellectual Property Management. Finally, we must express our deepest gratitude to our muses, Sabrina and Cathie, who continue to be our indefatigable companions during our many journeys through Renaissance Italy.